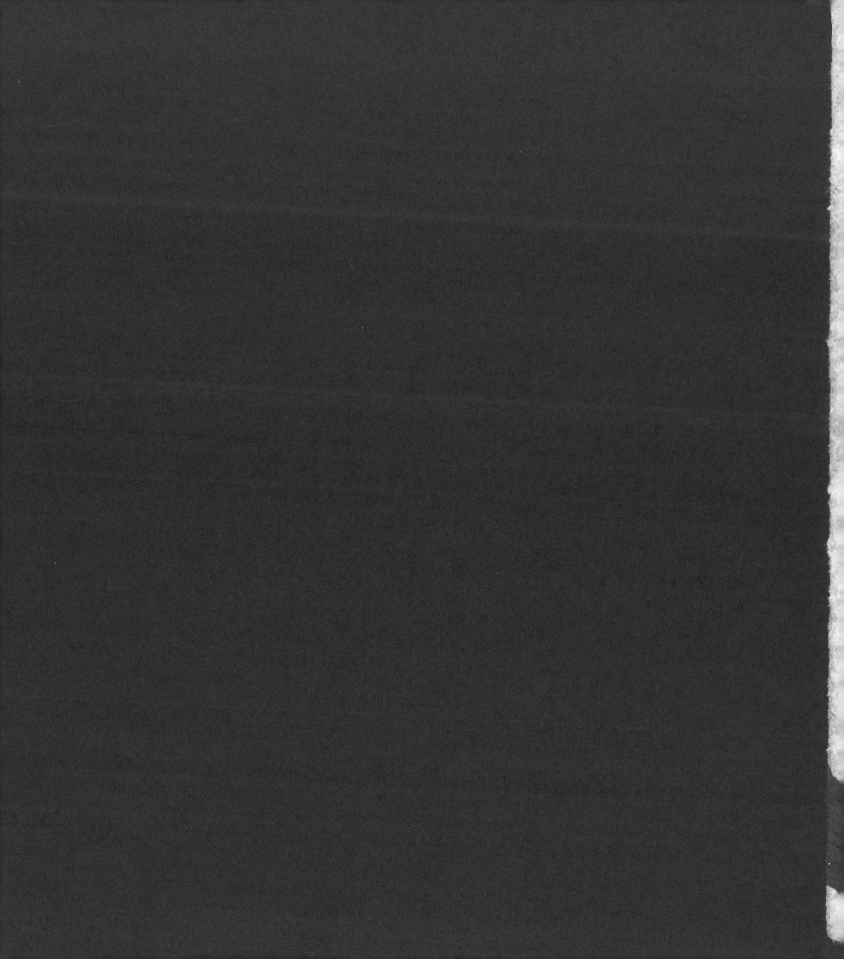

After the Smoke Clears

After the Smoke Clears

Struggling to Get By in Rustbelt America

STEVE MELLON

University of Pittsburgh Press

For Brenda, Chloe, and Brooke

A John D. S. and Aida C. Truxall Book

Published by the University of Pittsburgh Press,
Pittsburgh, Pa., 15261
Copyright © 2002, Steve Mellon
All rights reserved
Manufactured in the United States of America
Printed on acid-free paper
10 9 8 7 6 5 4 3 2 1

Contents

Illustrations

Acknowledgments

Special thanks go to those who opened their lives to me and told stories that were sometimes joyful, sometimes painful, and often beautiful. This book belongs to them. I also need to thank Peter Leo, who suffered through early versions of the manuscript and challenged me to make it better. David Demarest was a careful reader and provided thoughtful suggestions. I am indebted to Scott Goldsmith, whose fine darkroom, hospitality, and friendship eased the burden of making photographic prints the old-fashioned way. Thanks also to Pittsburgh Filmmakers for the use of their wonderful darkroom facilities. Fellow journalists Bob Batz and Annie O'Neill were always willing to listen and offer advice. Cynthia Miller, director of the University of Pittsburgh Press, showed interest in this project at an early stage and provided the guidance that made its completion possible. John Efthemis was an early reader and a great friend. My brother Jeff Mellon and sister Debbie Brammell shared their memories of a painful moment in the fall of 1983, and for that I'm eternally grateful. My mother, Wanda Hood, carefully answered every question about herself and my father. She remains a pillar of strength and a great inspiration. Thanks to my father, Mike Mellon, for being the complex man that he was. And thanks mostly to my daughters Chloe and Brooke, and especially my wife, Brenda, who put up with my obsession and insisted I see this project through to its end. You have my love.

After the Smoke Clears

Introduction

In December 2000 I received a letter from a colleague who was out of work because of a labor dispute. It was a messy affair, he wrote. Contracts were being reevaluated, layoffs threatened. There were ultimatums and threats and, finally, a walkout. He wrote a few lines about his last day of work—it was a long day, spent in seventeen-degree weather, but "we did great and it was a joy." Then he wrote of the "bitterness, anxiety, and depression" that one feels when a way of life comes to an end. "Things will never return to normal," he wrote. "And it's a damn shame. It really didn't have to go this way."

It was a lament I had heard several times before—in places that were old and frayed from years of industrial production. Words like "bitterness" and "anxiety" and "depression" seemed to fit the collapsing steel- and auto-making towns in America's Rust Belt, or the ragged coal towns of Appalachia. But this letter came from Seattle, the land of Microsoft and Amazon.com and Starbucks. This letter came from the land of the new economy, which in the new century was beginning to display a certain "old economy" characteristic: a tendency to discard people the moment things got a bit dicey.

The letter precipitated a sort of flashback. Several years before, under circumstances remarkably similar to my colleague's in Seattle, I was among those tossed into our country's economic trash bin. Quite suddenly my job as a newspaper photographer, and the newspaper that provided it, was gone. I was out of work.

I girded myself for financial hardship. It came, but was less devastating than expected. In fact, learning to live with less money proved to be the easy part. We Americans get much more than an income from our work. We're a country of people defined by what we do, a "be-all-you-can-be" type of place. On the Pittsburgh street where I lived, there was Gary the machinist, Kevin the teacher, and Norita, who was a nurse. It was a neighborhood of people shaped and labeled by what they did forty hours of each week. I was Steve, the guy who shot pictures for the newspaper. It was an identity I had spent years acquiring. I was emotionally unprepared to lose it.

In the beginning I photographed events for small Midwestern newspapers with names like the *Dubois County Herald* and the *Corydon Democrat*. Later, I worked for larger publications, but the work was never glamorous—there were no wars or revolutions or presidential campaigns on my lists of assignments. Still, I loved the work. Covering everyday occurrences connected me to something much bigger than myself. In a farming community in southern Indiana I photographed high school beauty queens as they paraded across a stage that was really a flatbed trailer swept clean of hay and decorated with a thin disguise of balloons and crepe paper. For a few hours that night, life in that town was a Broadway production whose cast members performed their roles perfectly. Despite awkward high heels and an uneven runway, the contestants walked gracefully. Mothers and fathers cheered, brothers and boyfriends whistled and hooted. In the wings, little girls practiced elegant walks, hoping they, too, would someday parade across a flatbed trailer. Even I had a role—a newspaper photographer being present made the event seem even bigger.

Once, in eastern Tennessee, I photographed a sixth-grade boy as he buried his head in his hands and cried after winning a spelling bee. A few months later, in my only overseas assignment, I photographed a boy about the same age silently suffer in a puddle of his own urine in a Liberian hospital bed. I photographed a mother in Pennsylvania as she sat on a couch and grieved over the death of her son, a soldier in the Gulf War. Through a camera viewfinder, I saw laughter, sadness, bewilderment, and giddy excitement, and took its measure in light and shadow.

Throughout the 1980s I worked for newspapers in Kentucky, Indiana, and Tennessee. From 1989 until the end of 1992, I was a photographer at the *Pittsburgh Press,* an afternoon publication well known for its excellent black-and-white photojournalism. Over the years, my enthusiasm for the newspaper profession never dampened. The work gave my life texture and form; I clung to it like bark to a tree.

Then the tree disappeared. In December 1992, after a long and bitter labor dispute that at times captured the nation's attention, the owners of the *Pittsburgh Press* closed the newspaper. It was a business decision, they said. Dozens of journalists—myself included—were suddenly jobless. I walked out of the *Press's* downtown headquarters for the last time on a rainy December afternoon that was memorable for its grayness. Roads, buildings, and streetlamps faded into nothingness. I fit right in. For the first time in my professional life, I felt undefined, without purpose, irrelevant. I was linked to nothing more than my dwindling self.

In those first few months of joblessness, I was consumed by frustration, rage, a sense of injustice, and a sort of loneliness, a feeling of being disconnected from the rest of the world. My judgment was bad. I brushed off or ignored job possibilities. I started a freelance photography business, but my heart wasn't in it, and the busi-

ness flagged. Sometimes I'd absentmindedly telephone friends in the middle of the day. There would be no answer. Then I'd remember: "Hey, they're at work." And I'd feel more alone and depressed than ever.

Those were days of shameless self-pity, and they are embarrassing to remember, but they contained a genesis of an idea. Sometime in those first several months of joblessness, I began seeking out those who would understand my sense of loss. I didn't have to go far. Near my Pittsburgh home were entire towns that had lost their identities and thousands of jobs when the steel industry collapsed in the 1980s. They were places of lost glory, shuttered business districts and high unemployment. I became a regular visitor. Eventually, the process that became this book took me to four states and evolved into an exploration of, among other things, the complex relationship between work and loss and the human spirit. But the motive from its beginning was something much more primal: an urge to soothe an aching loneliness.

My first visits were to a town called Homestead, in western Pennsylvania's Monongahela Valley. For students of the steel industry and of labor, Homestead is legendary. It had the country's biggest, baddest mill and a long and colorful history. But the mill closed, and Homestead lost the basis for its economy as well as the reason for the town's existence. I walked Homestead's streets, visited its churches, businesses, and bars, and knocked on its residents' doors. A surprising number of people were willing to talk. They told stories of triumph and tragedy, of jobs loved and lost, of success and failure, of life and death. I heard about hardships that dwarfed everything I had experienced.

Many in Homestead felt trapped—they were too old start over, or they lacked the skills to find new jobs in a quickly changing economy, or they simply couldn't imagine living anywhere else. So they stayed in a depressed town and suffered losses that were cumulative. Their income was gone. Their friends and families moved away. Their schools and churches and stores closed. Everything familiar and comfortable disappeared.

And they were being left behind. By 1996, the story of the Monongahela Valley seemed extraordinarily out of place. Quite often I would spend a day in Homestead, then drive home and listen to giddy news reports on the radio about America's booming economy. NASDAQ and the Dow were reaching record levels. People were making money—lots of it. Dot-com millionaires were sprouting up everywhere. The news was full of rags-to-riches stories. In Homestead, I was hearing quite the opposite. Where did Homestead fit in a nation that appeared monolithic in its prosperity, a nation with less than 6 percent of its people out of work? What could be learned from a town that once viewed its prosperous mill as an indestructible monolith?

One lesson quickly came to mind: It is foolish to assume you'll always be safe

from hard times and layoffs. But were there other, more constructive lessons? I looked for signs of cohesion and hope in the shattered town and wondered: what was the key to surviving loss on a massive scale? Could history, with all its tragedy and triumph, offer a measure of salvation?

One day, while researching Homestead's recent past, a librarian handed me an overstuffed file folder labeled, "Suicides, 1980s." Inside were dozens of newspaper clippings, many of which were brief items chronicling the deaths of former steelworkers whose lives had spun out of control after the steel industry collapsed. It was a sad and shocking discovery. These were people who had had families and houses and normal, middle-class lives. They had been the success stories of an earlier generation, yet they had reached such a point of despair that they considered their lives worthless.

These stories struck a nerve. For years I had blamed the stresses of work for the death of my father. He didn't commit suicide, but in his last years he was plagued by worry over the ill fortunes of the industry in which he worked. He died a relatively young man, beset by financial woes. While looking through the yellowing newspaper clippings the librarian had given me, I thought of my father and the job that seemed to have the power to at once make him and destroy him. Suddenly, questions about work and loss and its effects—on the human spirit, on succeeding generations—seemed all the more urgent and worthwhile.

What began as an exploration of Homestead soon became a quest that took me to other towns and cities—Braddock, Pennsylvania; Lewiston, Maine; Matewan, West Virginia; Flint, Michigan. These places varied in size and location, but they shared a few distinguishing characteristics. Each had staked its fortune to an industry—steel making, textile manufacturing, automobile assembly, and coal mining—and each had suffered greatly for it.

My specific interest was in the people left behind, so I sought them out, at their homes and businesses and hangouts. How were they coping? Did they have hope for the future, or did they only despair? How had their views of the world, and their communities, been altered? I looked for differences and similarities; very quickly, a common and recognizable thread emerged. The stories I heard were not of individuals, but of families, of generations of people linked by blood. Sons told stories about their fathers, grandfathers, and great-grandfathers. Daughters talked about mothers, grandmothers, and great-grandmothers. Parents discussed their children, their children's children. I heard about husbands and wives, sisters and brothers, aunts and uncles. In these towns of disconnection and dislocation, survivors clung to those with whom they shared blood. Families gave these people a place in time and history, gave them a reason to be where they were, who they were, what they were. Family was their context. Family, even if it existed only in memory, could save them.

I often heard people in these towns describe a relationship with co-workers by using the phrase, "We were like one big family." It conveyed the sense of loss they felt when the job was gone; in essence, a blood bond was broken apart. What could be worse? the phrase implied.

In the old steel town of Braddock, Pennsylvania, just south of Homestead, the worst did seem to be happening. Braddock still had its mill—the sole surviving steel-production facility in the Monongahela Valley—and it rumbled on the edge of town, as it had for more than a century. Such a long and continuous proximity to heavy industry had shaken the town to pieces. Braddock was, quite literally, falling apart. Buildings and houses collapsed; even families appeared to be crumbling. Death visited Braddock while I was there, stealing away a beloved husband and a mother who was one family's bedrock. These losses reverberated throughout the community. In this town of many contrasts, could blood transcend death and hopelessness?

In Lewiston, Maine, I touched the coarse brick walls of empty textile mills more than 140 years old and considered the generations of workers who once labored in the gigantic buildings, making everything from fabrics to bedsheets to shoes. Then I sought out those workers' descendants, many of whom remained in the town, though they spoke with a different accent, sometimes even a different language, than that of their forebears. I found little rage or bitterness or intense frustration in Lewiston. Instead, in this long-suffering town, there was an odd combination of weariness, wariness, and contentment. Lewiston's sons and daughters work too hard for too little, yet they continue to work. History has left them with little choice, but as wages and opportunities continue to dwindle, is it enough to simply work?

Nowhere was the sense of family stronger than in the tiny West Virginia coal town of Matewan. For nearly a century, Matewan had been dependent upon the business of extracting coal from the earth. And for this it has suffered. I should have known something of this region. My father was born and raised in a Kentucky mountain town not far from Matewan. Yet the Appalachian coalfields remained a mystery to me. My father never talked about his childhood in this rugged region, or how it shaped his attitudes about work and responsibility, and about loss. Matewan is a place where parents have for generations passed down attitudes to their children, but it is also a place of secrets. There, I learned about the very nature of loss and survival and stoic silence. And in the process I unearthed a few secrets about my own family.

Flint, Michigan, is a city long wedded not just to a single industry, but to a single company—General Motors. It was for decades a fruitful relationship. General Motors prospered, and so did the people of Flint. Workers organized and a union was born—an event that would have repercussions throughout the country.

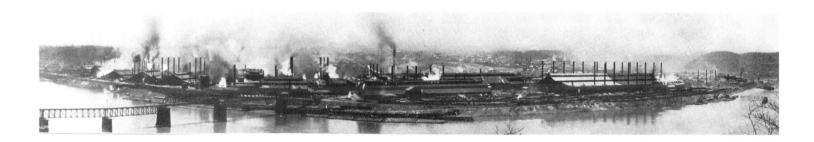

Homestead Works, circa 1900
(courtesy of Carnegie Library of Pittsburgh)

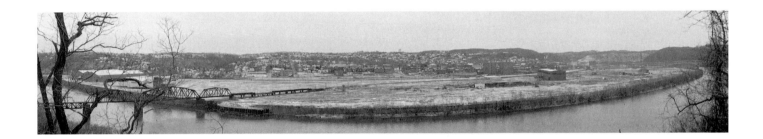

Homestead Works site, 1996

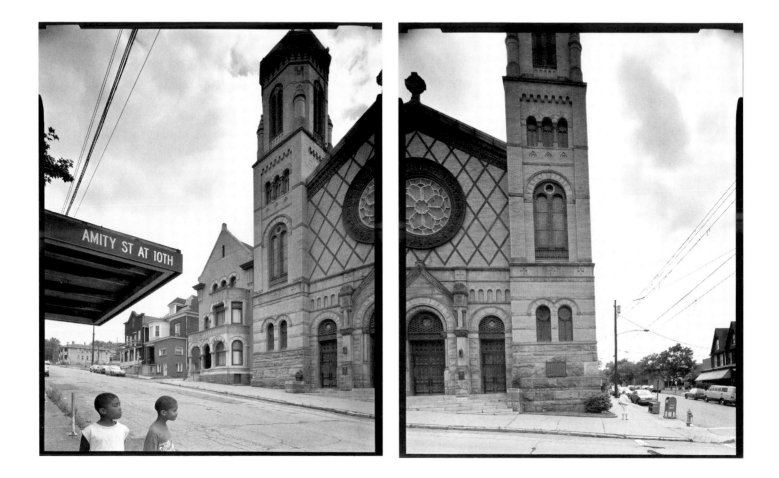

Saint Mary Magdalene Roman Catholic Church in Homestead, Pennsylvania

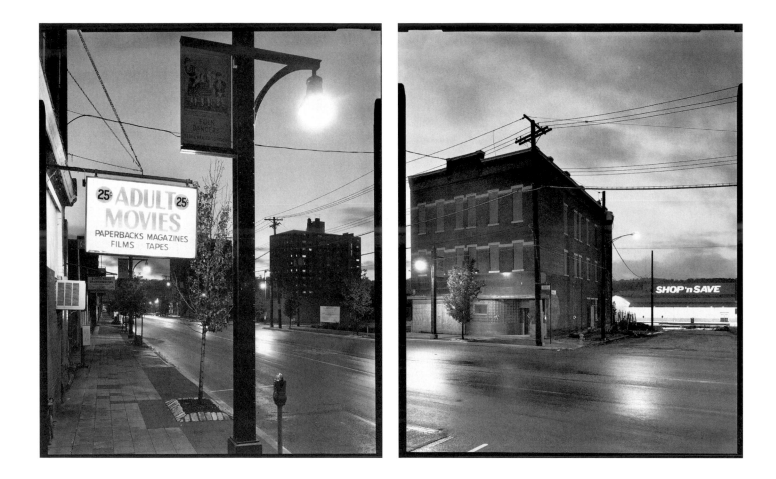

Bost Building on Eighth Avenue, Homestead, Pennsylvania

Edgar Thomson Works, Braddock, Pennsylvania

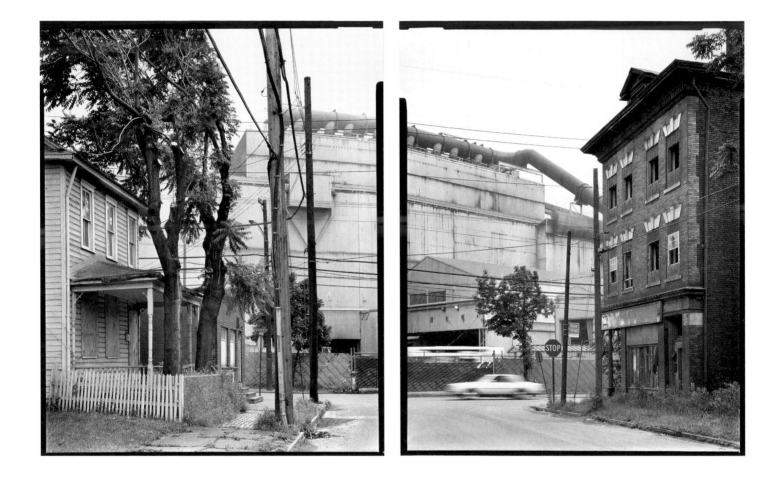

Talbot Avenue at Eleventh Street, and Edgar Thomson Works, in Braddock, Pennsylvania

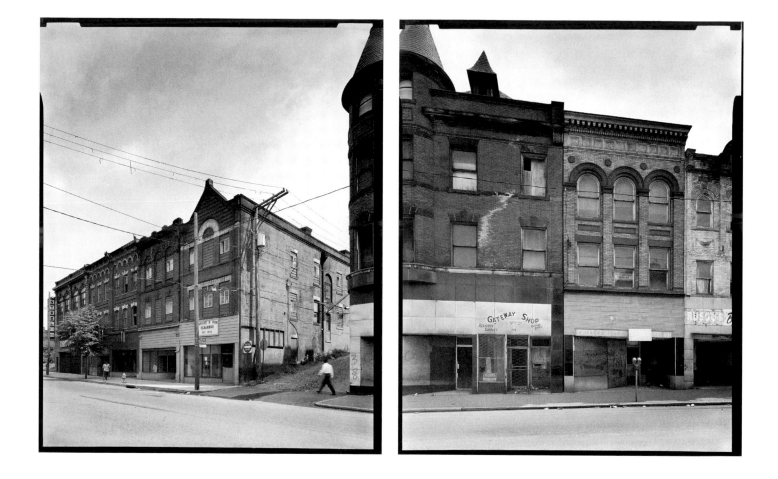

Braddock Avenue in Braddock, Pennsylvania

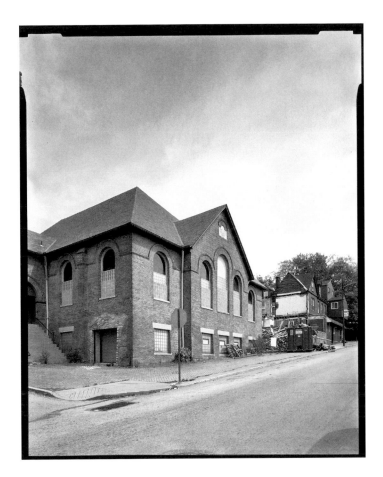

Carnegie Library and First Methodist Church in Braddock, Pennsylvania

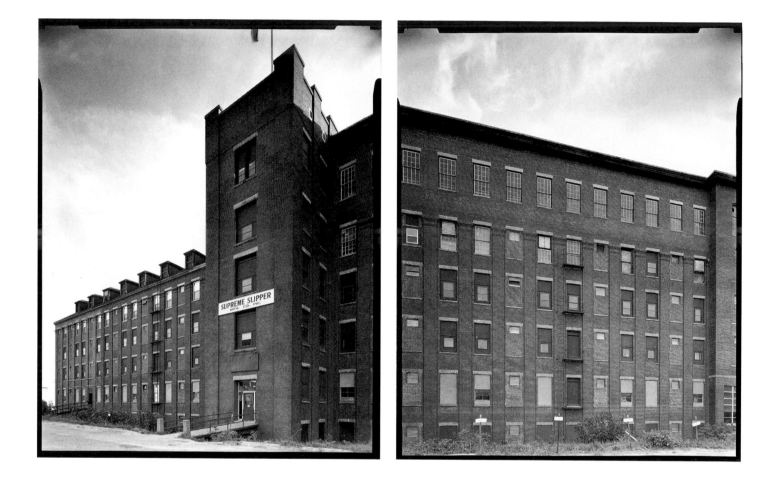

Hill Mill in Lewiston, Maine

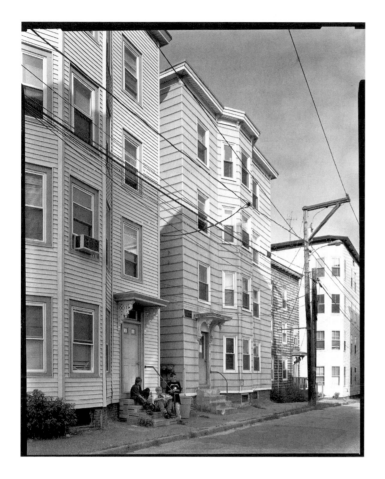

Little Canada in Lewiston, Maine

Lisbon Street in Lewiston, Maine

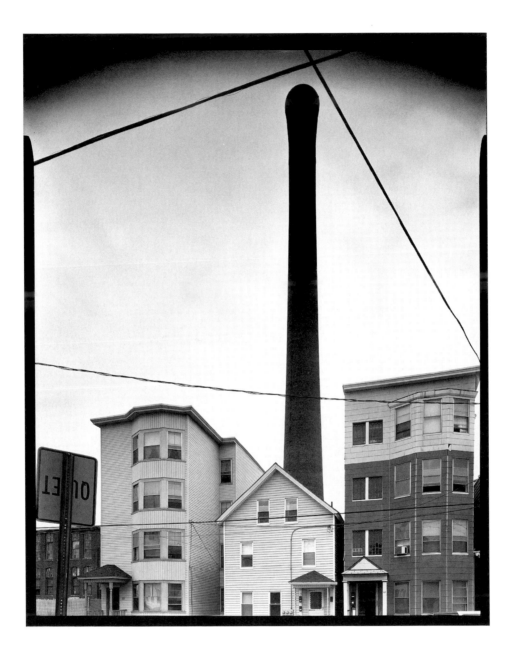

Smokestack and Lincoln Street homes in Lewiston, Maine

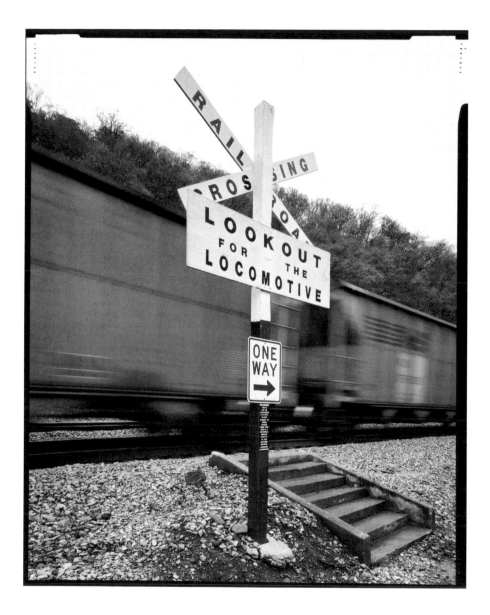

Replica of railroad crossing near site of shootings of Baldwin-Felts detectives in Matewan, West Virginia

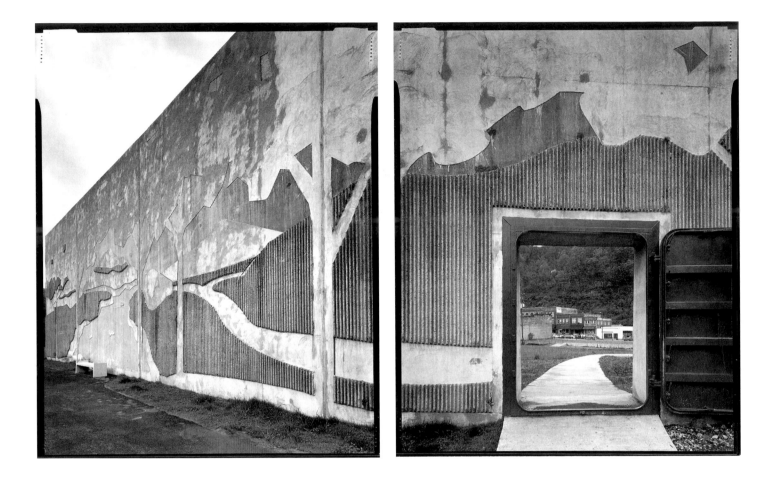

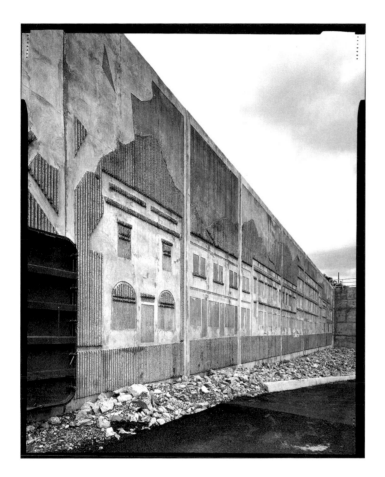

Flood wall protecting Matewan, West Virginia, from the Tug Fork River

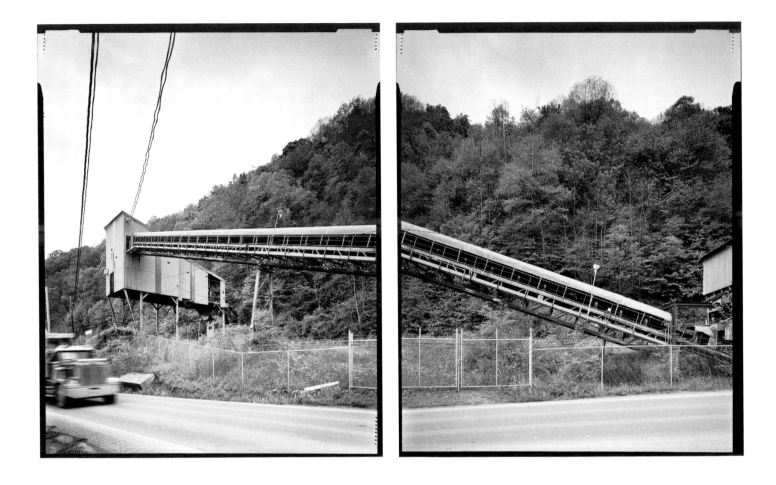

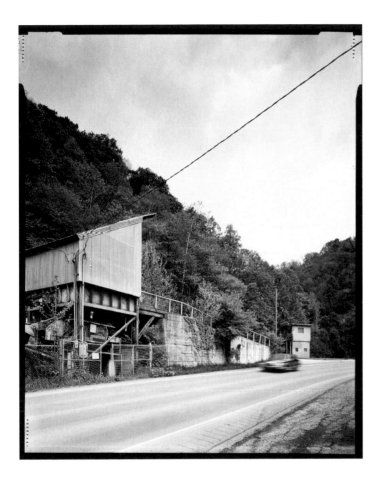

Coal tipple near Matewan, West Virginia

Saginaw Street in Flint, Michigan

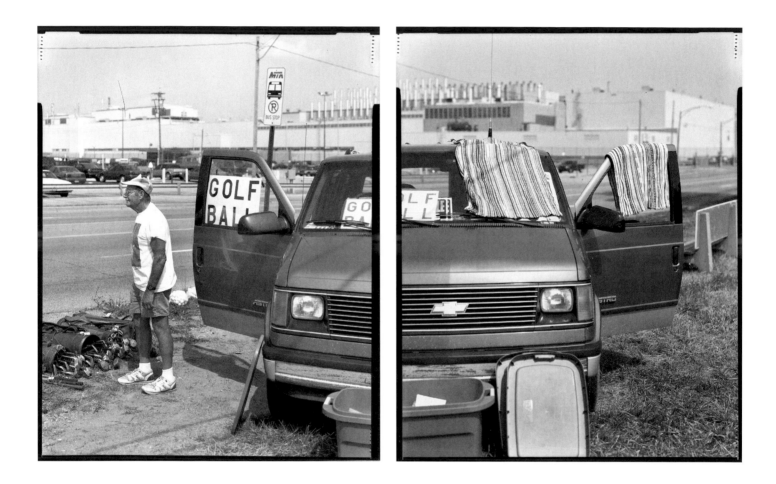

Selling golf balls near General Motors plant in Flint, Michigan

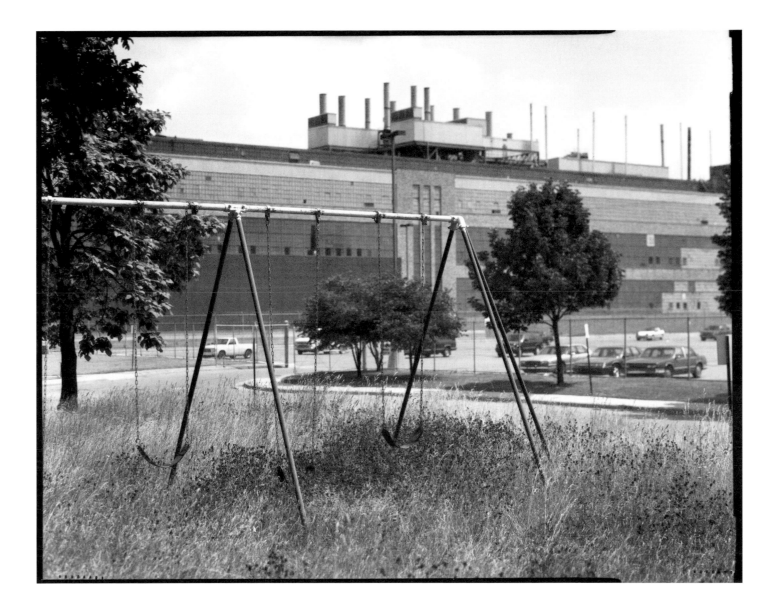

Park near Buick City in Flint, Michigan

People

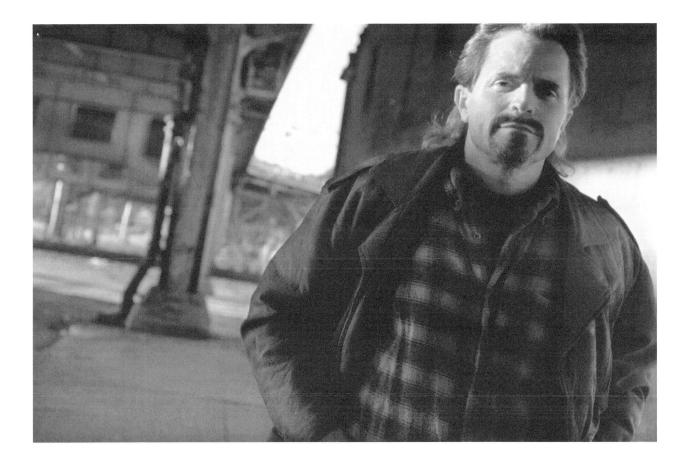

Mike Stout in Homestead, Pennsylvania

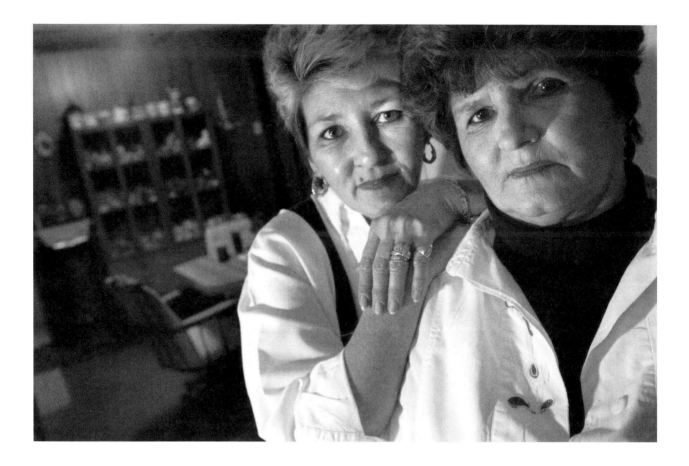

Kitty Reina and Bonnie Bowlin in Munhall, Pennsylvania

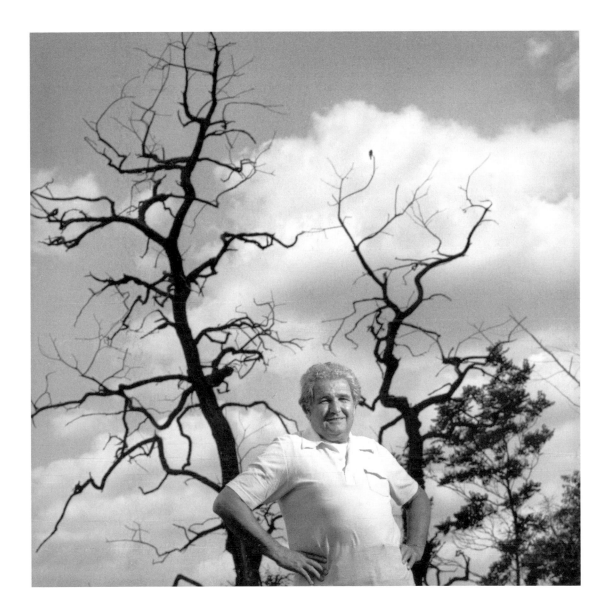

Angelo DeSimone in Pittsburgh, Pennsylvania

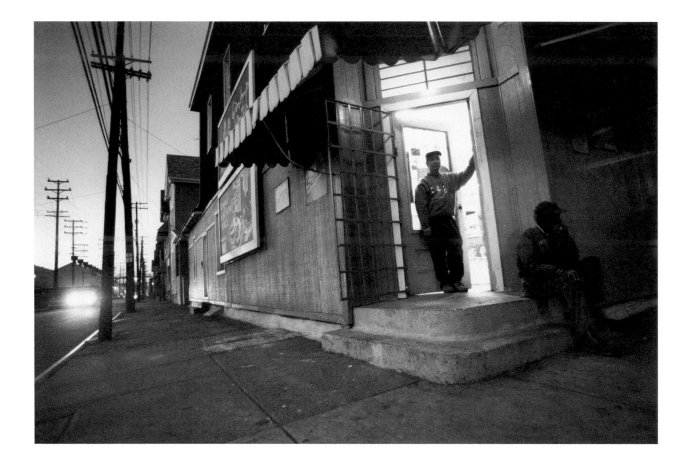

Sang Pham at his family's grocery store on Talbot Avenue in Braddock, Pennsylvania

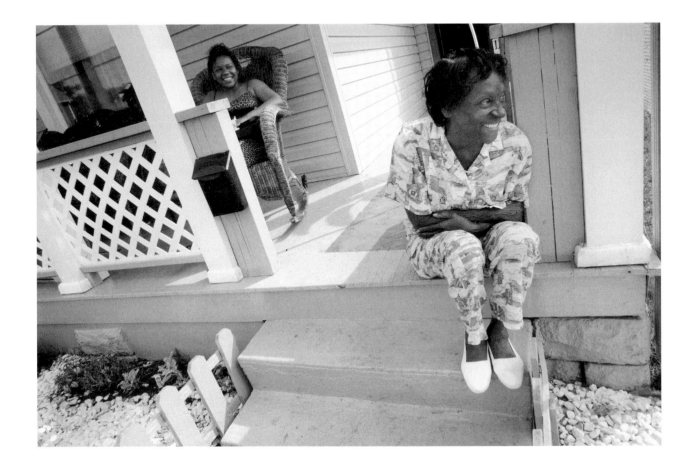

Arvella Hamilton—"Miss Vicky"—on her seventy-second birthday in Braddock, Pennsylvania

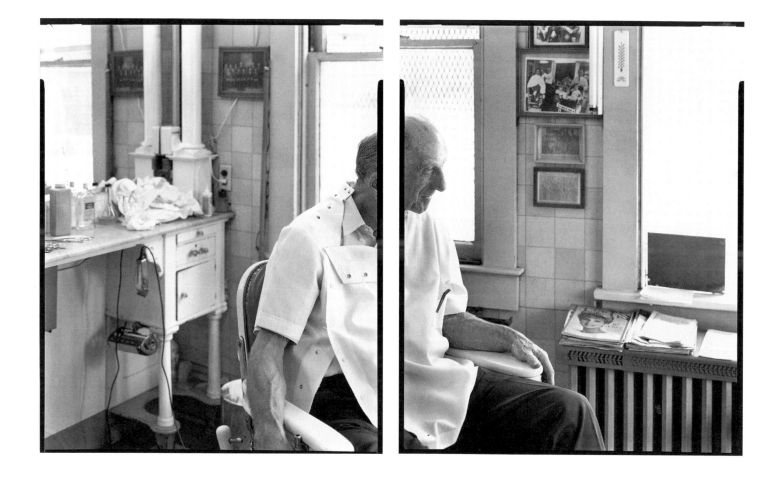

Joseph Szwarc at his barbershop on Talbot Avenue in Braddock, Pennsylvania

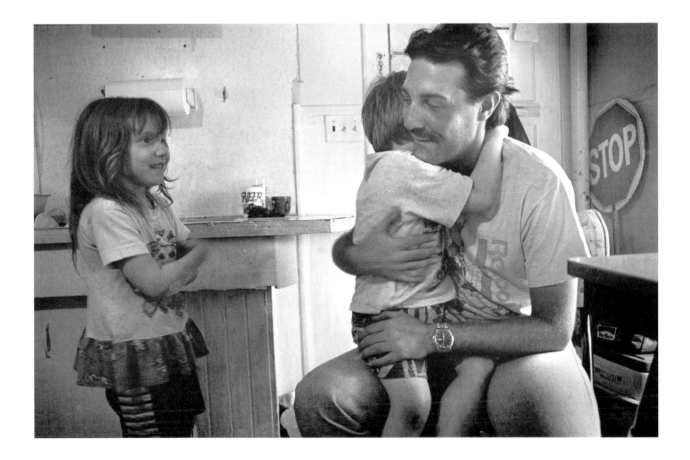

Wilfred Moreau hugging son Derek at their home in Lewiston, Maine

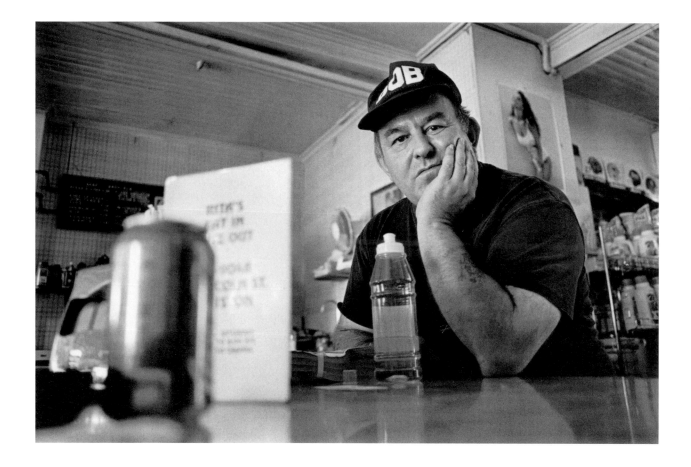

Bob Davis at Rita's in Lewiston, Maine

Claudette King and Don Allen at Fancy Stitchers in Lewiston, Maine

Dorothea Witham at Creative Photographic Art Center of Maine in Lewiston

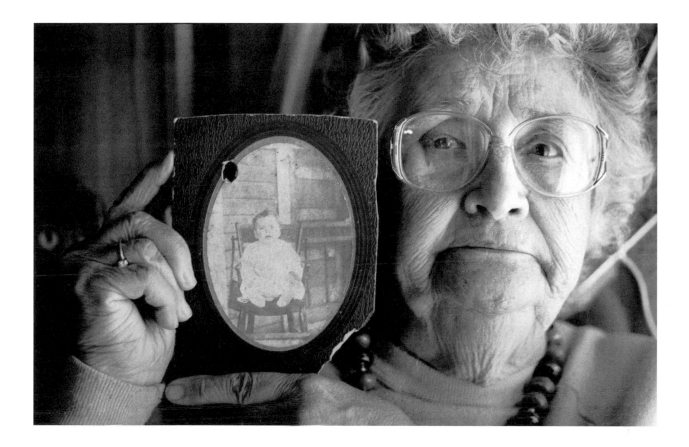

Mary Ward in Blackberry City, West Virginia, with a bullet-pierced photograph of her husband, Wesley Houston Ward, when he was a baby

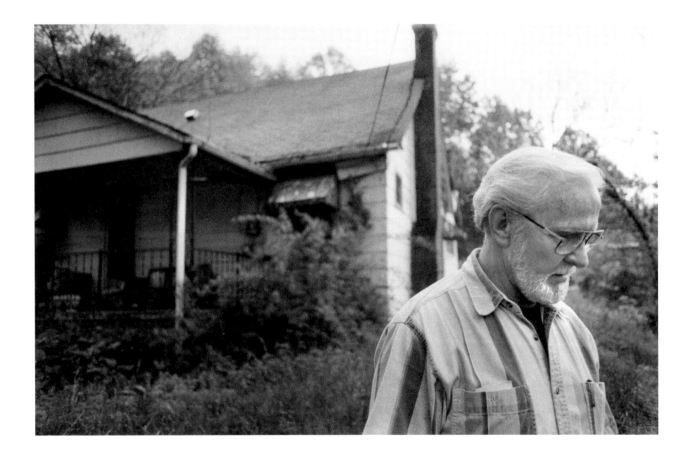

Franklin Mounts at the old Mounts home in Blackberry City, West Virginia

Christine Harmon in Matewan, West Virginia

Bob Keith in Flint, Michigan

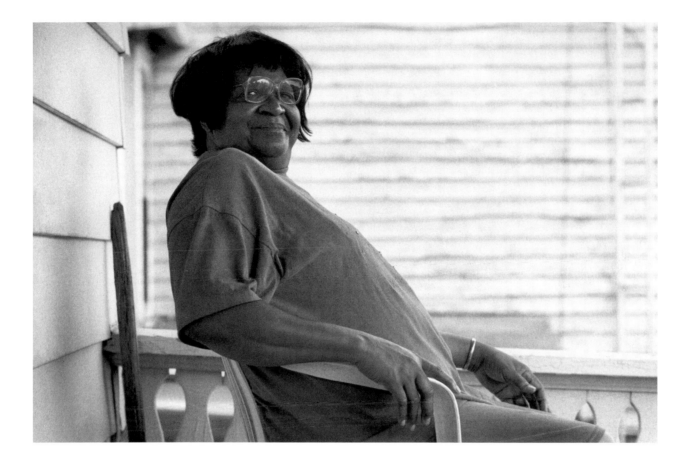

Emma Chilton on the porch of her home in Flint, Michigan

Mike Mellon, April 1983 (photograph by Randy West)

Homestead, Pennsylvania

My intent that January day was to record an image, but the cold slipped past the camera's shutter and onto the film, and so the photograph I made became an ice cube that refused to melt. Even in the heat of summer, looking at it still gives me a chill.

Weather reports said it was below zero—cold enough to sting your fingers after a few minutes of exposure. Flakes of dry, light snow swirled in the air. I thought about my car and that morning's drive. Cruising in traffic with the heat cranked up and the car stereo blaring, a fifty-five-mile-an-hour comfort zone. It was a warm and pleasant memory cut short by a frigid wind, which sliced through the thin nylon jacket I had grabbed when I rushed to leave home. Should have worn the heavy coat, I thought. Soon numbness would set in. Pain, then numbness. Warmth, then cold. My fate that day was to bounce between extremes.

I was standing on a bluff overlooking a bend in the Monongahela River, just south of Pittsburgh, Pennsylvania. Far below, across a ribbon of water and into the Monongahela Valley, was a swath of vacant land once occupied by a steel-making operation called the Homestead Works. Rising up a hillside beyond that land were homes and a few churches—the town of Homestead. But it was the expanse of emptiness that dominated the scene. Despite the overcast sky, I had a clear view, perfect for taking a picture of nothing that was once something. It would be a photograph to display next to one made at the same location a century earlier, when the mill was in full operation. The two images would present a then-and-now study in contrasts, in extremes. My first attempt to load my camera failed—the film was frozen and brittle and it broke. The Monongahela Valley would not surrender its image easily.

As recently as a decade earlier, this view was anything but hollow and vacant. The steel-making facility, owned by U.S. Steel Corporation (known in later years as USX), stretched more than three miles along the Monongahela River. In a turn-of-

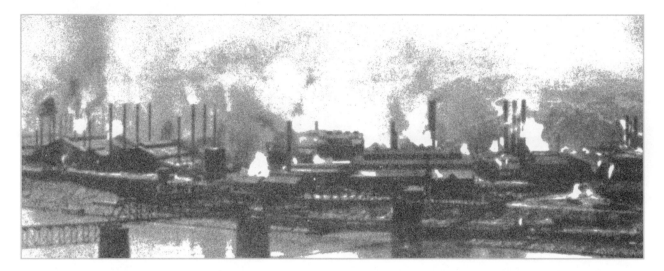

the-century photograph, the land is full of smoke and steel. The mill, which appeared as a series of perhaps two dozen long sheds with rows of smokestacks poking through, seemed to spill over into the sky and the river. Yet now, barely a trace remained. Far off to the north stood a row of lonely stacks. Slightly south I could see an old railroad bridge. I would return to this bluff several times over the years to watch as the emptiness became partially filled with development, representing a major shift in the nation's economy. New roads, expansive parking lots, a state-of-the-art cineplex, discount department stores, fast-food joints, restaurants that charge five dollars for a hamburger, and suburban-style shopping centers arose on the land and attracted customers from the wealthier sections of Pittsburgh. Homestead's business district, once so dependent on the mill and the wealth it generated, was cut off physically and symbolically from the newly arrived riches by a ten-foot high berm of earth and a series of busy railroad tracks. Thanks to new access roads, shoppers could avoid venturing into downtown Homestead.

This retail development represents a sort of progress, bringing some money and low-wage jobs to an impoverished area. But the old mill site never seemed to have as much poignancy, as much

poetry, as it did that frigid January day. Its emptiness stood as the perfect monument to anyone who had ever been laid off, downsized, phased out, outsourced, given the ax, or otherwise told to get lost while everyone else moved ahead. These people know about life in the extreme, about stepping out of the warmth and into the bitter cold. They know what it's like to have substance and form, and then suddenly to fade away and disappear in a world where everyone else has a place to be and something to do, where everyone else has a purpose. They would understand the chill I felt as I stood on a frozen bluff and photographed one of the greatest disappearing acts of all time.

The Homestead Works produced steel for, among other things, skyscrapers, bridges, roads, and ships, and in the process it firmly embedded itself in U.S. history. Homestead steel went into everything from the Empire State Building to President Theodore Roosevelt's expanding navy. And it was the site of one of the country's most important labor battles— a bloody clash in the summer of 1892 between a workers' union and Andrew Carnegie's steel company. Organized labor was crushed in that confrontation and did not reemerge for another forty years.

Glory days for the mill—and the small town of

Homestead that rose behind it—would last nearly a century. The plant opened in 1881 as the Pittsburgh Bessemer Steel Company, but after two years it proved as adept at producing headaches for its owners as it was at producing steel. Andrew Carnegie, Pittsburgh's most successful steel man, bought the mill in 1883 for $350,000, and immediately began improvements. Within a decade, it was the country's most modern and profitable steel operation, a model for an industry that was becoming the epitome of American strength in business and production. From the big gray steel sheds to the big bosses—men with names like Carnegie, Frick, and Schwab—everything about the mill was gigantic. Everything, that is, except for the lives of the men who actually worked there. Their role became smaller. After 1892, wages fell, and twelve-hour shifts became the norm. To the exhausted workers and their families, many of whom were recent immigrants from Eastern European countries and were living in dirty slums in a strange and new land, the steel industry's power seemed colossal.

In 1901, everything got even bigger. The Homestead Works became part of a newly formed conglomerate known as U.S. Steel. Both the steel industry and America were growing at tremendous rates, and Homestead was providing much of the muscle and bone. When wars broke out, Homestead provided both armor plate and soldiers, and the wars were won. To those in the small town, U.S. Steel and the Homestead Works were invincible forces. Labor unions arrived in the late 1930s and wages rose, allowing workers to move into better houses, to buy cars, to send their kids to college, to sink their teeth into everything the country had to offer.

Sure, both the industry and the mill had problems. Relations between management and labor remained acrimonious, at best. There were occasional strikes—one work stoppage, in 1959, lasted an agonizing 116 days. Still, no one worried too much. There had been layoffs and strikes in the past; brief doses of hard times were not new to Homestead. The boom always returned, because the Homestead Works was the biggest steel-making facility around. It was legendary, indispensable, invincible.

Or so it seemed. In the 1970s, after years of suffering tremendous losses, U.S. Steel began laying off large numbers of workers. The company was in trouble. Over the years it had failed to invest in new methods of steel making—much of the Homestead mill's equipment was old and outdated. Management had become lax and inefficient. U.S. Steel had built too many plants, had hired too many employees. Other, more competitive steel makers were squeezing into a tight market.

In November 1979, U.S. Steel announced it would close its huge operation in Youngstown, Ohio. Other closings soon followed. Production ceased in May 1984 at a mill in nearby Duquesne, Pennsylvania. Even parts of Homestead's mill were idled. Furloughed steelworkers remained optimistic, bided their time, waited to be called back.

Then, in 1986, the unthinkable happened: U.S. Steel shut down the Homestead Works for good. Two years later, the entire facility was sold to Park Corporation, a private company that took it apart and sold it as scrap. By 1995, little remained. Gone were the giant steel sheds, the machinery, the furnaces, the time clocks, and all types of steel-making tools and paraphernalia, from ladles to leather boots, from overhead cranes to corporate calendars. What remained was a lot of empty space and a community struggling to deal with disaster.

Homestead is one of a series of small steel towns clustered along the northern stretch of the muddy Monongahela River, which winds its way through the hills of western Pennsylvania before reaching

the city of Pittsburgh and converging with the Allegheny River to form the mighty Ohio.

The names of these towns—in addition to Homestead, there is Braddock, Duquesne, McKeesport, Clairton—are familiar to those who know America's steel industry. At one time this twenty-mile section of the Monongahela River formed the world's greatest steel production center. Braddock's mill remains, and there is a facility in Clairton that converts coal to coke. Otherwise, the steel industry in western Pennsylvania is gone.

Seen from a distance, towns in the Monongahela Valley seem perfect and quaint, like toy villages with houses of tan, white, red, and brown rising up the hillsides. In reality, these towns are places in distress. All have high unemployment (nearly 11 percent, according to a survey conducted in the early 1990s) and struggling, if not crumbling, business districts. All are losing population (Homestead lost 14.6 percent of its people between 1990 and 2000). All have a worn and battered look about them, and they are haunted by occasional high-profile crimes. In recent years, for example, stray bullets from shoot-outs have killed innocent bystanders in Homestead, a teenage girl was found raped and murdered in McKeesport, and a police officer was shot and wounded in Braddock. Fear keeps many from passing through or visiting.

Homestead is situated seven miles from Pittsburgh's gleaming downtown office towers and new professional sports stadiums. Nearly a mile wide at the flatlands near the river, Homestead narrows to a point as it rises twenty blocks up a hillside, giving it a triangular shape. Two hundred years ago, a farm occupied the land. In 1871, the land was surveyed, lots were sold, and Homestead was established; within a decade, steel production arrived and forever changed the town's history.

These days, Homestead has a population of thirty-five hundred, most of whom live in houses

on the hillside. The town's main street, Eighth Avenue, runs parallel to the river and is lined with weathered commercial buildings that rise two or three stories high. Most are made of red brick, and some have dates inlaid in the masonry at their tops—1906, 1903, 1898. In recent decades, the first-floor facades of these buildings have been cheaply renovated with painted wood paneling, masonry, or glass and steel, but the upper floors maintain their original character and give visitors a clue as to what the street must have looked like in its youth. Longtime residents recall the street's glory days in the 1940s and 1950s when shoppers crowded the sidewalks and stores offered everything from furniture to candies to automobiles.

By 2000, however, Eighth Avenue had more than its share of empty storefronts. Some were covered with sheets of unpainted plywood (attached, in one case, with duct tape). What remained was a collection of mostly small concerns—a bridal shop, a family-owned hardware store in business since the 1930s, a few bars, a lunch counter doing brisk business in lottery tickets, a print shop, a few bakeries, a drugstore. In one storefront, a casket company displayed its wares—pink and baby blue models, yawning at people waiting outside at a nearby bus stop.

Past Eighth Avenue and up the hillside are rows of two- and three-story frame houses—many are utilitarian structures, decades old, that long ago lost any architectural ornamentation they may have once had. Aluminum siding is common. The largest, most elegant structures remaining in Homestead—indeed, in all the Monongahela Valley towns—are the churches. Homestead has more than twenty. Their spires rise skyward, alerting visitors that religion played an important role in the town's past.

But it was the Homestead Works that dominated the town for more than a century. For those who grew up there, the mill represented more than just

big business. Making steel on a grand scale gave the town an identity, one it felt good about, which made loss of the mill all the more painful. One day I sat in an Eighth Avenue bar called Chiodo's and talked with Bud Ward, a graying man who, like his father, had been a Homestead steelworker. "We built the United States here, right out of this valley," he said, jabbing his thick finger into the top of the bar. "If you were from Homestead, you automatically went into the mill to work. It was a way of life. Everything centered around the mill. My father put in forty-five years there. I put in thirty-three." He then got up from his stool and walked over to a large, framed photograph that hung on a wall above a cigarette machine. "Look at this. This is the 160-inch mill. My father worked in the 160. He was a roller." In the picture, a machine resembling a press with huge rollers was spitting out a red-hot section of steel, which dwarfed a worker. That portion of the mill, Ward explained, was located just a few hundred feet from the bar. All that remained of the 160 was a lone smokestack.

For years, that stack, which rose a few hundred feet into the air, was the one of the first things you would see upon entering Homestead. It looked like a giant finger pointing skyward, testing the winds. In the mid-1990s, I telephoned the Park Corporation, the company that had purchased the mill site, and asked why the stack had been saved. "We're considering using it for a sign, or perhaps some other creative use," Kelly Park told me. "It's in an unusual location. Who knows? Maybe we'll make a Christmas tree out of it." Was he joking? I wondered how this would go over with the men who had for years labored in the furnace at the stack's base. One foreman told me those men worked in temperatures that reached 140 degrees. A few years later the Christmas tree idea was scrapped. Hundreds of people watched as a demolition crew set off a series of explosions that sent the stack

crashing to the ground. The loud booms were a sonic reminder of all that Homestead had lost—its mill, thousands of jobs, the feeling of worth that comes with making something essential, a comforting sense that there was some stability to the world.

And what remained in this town of fresh and open wounds? Anger and bitterness and wistfulness, quite certainly. These were the forces pressing down on me when I began visiting the town, and so I sought them out as recognizable and understandable reactions to loss. But I also searched for more constructive responses: optimism, humor, a determination to create something of value from the remnants of things deemed worthless, a determination to remember the past and to learn from it, and a coming together of the community. I searched for evidence that massive loss would not destroy the town, but would instead add to the complexity and history of the place and shape its character in unexpected ways. I searched for evidence that Homestead was a town not of sufferers, but of survivors.

It was one of those small offices with its door so close to the street that it had become an eddy, and the street flowed in, its noises and its smells filling the space, swirling around and keeping everything stirred up. Normally, you could close the door, use it as a dam to keep some of the street outside—at least muffle the roar a bit—but not this day, a steamy early August day. The air-conditioning unit had broken, just like the traffic light less than one hundred feet away, which had recently died, creating a scene of automotive chaos at Eighth Avenue and West Street, Homestead's busiest intersection. Small cars dodged huge, downshifting tractor-trailer rigs ticked off at having to stop for something as meager as an Escort or an Omni. One

diesel truck let out a growl so deep and angry I could feel it rattle up my spine as I sat and talked with Mike Stout, whose print shop occupied the office. Then, tires squealed and a horn blared. That was enough for Joan DeSimone, a print shop employee. She quietly got up from her desk, walked to the front, and shut the door. For a while, at least, we'd drown in the heat to give our ears a rest.

Stout, I had been told, knew a lot about the human wreckage that floated to the surface when Homestead's mill went down, so I sought him out. As owner of Steel Valley Printers, he was busy and didn't have much time—maybe thirty minutes, he said—but that was okay, I learned, since Stout speaks in such a direct, no-bull manner that he squeezes an hour's worth of comments into half that amount of time. His words often sound like they are shot from a machine gun—at times, it makes him sound impatient and angry.

Stout is a slim, wiry man with an intense gaze and wavy brown hair that is brushed away from his face. He keeps a well-trimmed mustache and beard. Stout had been a craneman in the 100-inch and 160-inch mills. He had served as grievance man for Homestead Local 1397 of the United Steelworkers of America and, through his involvement with an organization called the Tri-State Conference on Steel, played a very active and vocal role in fighting mill closings in the Mon Valley.

Later, Stout tried politics, twice running for a seat in the state legislature, losing narrowly both times.

Stout remained physically close to the Homestead mill site years after it closed—his printing company was located on Eighth Avenue, a few blocks from what was once an entry gate to the Homestead Works. I wondered: why would a place of work—often difficult and dangerous work—have such a magnetic pull?

Stout talked about the bond forged between steelworkers in such a huge and legendary operation:

"Instead of having a family of four or ten, you had a family of eight thousand. People spent eight, ten, twelve hours a day together, every day, five or six days a week, for years and years. Homestead was a very special place as far as steel mills go. It was one of the oldest, most established integrated steel mills in the country. It was the premier producer during four wars—World War I, World War II, Korea, and Vietnam. The only reason I bring all this up is because it gave a psyche to the worker that no other place did. You never thought in a million years it was going to shut down. Every day that you came into work there were accolades all over the bulletin board from the U.S. Navy and the U.S. Air Force about what a good job these guys had done producing steel for this submarine or that bridge or building.

"When mills started shutting down in Youngstown and Lackawana and different cities, I can remember guys telling me, 'It'll never happen here, not in a million years because we're too important, we've been here too long and we mean too much.' When I would try to tell them, yes, Homestead is going to shut down, and try to prove it to them, they would pick fights with me. They were that convinced.

"And when it did shut down, and when guys did lose their jobs—people with fifteen, twenty, thirty years on the job—the psychological and social

damage was a hundred times more than the economic. It was like somebody was standing in a room, like you and I are right now, and the floor was pulled out from under them. It was that devastating. Within four years of the place shutting down, I had eighty-one guys that I knew of personally—not just knew of, but knew personally—who died of strokes, cancer, heart attacks—including seven suicides—within a period of three-and-a-half years after the mill shut down. All under the age of sixty.

"One guy in the 160-inch shipping department where I worked, just to exemplify what I'm talking about, had thirty-seven years in the mill. He was fifty-six years old, he had a house that was completely paid off in Oakmont, he didn't have a bill in the world. He had two kids, one who was on a scholarship in college, one who had just graduated high school with honors. This guy was so quiet and so nice that we used to make fun of him. He used to get to work an hour before his shift started and wait for the gate to open. He would work all the overtime he could. He lived in that place. When the mill shut down, within a matter of weeks, around midnight, he took a shotgun, went in and blew his kids away, blew his wife away, then put it in his mouth and blew himself away."

(I later found newspaper clippings detailing the killings by James G. Radakovich in February 1988.)

"Another guy, his name's Dave Sapos, he was thirty-nine, going on forty, years old. He had nineteen-and-three-quarters years in the mill. He was a foreman, came out of the ranks. Went into work one night—he worked the ten-to-six shift—and they told him, 'Tomorrow morning, pack your shit, get your locker, and get out of here, you're finished.' He said, 'Yeah, finished, huh?' He went into the open hearth, which had been shut down three years, stuck his gloves neatly in his back pocket, took his helmet off, took his glasses off, stuck them in his pocket, and he hung himself between two ladle buckets thirty feet off the ground. In the mill! He made a statement. The next morning I came in to work and they said, 'Put your work clothes on and join the search party, we're missing a foreman.' It took us two hours to find him because he was way up in the air. To know seven people that committed suicide . . . I got sick of going to the funerals after a while."

The phone rang and Stout picked it up. A customer. I glanced out the window, saw automobiles, trucks, a bus, people walking by. The river still flowed, dammed up at the door. Inside were steel filing cabinets (one tan, one gray) and a few desks—all of different designs. Furnishing bought used or on sale. It was a functional place, not fancy.

Once he was off the phone, Stout told me how unemployed steelworkers found themselves trapped in a system that seemed designed to produce failure and frustration. Many tried to retrain, but their unemployment compensation expired before they completed their courses. Because most owned property and homes—which they couldn't sell in a glutted market—those steelworkers were ineligible for other forms of government assistance. Those who were retrained often discovered the jobs available paid a fraction of what they'd earned in the mill. He told me about two friends who, after learning to repair air conditioners and refrigerators, were offered jobs two states away, paying $5.68 an hour.

He continued:

"The biggest discrimination I saw, greater than the discrimination that occurred with women or blacks or minorities, was the discrimination with industrial workers who were in their forties and fifties trying to start a new career and get a job. People spit on 'em. People told them they were unemployable. Who's going to hire somebody in their fifties? It was just unbelievable. It was a slow-motion holocaust is what it was. It was survival of

15

the fittest, and those who had the ability and the brains and the stamina, they did whatever it took to survive and move on and made it, but those hundreds and hundreds who went down the tubes unnecessarily . . ."

Stout was one of those who made it, and he readily admits to getting lots of aid from people he'd met through his involvement in union activity, politics, and various organizations trying to save the mills and bring industry to the Mon Valley.

"Through all those networks I met all sorts of people who helped me. When I started my print shop I had a customer base. I had some friends in the union and the Catholic church that provided me with fifty to seventy-five thousand dollars worth of free equipment. And I still almost went under. I can tell you times, two years in a row, when I couldn't pay my bills and I'd call up customers who were friends of mine, and I'd say, 'Am I going to be doing a newsletter for you in two months?' They'd say, 'Yeah.' I'd say, 'Can you pay me for it now so I can pay my employees?' That's the type of safety net I had and that's why I made it."

We talked briefly about some of the problems facing Homestead—a city council mired in petty politics, unable to deal with the swift and devastating changes thrust upon it, apathetic citizens unwilling to vote, an influx of new residents dependent upon government aid—and we talked about solutions.

"We need a Marshall Plan," Stout said. "You can't take ten thousand, twenty thousand jobs out of an area and not . . ."

Again, the phone rang. I was pushing the limit of my time, and could sense that Stout was anxious to get back to work. But before leaving, we briefly revisited the subject of desperation, something that was experienced by so many in this town.

"In late '87 or '88, somewhere in there, I ran out of everything. No prospect of getting a job. I was about a year away from starting the print shop. I

had no income coming in, nothing. I can remember my whole disposition and outlook on life changed completely. When you don't have any income and no hope, when there doesn't seem to be anything on the horizon, your whole view of everything changes. You start thinking and doing things you'd have never dreamed of thinking and doing when you had an income coming in. And keep in mind I had a safety net, friends and people and organizations that were trying to help me out. Most people didn't have that. For a lot of them, their families and their lives were decimated."

One day, while I was visiting Stout's printing office, a man wearing an official-looking name tag walked through the door and asked, in a commanding voice: "What's the address of this business? I'm doing a business census."

"Shouldn't take you long to do a business census in this town," came a quick and sharp reply from Joan DeSimone, the print shop employee. She gave the address, then took another drag on her cigarette and returned to the work on her desk. DeSimone is a slim woman with short, blonde hair and glasses. Also in the office that day was a man who appeared to be in his mid-forties. He was balding, a bit paunchy, and wore jeans, a T-shirt, and sandals. His name was Lloyd Cunningham. He sat on top of one of the desks—obviously, he was comfortable in the shop. "I don't work here," he told me. "I'm just hanging around. All my friends are here."

It was slow in the shop—lunchtime—and a bit steamy. While I talked with Joan, Lloyd worked the phones, trying to find a repairman to give the shop's lifeless air-conditioning unit some much-needed CPR, or perhaps a decent burial. It had conked out just in time for a week's worth of ninety-degree days. "It worked fine all last week," Joan said. "Now that we need it, it's broken."

She rubbed her forehead. "I can't work in this heat. I'm losing all my energy. I can't do anything."

Lloyd hung up the phone and issued good news. "Joanie, the air-conditioning man is coming."

There are more than a few angry people in Homestead. Some feel used and cheated by the cold, monolithic business and government organizations that took what the town could give, then failed to provide life rafts when Homestead's boat sunk. Some are miffed at having to watch their town wither while much of the country—including Pittsburgh and some of its suburbs—feasts on high-tech industries and decent-paying jobs. But the most angry voices are the ones that rail against what they see as Homestead's worst problem—its own leadership. Joan is one of those voices. Some people call her a hell-raiser. Without much prodding, she'll start in on the town's government—or lack of it, as she sees it. She has little respect for the borough council, and even less for the mayor (who had failed to attend the last few council meetings) or the new police chief or a recent high-profile crime-prevention effort. "It's called Operation Trigger Lock," she said, her voice ripe with sarcasm. "It's a nice show, but it does no good. It used to be, when we had a real police chief and a police department, it wasn't so bad around here."

Politics in any small town is exercised on a personal level, and it's easy to find those who have suffered real or perceived slights and, as a result, complain bitterly about local officials. But Joan is not simply a passive whiner—she had once run for a council seat, a bid she lost. And her comments on this day were drawing support from Lloyd, who had twice served on council, in the late 1970s and early 1980s, and again in the early and mid-1990s. If the leadership is truly inadequate, I asked, then why don't Homestead's residents make changes at election time? Joan had returned to the work at her desk, so Lloyd answered.

"Apathy," he said. "Nobody else will run. Look, there were two seats on the ballot in the first district. I went to all the loudmouthed people who were always complaining about things and said, 'Now's the time to put up or shut up. Now you can do something to make a difference.' I couldn't get anybody to run. All these people were making noise, but none of them would put in the time and effort."

For years, Lloyd said, there was no need for strong or creative leadership in Homestead because the mill and its managers were such a powerful and paternalistic force.

"The mill ran the town," he said. "Told the council what to do from the 1890s to the 1980s. If the town needed something fixed, the mill would do it. The mill was like a grandfather. When I was on council, if I needed trees taken out of the park, I'd call the superintendent at the mill and he'd send somebody up to take care of it. When the concrete steps on the library were broken, the mill sent a mason up to fix them. There was a traffic accident once, involving a big truck. The tow trucks in town couldn't handle it, so we called the mill and they sent one of their big trucks."

When the mill closed, it took not only its paternalistic leadership, but also its money and resources. At a time when Homestead needed to make its longest and most arduous journey, the town lost its chauffeur, its automobile, and its gas money. Petty political squabbling was the result. It has happened elsewhere in the Monongahela Valley. In the nearby steel town of Braddock, an angry councilman was once cited for disorderly conduct after he threw a table during a council meeting. At a time when steel towns should have been pulling together, they were tearing themselves apart.

As we talked, Joan pulled away from her work, leaned back in her chair, and sighed. The phone rang. "It's too hot for people to be calling and bugging me," she said. Then she picked up the receiver and answered politely.

A sweaty, middle-aged man wearing a black T-shirt and a tool belt walked in. "I'm here for the air conditioner," he announced in a monotone voice. Lloyd pointed to it above the door. "Got a ladder?" the man asked. Lloyd retrieved one from a back room. After examining the unit, the repairman said flatly, "You need a new air conditioner. The compressor is bad."

News of unrelenting heat in the printing office was reason enough for me to make an exit. My stay had already been longer than planned—something I would pay for in the form of a parking citation. As I was leaving, Joan called out, "You want to see what it's like in Homestead? Go to the council meeting tonight at seven o'clock."

I took it as a challenge.

Several hours later, in an old but renovated school building at the top of a hill in Homestead, a small, elderly man with wispy gray hair opened his mouth and let out a roar that sounded like that of a passing train. "I've been in this borough *seventy-three years*," he bellowed, jabbing his finger at the nine Homestead Borough Council members seated before him, "and I've *never seen it in the mess it's in now!* You people have got a *rock around your neck!*"

The man was Elwood Yon, a longtime and well-known Homestead resident, and his voice continued to rise as he thundered on about property he said the council had purchased for two thousand dollars (council members claim it had been deeded over to the borough in lieu of taxes). Other citizens in the audience gave Elwood their approval—"You got that right," one hollered—and they were getting louder. I looked at the council members now under siege. One held his head in his hands, another inspected his fingernails. A few listened to Elwood intently, and the rest looked as though they wanted to duck under the table to avoid any of the shrapnel being hurled their way.

Duly impressed with Elwood's oration, a young woman in front of me turned to her friend and whispered, "Girl, I like him." Elwood, meanwhile, was raging on. When he mentioned a "girlie bar" downtown, the audience laughed. Certainly he was a crowd favorite. The legendary Leona Theater on Eighth Avenue may have closed years ago, but there is still entertainment in Homestead—once a month at the council meetings.

Democracy in a financially troubled community isn't pretty, nor is it necessarily efficient. It certainly isn't quiet. Political brawling in Mon Valley steel towns is legendary. Council meetings were described as events in which normally calm people found themselves screaming at their neighbors.

Homestead's racially mixed council consisted of seven men and two women. They sat at the front of the room in a collection of tables arranged in the shape of a horseshoe and faced an audience of approximately thirty residents, who were sitting in folding chairs. After a recitation of the Pledge of Allegiance (everyone participated, with hands over hearts), the meeting moved on to several typical small-town items—getting a fire whistle fixed, approving street repairs, demolition of gutted buildings, and temporarily closing off a section of a street for a block party. A young police officer with a Mohawk haircut sat by the door—a somewhat bored sergeant-at-arms. Two sober-looking men in business suits were at a side table, up front, facing the council. Lloyd, sitting next to me, explained that they were officials appointed by the state to oversee the borough's activities, since Homestead had been officially declared a "distressed" community. After several minutes of haggling over police overtime pay, uniform allowances, promotions and personnel, one of the state-appointed men publicly admonished the council to "start doing its job. It's time council took care of its responsibility." This brought a round of

applause from the audience. On several occasions, the mayor's absence was noted. "Impeach him," someone hollered. Several people snickered. A man wearing a Charlotte Hornets T-shirt whispered to the woman next to him that the mayor had missed several meetings. During a protracted and confusing discussion about the hiring of a zoning official, a woman in front of me turned around and asked, "Does anybody know what they're doing up there?"

Things got a bit more exciting during the last portion of the meeting, when citizens were allowed to address the council. Those with a grievance had signed a list as they entered. One by one, their names were called. Elwood was one of the first, and he blasted away at council for about five minutes. When he finished, Joan DeSimone launched into a tirade against council for failing to give her husband, a Homestead police officer, his uniform allowance and back pay (he had been discharged, then rehired after a finding by the Pennsylvania Labor Relations Board that the mayor had violated the Labor Relations Act). "Everybody in that department got a $250 uniform allowance except the dreaded DeSimone," she said. "Would you people get off the personal vendetta?" Then she vowed she would never be harassed out of Homestead. "I'm not leaving this town unless it's in a pine box." At one point, she rose from her seat and waved a piece of paper in the air. "I want to know who to give this bill to, so it won't get lost." Then she marched up and presented it to council. The town's solicitor called some of her allegations "absurd" and said she was conducting "nuisance litigation" against the borough, to which DeSimone hotly replied, "That's because council is a nuisance."

Later, a round man who appeared to be in his late thirties and had been standing in the back began by proclaiming, "Let me start off by saying I'm a third-generation Homestead resident. I'm fiercely proud of this town . . ."

"Get to the point!" one woman said.

"What's your name, ma'am?" the man demanded, but the restless audience was rumbling in agreement with the woman. He continued, harking back to the police overtime issue raised earlier in the meeting: "Open your ears, residents, I don't hear any gunfire. I'll pay the two hundred hours of overtime so I can walk the street, so my disabled mom can walk the street. The dopers are not out."

The overtime issue was tied to a recent police crackdown on the town's growing crime problem. Local, county, and state law enforcement agencies had increased their presence in Homestead, something one of the final speakers addressed. She told council about a friend who was stopped by police after leaving her house. "His turn signal wasn't working, so they stopped him. They used racial slurs on him. They said, 'How'd you get a car like that?' Like a black man can't get a Cadillac?" ("I've got one," submitted a man two rows up) "This man was fifty years old, he's got a good job at Duquesne Light, he's a boss. I'm glad they're coming into town to protect us, but don't harass us."

Shortly after, the meeting ended. It had lasted two-and-a-half hours, and the crowd quickly thinned out. Lloyd turned to me and, with a broad grin on his face, said, "I come every month just for the entertainment."

Kitty Reina scrunched up her face in her best I-can't-stand-this look, then announced to her older sister, "That smell is just *awful* . . ." Bonnie Bowlin nodded in agreement. The air on this otherwise perfect morning was saturated with a heavy stench emanating from the burned-out, water-drenched remains of a nearby storefront. Suddenly, the breeze shifted and ushered in the sweet smell of fresh-baked donuts from the A&B Bakery next door. Within seconds, the wind changed again and the pungent odor returned.

The sisters were easy to spot from a distance. I'd been walking down Eighth Avenue, several blocks from Stout's printing office, and had first noticed the fire trucks and police cars, then the yellow "Caution" tape that marked off the fire scene. Then Kitty and Bonnie. Kitty is forty-seven, a thin redhead with carefully styled hair; her sister, a brunette, is a decade or so older. They both wore red tops, white shorts, and tennis shoes, and therefore stood out among the soot-stained firefighters who were packing up gear nearby. The fire had been out for some time. I crossed the street and asked the women what had happened. Bonnie, carrying a cellular phone, looked both wired and weary as she explained how she'd been jarred awake at 3:00 A.M. by a policeman frantically pounding on the door of the third-floor apartment she shared with her seventy-nine-year-old mother, Vivian Phares. A fire had been discovered in the next-door storefront, occupied by a travel company, and Bonnie's apartment was being evacuated. Despite her age, heart problems, and asthma, Vivian beat Bonnie to the bottom of the steps. Once outside, the two saw smoke, then heard a policeman's orders to run toward the lighted Adult Movies sign just down the block, safely away from the fire. Disoriented and groggy, Bonnie wondered, "Why does he want me to go to the adult movies?" Still, she did as she was told.

Now, several hours later, Bonnie watched as an arson-sniffing dog nosed its way through the charred interior of the travel office. An elderly woman with wavy hair poked her head out of an open window in Bonnie's apartment high above, and stared down. It was Vivian Phares, who had been allowed to return to the safety of her abode, which had received no serious damage. The sisters explained that their mother has lived in various apartments on Eighth Avenue in the adjoining towns of Homestead and Munhall since the late 1940s.

"This is her area. She's not going to leave it.

Even this won't scare her off. It will scare me," Bonnie said with a bit of exasperation. Bonnie serves as her mother's caregiver, and she's become uncomfortable with the area's recent string of fires and shootings. Vivian, however, will not hear of moving. "She's seventy-nine, and she's very, very stubborn," Bonnie said. "She's got a mind of her own. My brothers have beautiful homes. My sister has a beautiful home. She can go live with any of them. But *noooo*, she wants to stay here, where she can see everything."

I looked up at the woman staring down from above, then her head disappeared back inside the apartment. Apparently, Vivian had seen enough for the moment. Bonnie and Kitty explained that their family moved to Homestead in 1948 after the closing of a Charleston, West Virginia, steel mill that had employed their father. "I was twelve then," Bonnie said, "and the only life I knew was country life in West Virginia. I was a rebel. And I was absolutely scared to death when we first moved here. My mother says I used to cry and she'd have to drag me out just to go to the post office. It's like it has come full circle. I'm absolutely scared to death to be here now."

At one time, Eighth Avenue was a bustling street full of department stores, five-and-dimes, theaters, and restaurants. But that was when the mill was still running, and before suburbs and malls sucked the commercial life out of the Monongahela Valley. Now many of those businesses were gone. Some of the storefronts were vacant, others had burned, collapsed, or been torn down. The empty spaces looked like missing teeth in a broad smile. Still, Eighth Avenue lacked the intimidating emptiness of Braddock Avenue, a street littered with empty and collapsing buildings in the nearby town of Braddock. Some stores were still open, selling everything from furniture to hardware to used books. There were plenty of people and lots of traffic. New sidewalks had been put in, trees had

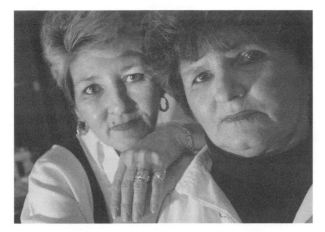

been planted. I had walked the street several times, always without incident, wondering if an unwarranted fear of crime was hastening the town's demise. Statistics showed there had been problems. During one three-week span in the summer of 1995, Homestead was hit with eleven fires, many of which were ruled arson. As for violent crime, a rash of mostly drug-related shootings in early 1996 earned Homestead an unwanted place on the local nightly newscasts, caused a public outcry, and resulted in a crackdown by law enforcement authorities. "There have been so many shootings here, you don't hear about them unless it's a fatality," Kitty said.

"I thank God that Dad's not around to see it as it is now," Bonnie said. Her father, Carl Phares, was horribly injured in an accident in the Charleston mill in 1942, when a sharp blade flew off a piece of machinery. "It cut off his leg just below the knee," Bonnie said. "The leg flew off, but he kept running until he passed out." He later returned to work at the mill until it closed, then moved his family to Homestead, where he worked until he retired in the early 1970s. Carl died in 1980 at age seventy. The sisters took a second to reminisce about the man. "He had only one leg, but every day was always fine," Bonnie remembered. "He never complained."

"'This is my kind of weather,' he'd say, no mat-

ter what it was like outside," Kitty added. "Now, we complain if we have a hangnail."

The next day, I returned to the fire scene. Outside the charred storefront were stacks of new, white cardboard boxes filled with office records that had survived the blaze. The word "Damaged" was handwritten on the side of several boxes. A small group of four or five people was at work inside, stacking salvageable items. I wandered in and asked for the owner. "Look in the office on the right," I was told. Everything was blackened—the walls, the ceiling, desks, an old manual typewriter, brochures advertising ocean cruises. The place soaked up light like a dry mop soaks up water and, since there was no electricity, I was soon far enough from the windows to be enveloped in darkness. The damp smell of a heavily doused fire, which had permeated Eighth Avenue the day before, was nearly thick enough to be shoveled out with the rest of the debris. Scraping, crunching sounds betrayed every footstep. Inside the small office, someone pulled manila files from a cabinet and stacked them in a box. I couldn't tell who it was; my eyes had not yet adjusted to the dark, and the only illumination was a small flashlight held by the person at work. "Sorry to interrupt," I said, "I was told I could find the owner here." On closer inspection, I could see I was talking to a woman with brown hair. She introduced herself as Jo DeBolt. "You're looking for my husband," she said. "He's right outside. I can hear his voice." She called for him.

Another figure, this time a man, entered the room. He also held a flashlight, and he shined it in my face as I introduced myself. Then he turned the light on himself, and I saw a man with disheveled brown hair and thick glasses. He told me he was George DeBolt, owner of DeBolt Unlimited Travel

Services, a company that had been in business, in one form or another, since the late 1800s. Now wasn't a good time to talk, he said, but he invited me to his home in a nearby town the following day.

The DeBolt residence is one of the larger homes on a quiet residential street filled with well-manicured lawns. If Homestead's appearance is, as I once heard it described, that of an undersized boxer whose nose was broken during a fifteen-rounder against a seasoned heavyweight, then the tree-lined suburbs in this section of Munhall, just a few miles away, have the pleasant and confident face of a ringside observer who has covered his bets.

The Debolt's large, grassy backyard has an in-ground swimming pool and is surrounded by a fence. George DeBolt gave me a brief tour of the grounds and told me that his parents built the home several years ago. He suggested we sit by the pool to talk. "It's quiet there," he explained, because large trees shield the sound and sight of traffic on a nearby road. We began talking and he stopped himself in mid-sentence: "Want to know how nice it is here?" he asked. "Look to your right, in the grass." Ten feet away crouched a rabbit, still as a statue. DeBolt motioned to the trees. "My mom made sure they put these pine trees here in 1959. They form a wonderful barrier. Most people wouldn't think you're this close to Homestead."

DeBolt told me about his family. His grandfather, also named George (the last name was then spelled Diebold), was employed at the Homestead Works during the violent upheaval of 1892. He was one of nineteen people charged with murder after the shoot-out with Pinkerton guards and, though he was ultimately acquitted, never again found work in the mill. In 1895, he started an animal feed business. A few decades later, as motor vehicles replaced horses and wagons on Homestead's streets, the market for feed dried up, and the DeBolt family enterprise purchased trucks and

shifted into the moving and hauling business. At first, the DeBolts moved mostly furniture—"My father was very well known for his ability to move pianos," DeBolt said—but as the area's primary industry grew, the DeBolts began hauling iron and steel materials. Later, they added a bus company and hauled people. The industrial hauling portion of the business dried up when the area's steel mills closed, but DeBolt continued to move people in buses, and to serve as a travel agency. The fire two days before, which was under investigation, wasn't the first to strike the business, DeBolt said. I asked him why he kept his business in Homestead, a town that has for years been haunted by fires.

"It's our home, it's our heritage," he told me. "I don't know what you've heard about me, but I was assaulted in my office in 1983. I just fell asleep working at my desk and an intruder came in about four o'clock in the morning and just started beating my brains out. I almost died. But the thought of leaving Homestead never crossed my mind. You can still see," he said, moving closer and pulling back his hair to reveal a faint scar on his forehead. "I've got some scars here, and there's some scars here."

The DeBolt business has been burned out three times—the first in 1989, he explained: "That was arson. They never solved that one. There was a fire in '92, which was actually in the building next to where our offices were, so that was not directed at us. And then this one on Friday. How many businesses do you know that have experienced three fires in seven years? That's real tough. Real tough."

Though he's a Homestead native, DeBolt spent much of his youth away from the town, attending boarding school and going to college. "Then I was a volunteer in Belize for two years," he said, "so by the time I was twenty-four, half my life had been spent away from this community. It gave me a more worldly perspective, if you will. I had been brought up, until age twelve, in an industrial community that was pretty well-to-do, where the center of life

was the steel mill. I thought that's the way the world was. Then I went away to school. Going to New England, I saw a different type of community. In South America, I saw a different type of community. When I came back in '73, I was able to look at this community and appreciate it more."

So how did his view of the town differ from that of the residents who spent their entire lives there? I asked. He began by telling me a bit about the town's history, and its relationship to the mill:

"When the immigrants came and got off the train in Homestead, they went to a dormitory-type hall of their nationality—they'd go to the Slovakian hall, the Croatian hall, because they didn't speak English. Then," after they'd become acclimated to their new world, "they'd always want to move away from the mill. They'd want to work in the mill, but to better themselves, to make life better for their children. So they'd move from this dormitory-type living arrangement to an apartment, then to a house, then to a house up the hill, then to a house away from the valley, so that when the mills closed in the 1980s, it didn't affect the unemployment rate that much in Homestead. A lot of the steelworkers were living in the suburbs. You even had people who came in by bus every day to work in the mill. By this time you already had the malls and shopping centers being built in the suburbs. So the community, especially the business district, was already in a state of decline by the early 1970s. A lot of people forget that. Mill jobs don't necessarily make a good community. It's a point a lot of people overlook, unfortunately. You try to say to people, 'This is what makes a good community: it's not just jobs, it's the quality of life, the recreational opportunities, shopping opportunities, churches, schools.' This got really hammered into me when the prince came to Pittsburgh, and Saint James Palace asked me to be one of his escorts."

In 1988 Prince Charles of Great Britain traveled briefly to Homestead. He was visiting western Pennsylvania to speak to a group of American and British architects who had gathered in Pittsburgh to find potential uses for the old mill sites. At a meeting in Homestead, the architects told residents of their plans, which included using some of the mill buildings to house a flower show, and converting a blast furnace into a museum. Those ideas came under immediate attack from former steelworkers more concerned about paychecks than peonies. Few people these days mention Prince Charles's visit, but plenty of people remember the flower show proposal. In fact, the subject came up one day while I talked with three retired steelworkers. One of the men, who had attended the meeting, told me in a voice that was more sad than angry, "We were the steel-making capital of the world, and they were talking about flowers. We wanted to get back to making steel, to get people working again."

DeBolt, too, remembered the meeting: "The night of the presentation, they had all these wonderful plans for the mill sites, and all the locals screamed, 'How about the jobs? How about the jobs?' And the report on all the work was blindsided by this myopic view, that we wanted to know about jobs, jobs only. I kept trying to make the case that what we needed to do as citizens was to build a good community. They didn't want to hear that then."

Why did he think those residents were so concerned about work? I wondered.

"Keep in mind that the mills had been open for a hundred years," he said, "and they'd been providing jobs for a hundred years. People had to have a perspective they'd never had before, that their fathers never had, that their grandfathers had never had—in some cases—that their great-grandfathers never had. That is, life without the mill. I had that perspective, because I spent half my life being away from the mill. In many ways, when the prince came, I was a voice in the wilderness. It was very lonely out there."

A few miles away, a sturdy, gray-haired man named Angelo DeSimone raked his well-groomed yard and thought about work and about jobs. He paused, then tapped me on the shoulder with the handle of the rake. "There was a guy from Braddock," he said, his thick accent announcing an Italian heritage. "He was on the track gang with me."

Angelo had a story to tell, and by the broad smile on his face, I knew it was going to be a good one.

"We were working labor together. He was a young kid, just got out of school, and it was raining—this was in October. It was cold. He couldn't take it no more. He came over to me and said, 'They're working us like mules.'"

Angelo shrugged at him and replied: "If the superintendent says you've got to work, you've got to work."

Unsatisfied with that response, the young man turned to the superintendent. "If I'm going to work like a jackass, I'm going to look like one," he said. With that, the young man dropped his pants and mooned the superintendent. "Then he took off his gloves, and he quit."

Angelo laughed. Some guys could afford to flash their fanny and walk away from a job and its paychecks. Not Angelo, not with a wife and four kids, a mortgage and memories of growing up poor in Italy during Benito Mussolini's Fascist regime and the Second World War.

"With me, I had to work."

On the last morning of 1948, Angelo and his older brother Joseph stepped off a train in the East Liberty section of Pittsburgh and felt the city's concrete under their feet. Angelo, nineteen years old, stood there "like a dummy," he said. Didn't know the language. Didn't know where he was. He had come from a small community near Naples, Italy, where his family owned a fifteen-acre farm and everybody knew everybody. But Italy had been wracked by fascism and war, and there was little from which the DeSimone brothers could mold a future. So they left Italy, first traveling by boat to New York, where they caught a train, and on New Year's Eve they were smack in the middle of the most industrial city in the most industrial nation on Earth, looking for relatives they had never met.

The brothers were following a family tradition—leaving home to find work where they could. The relatives they were meeting in Pittsburgh—two uncles and a cousin—had done the same years earlier, as had the DeSimone's father.

It didn't take them long to get started on the futures they couldn't find in Italy. A few days after arriving, Angelo was hired by Union Railroad, which serviced the mills owned by U.S. Steel. Angelo was excited about being in the United States. As a youth, he'd heard that everyone in America was wealthy, that making a living was easy. And that appealed to a young man who had known mostly poverty and war.

The truth was just around the corner, however, and it hit like a locomotive: "They made you work like an animal," Angelo says. "Rain, snow, it didn't matter. You had to work." Nearly half a century later, Angelo could count the fruits of that labor. He had a family of his own—he and his wife Mary Rose had four children and six grandchildren—and a home overlooking Homestead and the Monongahela Valley. DeSimone's place commands an impressive view of what was once a major industrial center. From his back yard, you can look south, where smoke rises from the Edgar Thomson Steel Works in Braddock. And just a few hundred yards away from his house are the remnants of the Carrie blast furnaces, towering hulks that once produced molten iron for the Homestead Works.

It's natural that he would live so close to those furnaces—they played a big role in his family

history. Angelo's father, John, came to America in 1912 and worked in the furnaces. Indeed, Angelo is named after an uncle who lost a leg in an accident there sometime around 1908. Once he moved to America, Angelo himself became finely acquainted with the furnaces, mainly through the red dust the furnaces spewed into the air, dust that covered the houses and cars in Angelo's neighborhood. And after the furnaces closed in 1982, Angelo was part of a crew that removed its railroad tracks.

By the late 1990s, the furnaces were mostly gone, as were the industrial jobs that brought members of the DeSimone family to America. Angelo could look across at the Homestead mill site and say that he didn't miss the smoke, dirt, and noise. But he felt sad that the jobs the mill provided were unavailable for a younger generation trying to cope with a smaller number of low-paying service-sector jobs.

It was a different scene earlier this century, when the mills were thriving and jobs were plenty. Those jobs attracted members of the DeSimone family, but were not always enough to keep them in Pittsburgh. A few years after arriving, Angelo's father returned to Italy to fight for his homeland in the First World War. He returned to the Mon Valley in the early 1920s and resumed work. Later, John DeSimone and his brother Angelo pooled their money and bought a farm in Panduliano, a small agricultural town near Naples. Angelo DeSimone, who had been fitted with an artificial leg after his accident, continued to work as a janitor in the Carrie furnaces and never returned to his native country. ("He told us they gave him a thousand dollars and a lifetime job," the younger Angelo DeSimone says. "All these steel mills, they had a price. You loose a finger, you lose an arm or a leg, you get so much money.")

John DeSimone made several trips back and forth between Italy and America, each time leaving his family at the farm. In America, "You'd work day

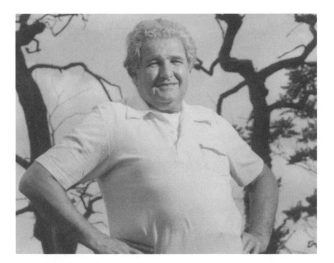

and night, save a little money, then get laid off," Angelo said. "So you'd pick up and go home. There was no unemployment compensation." In 1932, in the midst of the Depression, John again returned to Italy, now under the repressive rule of Benito Mussolini's Fascist dictatorship and on the verge of war. John DeSimone would be unable to return to America.

War started for Italy in 1935–1936, and as the fighting dragged on it became apparent that the family's investment in the farm was a blessing. The DeSimones were able to live on what they produced. "A lot of people went hungry," Angelo said. "They had no food at all. If it was only beans and potatoes, we ate. But some people had nothing. Some people, if you had bread, they'd take it. Some people would kill for a loaf of bread."

In the winter of 1943–1944, DeSimone watched as Allied and German troops lobbed shells at each other, not far from his home. Nazi troops were eventually driven from the country, and Mussolini was executed. Though the country was finally at peace, DeSimone said, Italy offered little for young men like himself. He was planning to join the Italian police force when a friend of his father pulled Angelo aside and told him he should go to America. "You'll be better off," he was told. Soon,

Angelo and Joseph, who was twenty-one, had their papers together and were on board a boat bound for America.

After arriving in Pittsburgh, Angelo and his brother were taken in by their Uncle Angelo. The brothers then went about the business of learning to speak English. "We had a lot of help," Angelo says. "On the job, at home. Within three months, I could speak English pretty good. My foreman was Polish—a lot of the guys I worked with were Polish—and they would help us with the language. They'd say, 'This is a shovel, this is a pick.' There were a lot of nice people around. A lot of people laughed at us. You find those people no matter what. But 95 percent were nice."

Despite growing up on a farm, Angelo quickly adjusted to living near the Mon Valley's huge industrial facilities. He got used to the fine red dust that the Carrie furnaces belched into the air and the noises made by the mill and the trains that constantly ran on tracks at the foot of the bluff—"All night long, *budda-boom, budda-boom,*" he says. "It never stopped."

In 1952 he married, then bought a house. He liked living close to work—he could walk there in five minutes. Many of his neighbors were employed in the Homestead mill; at every shift they would form a procession past his house, to nearby steps that took them down the bluff to a ferry, where they would cross the river to work.

Angelo was a Union Railroad employee for nearly forty years, most often as a laborer on crews repairing tracks that snaked through the mills. The work was difficult and sometimes dangerous. In August 1951, the thumb on his right hand was crushed in a work accident. He spent ten days in the hospital; his hand bears the scars to this day. The work conditions turned co-workers into comrades, no matter what their race or ethnic background. "All nationalities, all races worked side by side," DeSimone said. "It was different. If you

needed coffee, they'd get you coffee. If you needed a ride home, they'd give you a ride home. It wasn't like it is now. We stuck together, we worked together." In 1970, he was promoted to foreman. In 1988, at age sixty, he took early retirement.

For DeSimone, coming to America was an easy choice. There was no future for him in Italy, he told me. When he traveled there in 1966, he saw none of the friends he knew as a boy. They had all moved away to find work.

In his Pittsburgh backyard, DeSimone chewed on an unlit cigar. The sun was still out. Across the river, he could see green grass starting to sprout on the otherwise brown and barren site of the Homestead Works. His story told, he picked up his gloves and rake and returned to work. "When we came here, we had nothing," he said. "We've done okay."

viii

Some people will tell you the Ward was simply in the wrong place at the wrong time, just like the twenty-six-year-old Pittsburgh man I read about in the newspaper, the one who was gunned down because he happened to be in a rough section of town, walking through a housing complex where destiny put stupidity and anger in one resident's head, then put a gun in his hand. *Bang.* It was over quickly. A young life ended, a few people mourned him, and the rest shrugged, knowing *they* were safe, that such a fate falls only upon certain people, in certain neighborhoods, at certain times.

The Ward fit that certain description: It was a noisy, boisterous neighborhood, considered by some a bad neighborhood, full of people who often spoke a different language and had strange customs, and it happened to find itself standing in the way when guns went off halfway around the world. As a result, the Ward became a casualty, just as surely as if it were struck by an errant shell.

I had often heard stories about the Ward, mostly

from elderly Homestead residents who had grown up there, but I had difficulty visualizing the place. In 1996, I went to the area where the Ward was located. It looked like the surface of the moon—barren and desolate. There were no buildings, no roads, nothing. It was impossible to image children playing, men mowing lawns, and women tending gardens. The only activity I saw was a backhoe in the distance, methodically digging out the earth. *There was a neighborhood here? You've got to be kidding.* Then I went to a Pittsburgh library and found some old photographs of the neighborhood, saw images of its tree-lined streets and tidy homes, its churches and bars. If you believe a sense of security and permanence is important to a community, then don't compare old photographs of the Ward with what is there now. It will give you nightmares.

Six blocks long and six blocks wide, the Ward was jammed full of everything that made working-class life in an industrial city both wonderful and difficult. It was always home to Homestead's most recent immigrants—first Germans and English, then, in the early 1900s, eastern Europeans and Southern blacks—and they gave the place a richly diverse ethnic flavor. Some residents lived in well-maintained homes; others lived in immigrant courts, boarding homes, or row houses. The Ward had a mix of business, religious, and cultural establishments. It was home to twelve churches, five schools, and a number of social clubs, mom-and-pop stores, movie houses, and candy shops, as well as a number of whorehouses, seedy bars, and gambling dens.

What made life tough in the Ward was its location—it had a dirty, noisy neighbor. The Ward sat on the city's flat land near the Monongahela River and was wedged tightly against the Homestead Works, which meant residents endured the black dust spewed from the mill's smokestacks, and the rumble and boom that was the song of steel making. Trains continually rolled through the Ward's neighborhoods, rattling and shaking homes.

John Dutch, a gruff eighty-one year old who grew up in the Ward and worked there as a barber before taking a job at the Homestead Works in 1936, remembers all of the noise and dirt. He and a few other retired steelworkers traded stories of their old neighborhood one morning in a small office used by the United Steelworkers of America Pensioners Association. They let me listen in. Dutch said one section of the mill sat particularly close to the Ward, and it is firmly planted in his memory: "That thirty-inch mill, that shook the whole Ward. *Boom-boom-boom.* When you heard that noise, you knew everybody was working. That was our cradle, the old thirty-inch mill. It would put us to sleep at night." What about the smoke from the mill? I asked. "Who cares about that smoke?" he barked. "That's why I lived so long, 'cause my lungs are full of good old smoke."

By the 1940s, many people in better sections of town considered the Ward a slum with dilapidated houses—some of which had no indoor plumbing facilities—and vice that was legendary. (Dutch joked that efforts to save historically important structures in Homestead missed the mark because "they didn't save the cathouse. That's the historic building they should have saved.") It did have those things. But the Ward was too complex to be defined purely by those standards.

Babe Fernandez, a retired steelworker who sat across from me in the pensioners office, quickly spoke up when I asked about the vice. His parents came to the United States from Spain in the early 1920s, he told me, and had raised him in the Ward. "It was a beautiful place," he said, his voice rising in defense of his old neighborhood. "We had good people, honest people. You could leave your door open when you left home, and you didn't have to worry about a thing. The people who lived up on the hill thought it was a bad place. They wouldn't

go down below the tracks, wouldn't let their kids go down there. Right away, they'd paint a bad picture. All they had to do was go down there for twenty-four hours and see for themselves."

The Ward's fate was sealed in the early 1940s, when the rumble of war joined the rumble of industry. After the United States entered the Second World War, patriotism ran high in Homestead. And when Uncle Sam demanded more steel for the war effort, the city willingly gave up 121 acres of its land, forcing the displacement of nearly half of its twenty thousand inhabitants, so that the mill could grow.

An official announcement that the Homestead Works was to expand came on June 28, 1941. The expansion was a huge project, costing $75 million, and it was directed by the Defense Plant Corporation (DPC), a federal agency set up to guide the nation's wartime industrial growth. On June 30, the *Homestead Daily Messenger* ran an editorial proclaiming that, as a result of the DPC's action, "The future of Homestead was assured for all time as a great industrial center." Next to the editorial was a cartoon showing an evil, gun-wielding Hitler groping for Alaska as he stepped across a burning and smoldering Russia. Within months, Ward residents were moving out and wrecking crews were tearing down buildings.

Once the Ward was cleared, new steel-making facilities were built on the land, but the war was nearing its end by the time they were in full production. After the war, those facilities continued to be a vital part of the Homestead Works until the mill closed in 1986. The huge steel sheds and buildings began to be dismantled shortly thereafter. By the mid-1990s, the area was once again cleared and ready for new retail development, which arrived within a few years.

And what happened to the Ward's residents? Many were moved to newly created housing projects in nearby West Mifflin and Munhall, and across the river in Pittsburgh. Others found homes on their own. Some were uncertain what to do. Babe Fernandez's family was eventually moved to a Pittsburgh housing project called Glen Hazel, where the streets were muddy and unfinished. He remembers the Ward's last days, when the homes left standing bore red crosses, indicating they would soon be destroyed. The few remaining residents, he says, felt confusion mixed with faith and hope that government agencies would take care of things.

"There were only about ten people left there at the time," Fernandez said. "It looked like the place had been bombed. My parents couldn't speak English. They didn't know what to do. We just sat there and waited for the authorities to tell us what to do. And they did."

Rufus "Sonnyman" Jackson was one Ward resident who had enough money to improve upon his life once the old neighborhood was bulldozed. Jackson was a well-known Homestead businessman—he owned a local jazz club, the Skyrocket Lounge, as well as a record store and a jukebox business. In the late 1930s and early 1940s, he was also part owner of the Homestead Grays, a Negro League baseball team. When the Ward was being demolished, Sonnyman built a fine new brick house on Twelfth Avenue, several blocks up the hill.

Information on the life of one man who lived in a small community years ago can be difficult to come by. One old newspaper clipping about Sonnyman was stuffed in a folder at Homestead's Carnegie Library. It praised him for his business sense and his leadership in the black community. Another clipping in a Pittsburgh library showed a photograph of Sonnyman—smiling, a friendly face, a gap between his teeth—and said he had "floated into town on the rods in the late twenties [and] began to muscle in on the rackets."

Other information came from those who knew him, or knew about him, just sentences here and there:

"I remember the guy died in '48."

"Sonnyman was a big shot, but he gave back to the community."

"A lot of the big names in jazz stayed at his house when they came to play in the Pittsburgh clubs. Lena Horne stayed there. So did Earl Hines."

"I used to see Sonnyman around. He ran a good business. He also had a numbers operation. That was illegal, of course, but a lot of people did it. He always drove a nice car."

"I remember going into the Skyrocket. I used to sneak around and shine shoes as a little kid. Hustling to make money."

Finally, I went to Sonnyman's most visible legacy—his house, which is contemporary in style, but not pretentious, two stories with three front-facing gables stacked atop each other. The home's current owner is Dean Smith, a man in his mid-forties. He invited me inside and showed me a framed black-and-white photograph that hung on a wall in the entry. It was a 1935 Homestead Grays team photograph. Dean's wife had won it in a raffle, he said. A stroke of luck. Then Smith led me into the kitchen, which after more than half a century still retained its original art deco flavor. Its wood cabinets and its walls were painted white with red trim and we sat on padded red seats that resembled those in a booth at a diner. In the late 1980s, Dean and his wife, Bonita, bought the house from the Jackson family. The Smiths knew it was an important part of the region's black history.

"This house was built exclusively by African-Americans," Dean said. "That was significant in that era. It was something to behold. Some say it was like a festival. People would come just to watch the workers." The Jacksons moved into the house on the day Japanese planes were bombing and strafing American ships at Pearl Harbor—December 7, 1941.

"When Sonnyman moved out of the Ward, he took the bricks from his old home and built the apartment building next door." Dean told me. "I lived in that building with my family for the first five or six years of my life."

Dean grew up in Homestead in the 1950s and 1960s. Like Sonnyman, he was a minority in a town whose residents had little experience with blacks until the Southern migration to Northern industrial cities in the 1910s and 1920s. "Racism wasn't prevalent here," Dean said. "Growing up, I had as many white friends as black. We'd go to each other's houses for parties, to sleep over. There was some separation. There's always a dividing line. Blacks lived as far as Fifteenth Avenue, then it was predominantly white up to Twentieth. Blacks are moving further up in that area now."

After graduating from high school, Dean went to college out West, first to Nebraska and then Colorado. After six years of school and work, he returned to Homestead where he has been employed in a variety of social service jobs. For a while, he ran a program called Alternatives to Unemployment, helping people put resumes together, tutoring, teaching interview skills. "Lots of people didn't want to leave the area. A lot of these Mon Valley people, they don't want to leave. They say, 'This is my home, this is where I was born, and I'm not leaving.'" Now Dean works in McKeesport, another steel town a few miles upriver, in a facility offering family therapy. The Mon Valley has changed over the years. "I don't see that bonding between white and black kids that I saw growing up," he said. "All these playgrounds around here used to be really active, and there was a meshing of all kids, in all neighborhoods. Now there's a real decline in that."

Much of that change is a result of the Monongaleha Valley's poor economy. "There are a lot of

families where both parents have to go out and work. People work two or three part-time jobs. And there are single family homes, especially with minorities, where women are the heads of the homes. Consequently, kids just aren't involved in community activities like the church, Boy Scouts, or recreation. There's not an adult population active in the lives of young people." Dean remembers the mill, remembers the shift changes, when workers poured out of the gates, walked to their cars, some of which were parked several blocks up the town's slope. "There were hundreds of people. It was like they opened up the gates at a stadium. Just a swarm of people."

Then hard times came to the steel industry. "I had two brothers working in the mill," Dean said. "There were rumors that it was closing, but they didn't believe it. They said it was just gossip."

And after the mill closed, he said, "what you saw was people holding on, like the mill would reopen. It was phenomenal that all these people would believe this. They'd go on unemployment and wait for the mill to reopen. I'd say, 'Man, you'd better go out and retrain, learn how to do something else.' Instead of retraining they stayed on until there was simply no more work. That's when they were sending people to community college for computer skills. My brother went to two or three different types of training, but none ever worked out."

A decade after the mill closed, one brother holds down two jobs; the other has been jumping from job to job for the past ten years. "He's been to school, tried to start his own business," Dean said. "He's been in no steady, stable job since the mill closed. I worry about him. He's got kids, a wife, a lot of responsibilities. The pressure on him is much greater.

"I spent some time in the mill," he continued. During college breaks, "I'd come home, work in the mill for a few weeks, then quit and go run and operate the local playground. I ran those play-

grounds at least three summers. I saved one of my checks from the mill just to say I worked in there. It was a small check. Just a few dollars. But it was that easy to get employed in the mill. I even considered going there to work full-time. But I didn't go to school to work in a steel mill. It was dirty, noisy. I told myself, I may make less money in social services, but I'll be able to maintain a job."

⚬℀

One Sunday evening I waited along Eighth Avenue for something rare in Homestead—perfection and balance.

A light autumn rain had fallen and daylight was receding. Streetlamps clicked on and hummed into brightness, creating pools of light that glistened like polished fingernails on an otherwise gnarled and calloused street. Dusk was a whisper, and before it was silenced by darkness, the intensity of its light would perfectly match that of the street's artificial lamps. I could open the shutter of a camera lens during that moment of balance and equity and allow the light to lay itself across a sheet of film and produce an image that wedded highlight and shadow.

But that moment was several minutes away. So I waited.

I had arrived at the location a bit early. Set up a tripod, mounted the camera, framed and focused the image, made adjustments to control perspective and depth of field.

Sunday traffic was light, a car passing every few minutes. Sidewalks, too, were empty. During waits like this I get restless, bored, and am easily seduced by daydreams. I stared across the street at a drab three-story red-brick building. Having read of the events that took place here a century ago, my knowledge was adequate for an imaginary trip back to that time. Many of Homestead's streets in the late 1800s were little more than unpaved dirt

paths, and, standing where I was, you were likely to hear conversations curled around accents that echoed from some distant place—Ireland or England or Wales. Perhaps you would not hear English at all, but on a Sunday night such as this, a man might have walked by singing a popular Slovak tune: *A ja zo Sarisa,* about a young girl married to an old husband. Homestead was very American because its people were from another place. I closed my eyes and, in my mind at least, it was early in the morning of July 6, 1892—the sun was just beginning to rise—and townspeople were rushing by, running toward the river, to the nearby steel mill. They were angry. Many carried rifles; some women carried babies as well as firearms. Then, I heard the crack of gunfire, shouts, and . . .

"Go! Go! Go baby, go!"

Quickly, I was jolted back to reality by a Pittsburgh Steelers fan whose muffled cheers escaped from a nearby apartment lighted by the blue glow of a TV tube. It was NFL game day.

Having an affair with the past in this town is difficult because the present is always barging in, demanding your devotion with an in-your-face attitude. The Battle of Homestead, for example, is one of the country's most important labor events— a confrontation that turned bloody and erased unions from the steel industry for more than forty years—yet there's little on Eighth Avenue to indicate you're in a town of such consequence. Lost among the jangle of telephone poles and street lamps is a historic marker, planted in front of the small brick building across the street. It casts a few facts at those able to speed read while zipping through town:

BOST BUILDING
Completed, early 1892. Through that summer it was headquarters for the strike committee of the Amalgamated Association of Iron & Steel Workers. Telegraph lines installed here transmitted the news from journalists who were covering the Homestead Strike.

The Homestead Strike—in reality, a lockout— was a clash between two groups who saw America from strikingly different vantage points. One group had a view that was quite bleak: its members toiled at dangerous and exhausting jobs in the steel mill. New technology threatened to squeeze their paychecks and destroy job security. The other group saw opportunity in the new age, a chance to cut costs and increase profits, to eliminate workers' organizations and make certain employees did what they were told and shut up about it. The conflict got so heated in 1892 that people were willing to die and to kill in order to see their side prevail.

This controversy swirled around the Bost Building, hub of activity for the steelworkers' union (the AAISW—Amalgamated Association of Iron and Steel Workers—identified on the sign), and the nation's press, which sensed the events that summer were leading to a showdown. The building's location a few blocks from the Homestead Works made it an ideal headquarters. You can see the building lurking in the background of numerous drawings and photographs made during the confrontation. By the late 1990s, it was an empty shell with plywood windows.

A nonprofit organization called the Steel Industry Heritage Corporation had purchased the Bost Building and planned to make it a central part of a heritage park that would "conserve the memory of Big Steel's era before it is lost forever," according to a slick and colorful SIHC publication. The SIHC saw the park as a way to promote tourism and economic development—something desperately needed in all of the Mon Valley's mill towns. Their plans were big—they included sites in several western Pennsylvania steel and coal towns, tours along the region's rivers, even a virtual reality steelmaking exhibit. In spring 1995, SIHC received a $2 million grant from the state for improvements on the Bost Building which, according to the plan, would be converted to a visitor's center with exhib-

its, a library and archive, a theater and a gift shop. The SIHC then began raising matching funds.

These ideas did not have universal support in Homestead. Some former steelworkers I talked with got angry when I brought up the subject: "We need good-paying jobs, not museums and memorials," one told me. Mike Stout viewed with irony the money being spent to save historic structures like the Bost Building when so many former steelworkers and their families continued to face financial difficulties: "Two million dollars they got to redo the Bost Building," he said. Turning to a calculator sitting on his desk, he punched in some numbers. "That's eighty jobs paying $25,000. Really decent-paying jobs they could have brought into this town. *Eighty jobs!*"

Others argued that Homestead's recent suffering was being forgotten in the rush to enshrine and recognize century-old sacrifices. What about the

sacrifices of the 1980s, when mills were closing and thousands upon thousands of steelworkers were left without work or a future? In decades to come, which will historians view as more important: a great battle in the late 1800s that resulted in the loss of steelworkers' unions for more than four decades, or the economic devastation caused by the collapse of the entire industry in the late 1900s?

Perhaps the Bost Building should be saved simply because it was a survivor in a town where so much of importance has disappeared. For a while, it appeared doomed. By the early 1980s the steel industry was sliding quickly downhill, and so was the Bost Building. It was a decaying structure on a seriously decaying street. On the first floor was a hot dog shop. The third floor, where union leaders met, was a flophouse. Office workers on the second floor sometimes found residents asleep in the hallway, still drunk from the night before. Then, everyone moved out, and for years the Bost Building's future was wobbly, its floors empty except for the thieves who came by to strip away everything of value. Demolition seemed imminent until the SIHC purchased the building in the early 1990s and saved a chunk of history.

Named after William and Valentine Bost, brothers who owned a general store in Homestead, the Bost Building was completed in early 1892, just in time for the violent clash that would occur a short distance away at the Homestead Works. That mill was the only mill owned by Andrew Carnegie in which the union had a significant presence. Carnegie, hoping to cut costs and gain greater control over his mill, wanted that union destroyed. To do the deed, he enlisted the help of his superintendent, Henry Clay Frick, who already had a reputation for disliking organized labor. In May 1892, after months of futile contract negotiations, Frick gave the union an ultimatum: accept the company's terms or the mill would function with-

out a union. Then, on Frick's orders, a twelve-foot-high fence, three miles long and topped with barbed wire, was built around the works. Operations at the mill continued until June 28, when Frick locked out eight hundred steelworkers. In their support, the remaining workers walked out the next day.

Those events galvanized the town's residents, who viewed the mill as an appendage of the town, bone that gave form and stability to Homestead's flesh, something that families, churches, hopes, and communities had been built around, and not, as Carnegie and Frick would assert, private property that could be controlled as the owners saw fit. The mill went silent and its furnaces grew cold while Frick made his plans. Carnegie had left for a vacation in his native Scotland, leaving the matter in his superintendent's hands.

Early in the morning of July 6, bells sounded throughout Homestead, warning residents that something was happening at the mill. To protect and occupy the works, Frick had hired three hundred armed guards from the Pinkerton Detective Agency. They had arrived on two river barges and were met at a landing by a throng of armed and angry townspeople. Before long, there was gunfire—it's uncertain which side fired first—and in the ensuing shoot-out, three guards and seven residents were killed. The Pinkertons took up positions on the barges. Steelworkers sought protection behind piles of steel and iron near the riverbank. The battle had begun.

Gunshots echoed along the banks of the Monongahela. Thousands of rounds were fired. Throughout the day, steelworkers made several attempts to destroy the barges. They sent a flaming raft downriver, but it burned out before reaching the Pinkertons. Then a flaming railroad flatcar was sent plummeting down a track leading to the wharf. It failed to hit the barges. Next, the workers tried dynamite. Again, the effort was unsuccessful.

At 4 P.M. the guards, weary and frightened, raised a white flag. The crowd along the banks let out a cheer. The battle had lasted twelve hours.

The surrendering Pinkertons had been promised safe passage out of Homestead, but as they walked off the barge and up into town, they received a savage beating by angry strikers and their sympathizers. It was, by all reports, an ugly scene. The Pinkertons were clubbed, stoned, kicked, punched, and spit upon. Women and children joined in the beating. A number of striking workers tried to step in and protect the guards and, in the chaos, some of them were struck down. Finally, the Pinkertons were led stumbling into an opera house. They stayed there, under protection, until the county sheriff arrived several hours later to escort them out. Half of the guards suffered serious injuries. Reporters who witnessed the day's events sent their dispatches from the Bost Building's telegraph office, and suddenly the nation's attention was riveted on the small steel town.

Four days later, at Frick's request, the state's heavily armed, well-organized state militia arrived and took control of the mill. Nonunion workers were brought in, and on July 16, the mill was reopened under Frick's terms. The union had been crushed, and many of its leaders were banished from steel working for the rest of their lives.

Afterward, Homestead became a dispirited, beaten town. A writer for *McClure's Magazine* visited in 1894 and wrote, "The streets of the town were horrible; the buildings were poor; the sidewalks were sunken, swaying and full of holes. . . . Everywhere the yellow mud of the street lay kneaded into a sticky mass, through which groups of pale, lean men slouched in faded garments, grimy with the soot and grease of the mills."

Walking the streets of Homestead in the late 1990s, you would not find yellow mud or greasy mill workers. You would, however, discover a town that had again been devastated in the wake of

decisions made by the few people who commanded great wealth and control. Homestead would enter the twenty-first century much like it entered the twentieth: struggling with a new reality that, like the old one, failed to reach a perfect balance in any light.

ri

You can say it was the wind, the way it causes windows and doors in Homestead's old buildings to rattle and knock, or perhaps it was the distant traffic grinding its way along Eighth Avenue. To me it sounded like a voice, a mumble coming from Saint Mary Magdalene Roman Catholic Church, halfway up the hill on Amity Street. Saint Mary's is a massive yellow brick structure with twin towers and a heavy stone base, a building big enough to be intimidating, cold and impersonal. It is anything but that. Stare up at the church and it stares back and locks you in its gaze, ready to address you personally.

Soaked into the church's bricks are decades of industrial town life, the voices of worship, celebrations of birth, farewells to the dead, and, not too distant, trains screaming through the lower end of town, the rumbling of the mill, barges chugging along the river, the clomping of horses, the hum of cars on the roads. I thought I could hear those decades of sound finally being released by the clay, an echo long delayed. I answered the echo by banging several times on one of Saint Mary's huge wooden doors, hoping to start a conversation with the church, though I was willing to settle for a chat with anyone who would answer my knock. There was no response from either. I walked around to the side of the building, tried another door, and still no answer.

Across the street, a woman in her late thirties, wearing shorts, a T-shirt, and white tennis shoes, washed a car parked in front of a blue frame house.

Helping her was a boy about twelve years old. He was polishing a driver's side mirror. I crossed over and asked the woman if any life remained in the church. "They stopped having Mass here two months ago," she said, "so I've had a peaceful summer. They're always parking right in front of my house. They've got all this parking, on the streets. Why do they have to take my space?"

A group of three teenage boys on bicycles rode by. One held a pack of Marlboros. "Don't you give any of those cigarettes to my son!" the woman hollered at him.

She saw I was writing in a notebook and looked at me a bit suspiciously, so I said I was doing research on the town. "Mind if I ask a few questions about the neighborhood?" She began cleaning up, gathering the rags, the bucket, the hose, and said, "We can talk. I'm not giving my name."

In recent years, crime had increased, she told me while she wrung water out of the rags. "I'm planning on selling the house and getting out of here. It's a shame. We've got a lot of outsiders here. Crime and crack cocaine. It's happened because the community doesn't get involved to fix this stuff."

Then a truck pulled up beside the church and a young man hopped out of the driver's side. "Hey!" the woman yelled to him. "You working in the church?" He quickly looked up, startled at the attention. "Yeah," he responded. "This guy wants to talk with you," she said, pointing at me. I, too, was startled by this woman who so quickly took the initiative. She was very near to thrusting me across the street, I feared, so I thanked her for her time. "We're going inside to watch 'Days of our Lives' in a few minutes," she explained as she quickly retreated. "It's Friday. We have to watch Friday so I can look forward to Monday."

The young man with the truck introduced himself as a college student and a member of the Saint Maximilian Kolbe parish, which covers

Homestead, West Homestead, and Munhall. He was helping out with renovations at Saint Mary's, which, I would soon learn, had a significant story to tell, one that reflected the fortunes and tenacity of the town it served.

We walked in through a side door, and as we entered the long, narrow sanctuary, the student explained that the church was scheduled to reopen in a few months, after all the work was done. High above I could see exposed timbers supporting the roof. The walls were white stucco, which helped to brighten an otherwise dark space. Evidence of a church's transformation was everywhere. All of the dark wooden pews had been removed and were crowded together near the altar. Piled and spread everywhere were floor tiles that had been pried loose, making walking noisy and unsettling.

"They've just put in a cry room, a bride's room, and two bathrooms," my guide said. We walked to the front entryway, and he showed me a three-foot-tall painting of the church as it looked when it opened, in 1896. In a world of blue skies and green trees, women wore flowing dresses; some carried parasols. Men wore suits and derbies. In the dim light, I looked closer at the church in the painting. It was similar to the one we were in, but different in some ways—most notably, the huge twin spires that reached so confidently, so optimistically toward the heavens in the church of 1896, were now gone, capped at about two-thirds of their original height. With its spires gone, the church that stands today is still elegant, but it lacks the confidence and swagger of its predecessor.

"What happened?" I asked.

"Fire," the student responded.

Of course. Homestead was built on the fires that burned in the steel-making furnaces down by the river. Over the years, parts of the town flamed up, as if in periodic competition with the mill. Fires raged in the Ward while it was being demolished. Downtown Homestead buildings still burn on a

schedule much too regular for comfort. But Homestead's most spectacular fire occurred on a windy Sunday afternoon on March 13, 1932, right on this corner.

For four hours that day, Saint Mary's was an inferno. Flames lighted the sky as the sun slowly set, and by all reports it was an amazing sight. Pictures published in the *Homestead Daily Messenger* show Tenth Avenue packed with thousands of curious residents standing within several feet of the burning church, even with the steeples above burning furiously. After a while, one steeple teetered a bit, then crashed onto Amity Street, tearing down electrical lines and setting off a mad scramble for safety among both firefighters and onlookers. Burning embers flew everywhere and live wires danced around like angry snakes, throwing off brilliant sparks when they came in contact with water flowing down the street. Newspaper reports say that people as far away as the McKees Rocks section of Pittsburgh reported seeing the blaze, which is impressive, given the region's hilly topography.

Afterward, little remained of the church. Its artwork, paintings, stained glass, altars, and pipe organ were gone. The structure itself had mostly collapsed into ruins in the basement. Its congregation was a determined one, however, and church members went to work raising money for a new building, despite the hard times brought on by the Great Depression. It was a campaign of nickels and dimes, of card parties, lawn fetes, and individual contributions. The new church was dedicated May 21, 1936, "paid in full upon completion," according to published church history. Though it lacked the original's steeples, the new Saint Mary's was as impressive a church to be found in western Pennsylvania. It stood like a bookend, a firm presence holding everything upright, calling children home for dinner at six o'clock every evening with the sounding of the Angelus, a place that 1,175

families proudly described as *my church* in 1968, when five Masses were held each Sunday. From its location a few blocks up the hill, the church witnessed the last handful of workers exiting the Homestead Work's Amity Street gate in July 1986, ending more than a century of steel making. The church had survived fires that destroyed two of its buildings (a small wood structure that served as the first Saint Mary's church in the 1880s also burned), the upheaval and aftermath of the 1892 battle for Homestead (funerals for some of the workers killed in that conflict were held at Saint Mary's), and nearly a century of life smack in the middle of industrial America.

By the time I had finished a brief tour of the church interior, a few of the student's fellow workers had arrived and were busy using spades to remove the remaining floor tiles—a process that created a scraping noise loud enough to squash our conversation. I tried to ask about Saint Mary's recent history. "Go see Father Hank," I was advised. "He's down at Saint Michael's. He can tell you all about this place."

In the Monongahela Valley, it's easy to find threads that run deep in the area's fabric. Father Hank Krawczyk, pastor of the Catholic parish that covers the Homestead area, is an example. His was a family of tailors that emigrated from Poland in 1880. His grandfather's brother was a tailor to Andrew Carnegie, a man who knew, from a dollars-and-cents point of view, that religion was a very necessary force in the Mon Valley. Many of the churches organized in Homestead when Carnegie was king remained active for nearly a century.

At one time, the area had seven Catholic parishes, one for each of the major ethnic groups. "That was encouraged by the mill," Father Krawczyk said. Germans, Lithuanians, Hungarians, and Poles all had separate churches. The large Slovak community had two—Saint Anne's and

Saint Michael's. Saint Mary's was Homestead's first Catholic church, and it was basically a place where the Irish worshipped, though other ethnic groups worshipped there before growing large enough to break out on their own. "The mill helped the churches quite a bit," Father Krawczyk said. "For example, Carnegie bought organs for the churches. At the time, it seemed like a philanthropic gesture. But he was doing it to keep these groups at each other's throats. The owners wanted the groups to keep their own languages and customs because they didn't want them to be organized." Carnegie figured that a divided workforce was much easier to control.

Most of those original parishes lasted until the early 1990s when, faced with shrinking congregations, the Catholic Diocese of Pittsburgh developed a plan to reorganize its churches. Part of that plan included closing Saint Mary's, an idea that met with heavy opposition. The bishop backed off and issued a challenge: If in eighteen months Saint Mary's could raise the money needed for renovations and repairs—about $350,000—the church would be saved.

"The effort to raise the funds involved government, politicians, other churches, civic organizations, and businesses," Father Krawczyk said. "We had house tours, golf tournaments, we even had Barney weekends. Those were our most successful events—we made eight thousand dollars on those weekends. It was actually a 'purple dinosaur' weekend, because Barney is copyrighted. We had country-and-western nights at Sandcastle [a nearby water park]. We did just about anything. We had contributions from thirty-eight states."

Because the community pulled together, something many believed would never happen ("No one thought the other ethnic churches would help save an Irish church when they were fighting for their own survival," one Homestead resident told me), Saint Mary's was saved. Other churches were not

as fortunate: Saints Peter and Paul, founded by Lithuanians, and Saint Margaret, a Hungarian church, were both closed in 1992. Such a shaking up of the old religious order meant that patterns of worship would be broken and ethnic groups that had prayed separately for so many decades would kneel together in the remaining churches, like Saint Michael's in Munhall, a church founded by Slovakian immigrants. For a few parishioners, this was too much. "Slovaks were always Slovaks," Father Krawczyk said, "but never so much as when others started coming to their church. Some of them just decided to go somewhere else because they didn't want to mix with these other people." Sadly, some divisions in the community remained—outlasting the mill, even many of Homestead's churches.

As I prepared to leave his office, Father Krawczyk dug into his desk and pulled out a book of glossy pictures from Saint Maximilian Kolbe parish. In it were several portraits, individual parishioners and their families standing in front of a sky-blue backdrop. Below the smiling faces were the names, set in black type—Czajkoski and Cloonan, Waszczak and Welsh, Salaj and Straub—a listing of people whose families decided decades ago, perhaps even a century ago, that struggling for survival and fighting for a future in a strange and distant industrialized country was better than the life they knew at home, people whose parents and grandparents endured the fires in the mill, as well as on the hill. I looked at those faces, many shrouded in white hair and wrinkles—medals won in battle with the years—and they stared back, locked me in their gaze. Through those who remain and those who remember, Homestead speaks of survival and, at times, of hope, though quite often the voice is but a mysterious mumble.

Braddock, Pennsylvania

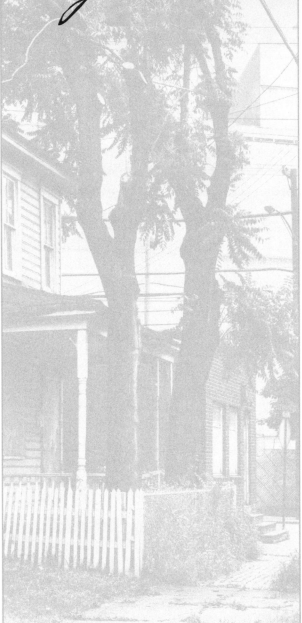

If you've ever been kept awake at night by the cold, dark fear that the best of your life has slipped into the past, and that your future consists only of empty bank accounts and unfulfilled dreams, then you'll appreciate the southern end of Talbot Avenue. On this bleak stretch of road, the feeling of being left behind is so heavy, so palpable, that simply crossing the street is like walking underwater.

Talbot Avenue travels the length of Braddock, a historic steel town that sits along the Monongahela River, two miles south of Homestead. Talbot is an old street in an old town that doesn't have much money, and for nine blocks it presents you with the expected: vacant lots, weathered homes, and a number of dilapidated buildings.

Here and there are signs of life, of hope. On the corner of Fifth and Talbot is a house with new siding, new windows, and a tiny yard decorated with white stones and protected by a chain-link fence. Brightly colored toys adorn the porch of another house a few blocks away. Past Ninth Street, Talbot flirts with prosperity, getting closer and closer to a gigantic steel-making facility named Edgar Thomson Steel Works, or "E.T.," as the locals call it. But before it reaches the mill and its recent $250 million addition, Talbot peters out and

collapses at its intersection with Eleventh Street, and all that prosperity drifts up and over Braddock, like the lazy clouds of white steam the mill puffs into the sky.

It is here, in these final few blocks, that Talbot becomes a vision of abandonment. Few homes remain—forgotten outposts in a lost war. The large, empty spaces between them are filled with overgrown brush and debris—a busted television set, an overturned desk, a mattress, stained and heavy with rainwater. On the right, if you're traveling south, is an empty, skeletal building whose only life is buried in the memories of those who left long ago. Another building across the street leans drunkenly backward. There is loneliness on these few blocks. I have walked them a number of times, always wondering, "Where has everyone gone?"

Like Homestead, Braddock is built on a piece of Monongahela Valley land that is flat near the river and, beyond, steeply sloped. Talbot Avenue, which lies in the flatland, first caught my attention in the mid-1990s. By then, I'd become accustomed to seeing devastated communities. Talbot, however, struck me as the most emaciated street in the Monongahela Valley. The nearby presence of Edgar Thomson, so prosperous and strong (In 1999, E.T. produced 2.8 million tons of steel) seemed a bit cruel. The mill was a Thanksgiving feast set just out of a starving child's reach.

Talbot Avenue cuts through a thin slice of Braddock that is an odd mix of houses, small businesses, heavy industry, and urban decay. Close to the river, on a street called Washington Avenue, you'll find a gas plant, a tire recycling center, and a scrap yard. One block away, on Talbot, there's life at a funeral home, a demolition company, a Polish Club where a handful of loyal, mostly elderly members stop daily to socialize and watch reruns

on television, and a bingo hall that's in use on Thursday and Sunday evenings. Several blocks north on Talbot are a few bars and a small grocery. The houses in this flat part of Braddock are mostly old, two-story frame structures. Many are vacant, with plywood covering their first-floor windows and doors. Every now and again a house will burn; the charred shell will stand for months. A few houses are collapsing without the help of flames or demolition crews. Age and neglect will do the trick. On one such house, the porch roof sags ominously, almost to the ground.

A number of Talbot's residents maintain their houses as best they can. Some have tidy, fenced yards that protect small gardens. During the holidays, some houses are festively decorated with elaborate displays of lights, wreaths, and religious figures. They appear as bright beacons among the blight.

Braddock is a tiny town of big names and big events: George Washington and Daniel Boone passed through on a hot July day in 1755. It wasn't a banner day for either man. They were members of General Edward Braddock's army of British regulars and colonial recruits—Washington was a colonel, Boone a foot soldier—that got soundly whipped by a band of French and Indian fighters in a battle that took place in a clearing about half a mile from the Monongahela River.

More than a century after General Braddock's defeat, Andrew Carnegie dropped in to start a steel empire that made him millions and helped to build America. His Braddock steel mill—named after railroad baron Edgar Thomson, with whom Carnegie was currying favor—became legendary for the innovations it brought to the industry. Later, in 1889, Carnegie donated a huge library to Braddock—the first of hundreds of such gifts Carnegie would make to cities and towns throughout the United States. Built on the town's rising

the area's children. It is one of the Monongahela Valley's most stunning structures. That it is located in an impoverished area makes the library all the more awe inspiring.

A century ago, when the library and the town were young, Braddock was full of confidence and bluster. It boasted one of the country's leading industrial facilities and a prosperous business district, along with enough hard-working citizens to make certain the two remained healthy. The Edgar Thomson Works attracted thousands of poor immigrants willing to trade their sweat and blood for a bit of money and the promise of a brighter future. Polish, Irish, Slovak, and Italian families were among those crammed into homes set too closely together. They filled Braddock with their voices and songs and curses. The smells from their undersized kitchens wafted onto the town's streets and sidewalks. These families built churches, clubs, and bars, and carved the names of their dead onto tombstones that soon became stained with soot from the mill.

By the 1920s, Braddock was Allegheny County's wealthiest borough. Its population peaked at twenty-four thousand, and Braddock Avenue was awash in lights, theaters, and stores that sold everything from furniture to clothes to candy.

Soon, however, change came to Braddock. As the town's residents became more prosperous, they bought cars and moved out of the neighborhoods surrounding the dirty, noisy mill. After World War II, distant shopping centers began draining business away from the avenue, causing many downtown stores to close. The tax base eroded. Then hard times hit the steel industry. In the 1980s, mills in other Monongahela Valley towns shriveled and died. Across the river, U.S. Steel's Duquesne Works closed in 1984. Next, the massive, sprawling works in Homestead went down. Edgar Thomson survived because it was upgraded to become a

slope one block from Braddock Avenue, the library is a mammoth three-story granite-and-steel structure that survived years of neglect and vandalism to eventually reclaim its status as the town's jewel. In the 1990s, more than $3 million in grant money was spent on repairs and renovations to the library's eleven-hundred-seat auditorium and its gymnasium, bell tower, swimming pool, bowling alley, and reading rooms. The library once again became a sort of community center, especially for

more efficient and mechanized plant, but the number of steelworkers employed there dwindled from a peak of five thousand to about nine hundred.

Braddock's population dropped sharply. Between 1980 and 2000, the borough's population dropped from 5,682 to 2,912—a loss of 38.7 percent. Braddock Avenue, the town's main commercial street, which runs parallel to Talbot, had become dark and desolate, despite the presence of a massive hospital, a chain drugstore, and a handful of other businesses. Many of the street's aging, three-story commercial buildings were empty, and signs bearing the names of their most recent occupants were fading. Gateway Shop Religious Supplies, read one. Others present in name only were Sol's Sporting Good, Isaly's Dairy Products, House of Cards, and, simply, Beauty Shop.

For a while, debris from some of these empty buildings flowed onto the sidewalk. Collapsing interiors posed a danger, so the town government tightly boarded the buildings to keep out trespassers. In some cases, the plywood had been adorned with painted murals depicting local history.

Through it all, Edgar Thomson remained, a looming presence that, once the steelworkers left town, grew more and more irrelevant to life in Braddock. The change was most notable on Talbot Avenue, home of the mill's closest neighbors, those who had either been left behind or had chosen to remain. There, E.T. seemed nothing more than an oversized and ironic backdrop for scenes depicting poverty and neglect. Television reporters stood at Ninth and Talbot in winter 1998 and told viewers about the shooting of a Braddock policeman who was wounded at that very spot while struggling with an armed suspect. A few months later, those reporters returned to tell about a woman found beaten nearly to death in one of the abandoned houses just past the Tenth Street intersection. On

both occasions, television cameras panned past the old, collapsing buildings to show E.T. a short distance away, and the neighborhood was described as a place plagued by gunfire and drug activity, a place that epitomized the worst of America.

But there was another side of life on Talbot Avenue. I knocked on some of the street's old doors and was greeted by a variety of people. Some had been around for a while. They knew the street's past—they were, in fact, closely connected to it. Others were new to the street—a few people, it turns out, were moving in. They were hoping

Talbot Avenue held a future for them, for their families.

Some of the faces I saw were white, some were black. A few were Asian. And on occasion I felt the heat of hate, of racism. In that way, Talbot Avenue resembled all of America. Racism flared in a whispered comment about how the area was better before "those people" moved in, just as it had flared a century ago when the Mon Valley's new immigrants were labeled with the epithet "Hunky" and blamed for bringing violence and brutality to the area. No one is exempt. A young African-American resident once pulled me aside to complain about the racism he had experienced in Braddock, then referred to Asian-Americans as "Chinks."

Mostly, though, there was change on Talbot Avenue. Demolition crews continued to make regular visits. I watched on a rainy afternoon as a handful of men near the Eighth Street intersection converted the Oddfellows Hall into a pile of bricks, a razing that took only a few days. The hall was one of the few remnants of the street's storied past, and news of its demise deeply depressed some of the area's older Polish residents. Sixty-eight-year-old Elmer Ptaszynski laid on a bed he'd set up in his kitchen, listened to polka music on a small portable radio, and lamented the loss of another piece of his past. A frail and white-haired man, he seemed utterly defeated, like he would never arise again. Yet he did, later, when aromas from his backyard flower garden wafted into the house and summoned him. As had his father before him, Elmer spent much of his time in that garden, weeding and pruning, vowing to make it a better garden than last year's.

During my visits, I searched for other signs of endurance and hope and found what I was looking for in two people—one the son of Polish immigrants, the other an African-American mother. Through their persistence, spirit, and optimism,

these two residents represented the best of the street and the town. Yet they suffered fates that stunned relatives, friends, and neighbors, and underscored Talbot's status as a place facing an uncertain and perilous future. The street was experiencing extreme loss, extreme change. I wondered if the community could hold itself together. Would it simply succumb to fear, despair, and apathy?

One winter morning, I parked my car on the southern end of Talbot and walked past Ninth Street, then past Tenth and into the street's most desolate area, looking once again for signs of life. A brisk Monongahela Valley wind numbed my face. Seeking relief, I entered a large red brick building, half a block from the mill. There, at the Bethel Baptist Church, 150 hearty souls had gathered to sing, clap, laugh, and pray. Their upbeat worship service sounded like a direct challenge to the emptiness, the bleakness just outside the door. The congregation joined the choir in a rousing version of "Battle Hymn of the Republic," and as everyone sang "He is trampling out the vintage where the grapes of wrath are stored," the floor began to vibrate ever so slightly.

Once the singing stopped, the congregation sat down and, through the wooden pew, the rumbling could still be felt. It continued through the sermon, through the singing of more hymns, even through the closing prayer, when everyone held hands and formed a giant chain. Worshippers seemed not to notice.

It was E.T., still rumbling, as if intent on shaking all the life out of the street.

ii

An elderly man burst into Joseph Szwarc's barber shop at the corner of Seventh and Talbot Streets one summer day and announced, "I got my Social

Security check today, so I can get a haircut." Szwarc, who was getting on in years himself, sat the man down in a barber chair and began clipping away. On this day, Szwarc was quiet and focused. He simply wanted to cut hair, but his customer, a regular named Paul Ofcansky, was reminiscing, so Szwarc was forced to become a shepherd and make certain his friend's flock of stories didn't stray too far from the truth.

As the clippings of gray hair fell about him, Ofcansky began telling of Braddock's past. "Dinner, bakeries, toy trains. Whatever you wanted, you could get in Braddock," he said, bobbing his head slightly as he talked. Szwarc paused, holding his scissors and comb aloft, waiting for Ofcansky to stop moving. He wanted this haircut to be bloodless. Then there was quiet and the cutting resumed. Snip, snip, snip.

"Furniture." Ofcansky began again. "And there were car dealers on the avenue, too. DeSoto, Dodge, Ford dealers. There were three theaters."

"Five of 'em," corrected Szwarc. His tone was stern, keeping a friend in line.

Ofcansky paid no attention. "Oh, Braddock was a beautiful place," he continued, savoring his memories. Then his expression soured. "Today, you can't buy nothing. Everything then was hunky-dory. There were no muggings. You could walk in Braddock at night and no one would bother you. I saw a guy selling dope here the other day. He pulled a bottle of pills out of his pocket and gave some to another guy and then got a ten-dollar bill. I'd never seen anything like that before."

A pause. Snip. Snip. Snip. Ofcansky again dipped into the past.

"There were five car dealers on the street," he said.

"Seven of 'em," reminded Szwarc.

"They sold Packers up on Corey Avenue. There were about nine dealers on the avenue."

"Seven!" Szwarc bellowed.

I first met Joseph "Red" Szwarc in fall 1995. He was sitting in one of two barber chairs in his shop, staring out at Talbot through a large picture window. It was just past noon, and the shop was otherwise empty. "You caught me at a good time," he said. "This morning I was busy."

The shop itself, located in the first floor of a two-story white clapboard building with a weathered barber's pole mounted near the door, was a sort of time capsule. A mahogany back bar with three large mirrors covered one wall. Antique dealers sometimes stopped in to ask if it was for sale. A cardboard sign, brown with age, was propped near Szwarc's brushes and razors. "Benefit Spring Dance," it read. "Sponsored by United Polish Societies for the Benefit of Their Various Welfare Activities." Dozens of black-and-white photographs hung on the tile walls or were stacked on shelves. Szwarc drank from a cup inscribed with the words "Polish Mug."

It was a picturesque place, and over the years it had helped Szwarc gain a certain amount of local and national fame. He dug through a pile of magazines and pulled out a tattered 1991 edition of *National Geographic*. Inside was a story on Pittsburgh, with a large photograph of Szwarc giving a haircut in his shop. He had also been photographed for a newspaper article about patriotism, since two small American flags were attached to one of his chairs.

Szwarc was a thin and wiry man. Most of his strength seemed to be concentrated in his forearms, thick with muscles and protruding veins. Szwarc's hair, once red, had faded and retreated to a few patches on either side of his head. He wore a white smock over a polyester shirt. He told me he was born in 1920 in a southwestern Pennsylvania coal town called Salina. The son of Polish immigrants, Szwarc was three years old when his father moved the family to Braddock and bought a barber shop.

43

"We came to Braddock because it was a booming town," Szwarc said. He remembered Braddock's heyday, when shoppers were attracted by an array of businesses—the Famous Department Store, Ohringer's Furniture, Woolworth's, candy stores, even a peanut shop. "It used to be that you couldn't walk Braddock Avenue on a Saturday," he said. "It was too crowded on the sidewalk, so you had to walk in the street."

Like many of his generation in the Monongahela Valley, Szwarc went to war—he served in an M-10 tank in Europe in World War II. During the Battle of the Bulge, Szwarc's tank was hit by a German shell that killed three of five crew members. Szwarc was so badly burned that he spent the next four years in hospitals. His wife, Anna, would later show me a black-and-white photograph taken at one of those hospitals, showing her heavily bandaged husband surrounded by other soldiers and a nurse. The scars from his wounds would be with him the remainder of his life, but in the image, Szwarc is smiling.

After recovering, Szwarc returned to Braddock to work as a barber, like his father. In 1950, he married Anna Gilarski, and the couple raised four daughters in the shadow of a giant mill. Over the years, Szwarc watched the steel town go boom, then bust. Stores, churches, and schools closed, residents moved out, yet Szwarc remained. He had a business to run, after all. His customers were regulars, guys who drove in from their suburban homes and fondly remembered Braddock's younger days. Eventually the shop became so dense with artifacts and collective memories that it was like a paperweight, keeping its portion of Talbot from being swept away by all the changes blowing through town.

Ofcansky's words and the snip of Szwarc's scissors continued to fill the shop. "My dad came from Europe poor and he died poor," Ofcansky said. "Ain't that a bitch? He died at the age of seventy-four. My father was from Austria. He was a bricklayer. He helped build several buildings here."

A pause.

"He died in 1952 at Braddock Hospital—the same building he helped build. My parents had ten kids. We had it rough. I left in 1940 because there was no food at home. How many times I came home and my mother was crying because there was no food for dinner? My dad was a builder, he worked for himself. A guy named Andy was his partner for a while. But something happened and they split up. He helped build Saint Michael's church. But the Depression hit and my father was fired from finishing the inside."

Ofcansky said his parents emigrated to the United States in the late 1800s. "When they first moved here, they lived in a boardinghouse. They paid fifty cents a week for room and board. Eventually, they bought a home in North Braddock, in 1927. They paid $3,200 for that house. It burned down for good four or five years ago. My dad never did get that house paid for."

After serving in the military, Ofcansky worked for a while at the Nabisco plant in Pittsburgh. "Making crackers," he said. Then he moved to

Detroit to take a job at an auto factory. "I made eighty-five cents an hour at National Biscuit, one-thirty-five an hour in Detroit," he said. He returned to Pittsburgh in 1950 and secured a job at a factory that makes steel doors. He remained there thirty-four years.

"I live in West Mifflin now," he explained. One of thousands who moved out of Braddock. "It seemed like I couldn't make nothing out of my life. The more you try, the worse it gets."

Three-and-a-half years later, in the dim light of the Polish Club, a short, seventy-five-year-old man named Joe Pustelny sat on a bar stool, sipped a glass of whiskey, and tugged on the few strands of white hair that crept down the back of his neck. "I look like a hippie," he said. "Hippie Joe."

It was a typically dreary January day in western Pennsylvania, and I was revisiting Talbot Avenue after a long absence. The place had certainly changed. Several buildings had been demolished. Gone was an old hotel at the intersection of Eleventh and Talbot, a building I remembered because its crumbling facade and busted windows gave it the empty, vacant look of a soldier that had seen too many battles. Now it was gone. Disappeared without a trace.

At the bunkerlike Polish Club on the 800 block of Talbot, Pustelny and a few other regulars watched a "Bonanza" rerun on a small television hanging in the corner of the bar. The town was full of men whose hair was longer than it had been in years, Pustelny said. "Did I tell you about my buddy? The one who cuts my hair?" he asked. His normally jovial voice dropped to almost a whisper. "He's not doing too well."

I left the club and walked to the Seventh Street intersection. Szwarc's barber shop was empty, and a small piece of green paper was taped to the door. Written on it was a note: "Closed until further notice."

At Szwarc's home on Eight Street, a few blocks away, Anna invited me into the living room, where Szwarc was lying on a hospital bed surrounded by handmade signs reading, "Welcome Home Papa," "We Love you, Dad," and "I Love Grandpa." His face was gaunt and pale. He looked at me and nodded but said nothing.

Anna walked over to her husband, gently placed her hand on his head, and gave him a drink of water. "Oh Joseph," she said. "Oh, Joseph."

A few months earlier, Anna told me, Szwarc had been diagnosed with a brain tumor. "Two days before Thanksgiving, he fell, and he couldn't get up," she said. "His right side was paralyzed. It was a shock to us. We didn't know what hit us. He had ten radiation treatments, but they didn't do anything."

Anna sat on a couch near her husband and, for a while, spoke about their courtship half a century ago—going to polka dances, to a New Year's party at the Polish Club, catching a movie on a Sunday afternoon, then stopping at Isaly's for five-cent ice cream cones. The two were married on November 23, 1950, the day before a huge snowstorm hit the Pittsburgh area.

"We were married forty-seven years," she said. "They were good years."

While she talked, her husband drifted to sleep. His breathing was deep, and occasionally he let out a heavy sigh.

"His friends, they can't get over it, how this happened," she said. "I'm hoping I can wake up and find out this is a dream."

Joseph Szwarc died on June 3, 1998. Braddock's newspaper, the *Free Press*, published a story on Szwarc's World War II experiences and called him a "true patriot." A month later, Anna returned to the barber shop and sifted through some of the memories stored there. She was accompanied by two daughters, Andrea and Mimi, whose last name

45

was now O'Donnell. Mimi sat her one-year-old son, Joseph, in one of the barber's chairs. He stared briefly out the window before squirming back into his mother's arms.

Among the stacks of photographs from Braddock's past, Anna found a tattered Western Union telegram that had been sent to Szwarc's parents. It was notice that their son had been wounded in battle. There, too, was the worn issue of *National Geographic* that easily fell open to the page bearing Szwarc's photograph. On the facing page I noticed another picture—one shot from overhead, showing the bright blue Edgar Thomson Works and, in the foreground, a portion of Talbot Avenue. As Anna gently closed the magazine, the two images, a man and a street, came to rest side by side.

iii

It was just a photocopy of a map, and not a very good photocopy at that, but it was enough for Sang Pham. He smiled when he saw it—Pham is a man who smiles easily—and set it down on the counter, between a box of snack cakes and a jar of hard candy. For a second, Pham stood nearly motionless in his family's small grocery at Third and Talbot. He was lost in concentration, or simply lost. The map was all varying shades of gray. The lines signifying borders were blurred. What is water and what is land? His finger wandered over Cambodia, then Laos, then over to the South China Sea before meandering down to the southern reaches of Vietnam, finally coming to a halt at the bottom of the map.

"Ho Chi Minh City," he said. "That's where I'm from. It was Saigon. Now Ho Chi Minh City because of the Communists."

Then, Pham recognized the names of other towns and cities—Bien Hoa, My Tho, Loc Nihn— and they took him back more than two decades. He

adjusted the leather-looking beret that covered most of his black hair. Then, for the next several minutes, he recounted in slightly broken English his days as a soldier in the South Vietnamese army, sleeping in the jungle, getting wounded in 1968 during the Tet offensive, and how he fled the war-ravaged country in 1975 by hopping aboard an overcrowded, leaking boat with little food or water. The boat floated for five days. "I was ready to die and felt lucky I didn't bring family with me," he said. "I see kid die, thrown in the water; man die, thrown in water. I'm glad family not with me."

Finally, the surviving passengers were rescued onto another passing ship, which took them to Hong Kong. There he caught a plane to the United States. Pham eventually landed in Oil City, Pennsylvania, where a Lutheran church had sponsored him, and he stayed for about fifteen years, working in a foundry, saving his money. In the early 1990s, he purchased the grocery in Braddock—he'd seen it in 1976, while visiting a friend—thinking it would generate an income of a few thousand dollars a month. It didn't turn out that way.

"When I first opened, all kinds of trouble," Pham said. "I cry every day. I'm stupid. Why I come here? Why? Why? I was mad at myself." At first, Pham experienced minor theft, a few broken windows. Those problems have diminished over the years, he said. Now, he knows most of his customers, though, he said, he still makes little money.

Suddenly, the door to his grocery squeaked opened and a woman entered and stood by a cooler full of soda and milk. She wore a heavy brown coat, yet still she shivered and hugged herself. "It's coooold," she said, and Pham nodded in agreement. "I had a four-hundred-dollar gas bill last month," the woman said, "so I turned off my heat. Now I can't get warm." Pham said, yes, he knows about high gas bills. He keeps the store thermostat set on fifty degrees.

The woman had short hair and sad, protruding

a man who bought a bottle of soda. Pham's profit? "Ten cents," he said, then shrugged his shoulders.

"I lived in the jungle," he said. "I don't need much money. I never buy new clothes. I buy at Goodwill. I could say I'm happy," he continued. "My children have good jobs, my wife is here. I'm happy. I don't care if I die. It doesn't matter, I'm happy."

い

The world seemed to be falling apart the day Arvella Hamilton died. It was exactly one week before Christmas, a Friday. Congress was on the verge of a historic impeachment vote, and the skies over Baghdad were filled with cruise missiles and bombers. "Day of Reckoning," blared a huge, front-page headline in the next day's edition of the *Pittsburgh Post-Gazette*.

Ten weeks later the impeachment story had played itself out and Baghdad was once again quiet, but the concussive effect of Arvella Hamilton's death continued to reverberate on the street she called her home. Andre Dutrieuille, the fourth of her eleven children, was still stunned. He sat in the dining room of the home she had occupied the last years of her life, shaking his head. "I lost my buddy," he said.

Everyone knew Arvella Hamilton as "Miss Vicky." She was a fixture at the corner of Fifth and Talbot, where on warm days she often sat in front of her handsome gray house and waved at friends rolling past in cars. She once said she waved so much she felt like a politician.

But then cancer took her, quickly. She was diagnosed in October. Shortly after midnight on December 18, death ushered her away. Miss Vicky's oldest daughter, Isabelle Burkley, was with her, as she so often had been. For years the two had worked side by side. In fact, Burkley said they were more like sisters than mother and daughter.

eyes. She looked at once both young and old. She was a neighbor and she had come to ask Pham if she could extend her credit and buy a pack of cigarettes. Pham agreed and recorded the transaction in a small tablet he keeps under the counter.

For a few minutes, the two talked about nearby houses that have been stripped of their aluminum siding and copper plumbing—metals that thieves can sell to nearby scrap yards. Then the woman walked out into the cold.

Through the iron grate that covers the front door window, Pham watched her cross the street. "When people have money, they go to the supermarket," he said. "When they don't, they come to me. I give them credit."

For an hour, Pham talked about his wife, Hoa Quach, whom he married in 1965 and who immigrated to the United States in the early 1990s, about his children who live in the Pittsburgh area, and about life in Braddock. During the conversation, two people entered the store—the second was

As death approached, Burkley held her seventy-two-year-old mother, watched her take her last breath, felt the warmth leave her body.

Miss Vicky had spent an entire lifetime in and around Braddock. She raised a large family in tough times, often by herself, without a man in the house. As the years passed, her children moved out, had children of their own, yet Miss Vicky remained the family's center, its core. Ten of her children lived within a few miles of her home. They always returned to her, on holidays and special occasions. "She was the glue that held us together," Andre said.

One such occasion was her seventy-second birthday party, held on a warm, sunny May afternoon. I had met Miss Vicky a few weeks earlier, and she had invited me to attend. Her house that day was filled with family members—her children and dozens of grandchildren. There were so many that they spilled out onto the porch and sidewalk. Inside, the smell of cooked chicken, turkey, and ham wafted from the kitchen and filled the house. Two of her teenage grandchildren fiddled with a radio—someone had called a local radio station to dedicate a song to Miss Vicky, and they didn't want to miss it.

As the afternoon gave way to evening and the air cooled, Miss Vicky went outside to sit on her front porch steps. Miss Vicky's hair had been styled by one of her daughters so that it parted at the top, and she was dressed colorfully in matching cotton slacks and blouse adorned with a floral pattern. Several times, drivers stopped their cars in front of her house and hollered greetings. "Happy birthday, Miss Vicky." A few hopped out to give her a hug, or to pin money onto her shirt—she was, by then, wearing several fives and twenties.

It was a cheerful scene on a beautiful summer evening, and Miss Vicky was smiling. She seemed to have it all—a loving family, a beautiful home. Miss Vicky's house, in fact, was one of the nicest on the street—it had new siding, a new roof, fresh paint, and its tiny lawn was neatly decorated with plants and white stone.

Her son Andre had purchased the house for her two years earlier. At the time, he had just been hired to work in the blast furnace at Edgar Thomson, which qualified him for loans. Miss Vicky had been living in nearby North Braddock, but wanted to move to a place where she could walk to a store. The house for sale at the corner of Fifth and Talbot was dark and dreary, covered with fake brick, but Miss Vicky liked it. There was a small grocery just down the street, and the drugstore and bakery on Braddock Avenue were only a few blocks away. At first, Andre balked at purchasing the home. Groups of young men often hung out on a street corner near Fifth and Talbot. He feared the location would be unsafe, but Miss Vicky insisted she'd be all right. She wanted the house, so Andre bought it.

Over time, Andre and the family made several improvements to the house. It received new wiring, insulation, and windows. The interior was repainted. Inside and out, it became a warm and inviting place. As we stood on the sidewalk in front of the house in May, watching Miss Vicky visit with

friends, Andre told me, "She's seventy-two. I don't know how much longer I'll have her. I want to make her happy."

Isabelle Burkley remembers playing in the streets of Braddock with a football fashioned from newspapers and rubber bands. She remembers sleeping three or four to a bed, and the smell of oranges on Christmas, when every Dutrieuille child received one article of clothing and one toy, unless the Salvation Army kicked in and gave the kids something extra. One Christmas Eve, she recalled, her older brother Billy wanted all the children to tie their feet together so they would be linked together like a giant chain to prevent anyone from prematurely sneaking to the Christmas tree the next morning.

But for Miss Vicky's eldest daughter, childhood in Braddock ended early. When Raymond Dutrieuille left the family in 1962, Miss Vicky needed help. So Isabelle quit school in her junior year and went to work with her mother, doing housework—ironing clothes, scrubbing floors, cleaning. In fact, Isabelle was at an ironing board when news of President John F. Kennedy's assassination flashed across the television screen in November 1963. It was a tragic and shocking event, but it didn't stop Isabelle's work. "We didn't follow politics," she said. "We had too much else to do. Feeding the family, clothes, paying rent." Isabelle made thirty-five dollars a week. She gave her mother thirty, kept five for herself.

Early on, the Dutrieuilles moved often. For a while, when Raymond was still around, the family lived in Homestead, hard by the town's famous steel-making facility. It was fifteen steps from the front door to the mill wall, Isabelle remembers. That home burned in 1955, and the family moved to the newly opened Talbot Towers, a high-rise public housing complex in Braddock. They lived

there for several years, but as the family grew, the Dutrieuilles moved again and again to different locations in Braddock, always looking for someplace bigger.

Isabelle has fond memories of her childhood in the old steel town. Mothers then looked out for each other's children, and residents felt no need to lock their doors. "There was no prejudice—at least I didn't see any prejudice," she recalled. In fact, Isabelle said, many of her best friends were white.

On summer Sundays, a spacious and wooded area called South Park was the place to be, and people in Braddock waited on street corners for a truck that would take them there. For fifty cents, they could enjoy a day of swimming, picnics, softball games, even a dance. "The dance was the big event," she said. "Dance, dance, dance."

Isabelle showed me pictures of those days. In one, a young, laughing Miss Vicky is lying on a blanket at South Park, kicking up her leg and throwing back her arm. Next to it is a photograph of Miss Vicky with husband Raymond and son Billy, who appears to be about a year old. Written in the margins of that picture are the words, "The happiest days of our lives."

But then Raymond left, and Isabelle went to work with her mother. The two labored beside each other for years. In the late 1960s, they worked in the kitchen of a Braddock elementary school, where Miss Vicky sometimes brought her own pots and pans from home to help fix lunch for the children. Mother and daughter then went into custodial work in the Braddock school system.

Isabelle moved out of the house and had a family of her own, but stayed close to her mother. When Miss Vicky became ill, she moved into her eldest daughter's home in the nearby town of Swissvale. As Miss Vicky's health declined, Isabelle took care of her most basic needs—she bathed her mother, changed her diapers. For a while, Miss

Vicky insisted on walking by herself, so Isabelle would walk behind her, making certain her mother didn't fall. Miss Vicky slept in a hospital bed in Isabelle's living room. Isabelle slept in a chair five feet away.

Early on the morning of December 18, Isabelle awoke to a frightening, gurgling sound. It was her mother's death rattle, she said. Isabelle called her brothers and sisters, and told them to come and say good-bye to Miss Vicky.

That day they came, and cried. As evening approached and death neared, Isabelle held her mother. Dr. Kenneth Burkley, Isabelle's husband, told Miss Vicky everything would be all right, and at 12:01 A.M., Miss Vicky died. Isabelle heard her mother's last breath, then pulled her close. "I tried to get that last little warmth," Isabelle said. "I tried to breathe some of her into me." Then her husband closed Miss Vicky's eyes and Isabelle's oldest son, James, said a prayer.

Both Isabelle and Andre wonder how the family will manage now that Miss Vicky is gone. "I don't know what we're going to do," Isabelle said. "Every-body is telling me I'm going to have to be the one" to hold the family together. "But I don't know. I don't have the strength my mother had. I can't go through what she went through. I can't be the rock she was."

So much had changed since the May birthday party. Summer gave way to autumn, then winter. Miss Vicky was gone. Andre had moved to the Talbot Avenue home with his fiancée and her son.

He planned on staying there until he figured out what to do with the house.

Without Miss Vicky, the holidays brought little joy. "We had a bad, bad Christmas," he said, "the first one in all these years we didn't laugh and sing."

It was the second day of March, and I had stopped by to see Andre, to talk about his mother and how the family would deal with her loss. At one point during our conversation, a wave of grief struck Andre, stopping the flow of words and starting a flow of tears. Wrestling to compose himself, he turned away and looked out a window. Across the street, a yellow backhoe was filling holes where two houses had once stood. Another vacant lot was being created on Talbot Avenue. For a few minutes, we watched in silence. Then Andre said, "They just tore those down. Took them down in an hour. They do it so fast now."

Before heading home, I drove the length of Talbot Avenue, as I had done hundreds of times before, and thought about the Dutrieuille family, how it would survive now that Miss Vicky was gone. What happens when a seismic shift yanks the Earth from under your feet, sends your once stable world careening into an uncertain future? Do you simply become accustomed to living on a fault, with all its fears, and find happiness there, or at least become content? How do you avoid the chasm of bitterness and self-pity, so wide, so inviting, so destructive? For decades, Braddock has been answering those questions, slowly, one life at a time.

Lewiston, Maine

i⁓

The two women walked quickly past a red-brick building on a corner where the homeless would gather later in the day for a free meal. Then they crossed the street and hustled around a large granite church. The younger of the two was a bit more nervous and edgy than her older friend—in fact, her jittery energy seemed to pull them both along. Half a block from their destination, the older woman slowed her pace, then paused to enjoy the coolness the clouds had brought to this August day. The two had a few minutes to spare. The younger woman stopped, too, but felt no joy in doing so. She looked across the parking lot a few yards ahead, past the rusted pickup trucks and the worn-out, mostly American-made cars that their owners hoped would last another fifteen thousand miles or so, God willing. She saw her colleagues huddled in small groups near the entrance of the giant, six-story mill sitting hard by the Andro-scroggin River in Lewiston, Maine. It was a blue jeans and T-shirt crowd, people with hunched shoulders and eyes that drilled holes in the con-crete as they took final draws on their cigarettes and eked the last bit of sweetness from the day's lunch break.

The younger woman sighed and kicked at a few loose stones on the sidewalk. She wanted to be

with the pack, near the door, where a bell would soon sound and the mill would draw its few hundred workers, including these two women who had escaped briefly to get sandwiches at a nearby convenience store, back inside, back to a few more hours of cutting and stitching, a few more hours of making shoes. For her, the mill, the job, had become a vortex, and it was pulling her in.

But why did it entice her? Was it the eight dollars an hour the job paid? Certainly not. "I made more ten years ago than I do now," she said.

Then, before saying anything else, she was gone, her blonde hair bouncing off her shoulders as she crossed the street and headed toward the cavernous mill, because being a part of something is better than being a part of nothing, even if that something pays too little and offers nothing but an uncertain future. For the past two decades, shoe manufacturing jobs had been disappearing in the old industrial town of Lewiston. This fact surely weighed on the minds of those standing outside the giant Continental Mill, which had stood for more than a century, its French Imperial cupola rising eight stories above the street.

The older woman stood on the sidewalk and watched her co-workers. She was a small woman with short dark hair and glasses. Lots of people at the shoe shop were nervous, she explained. Hours had been cut back, and some departments were working only four days a week. She was fifty-nine now and hoped to stay another six years, but she wasn't certain the job would be there that long. "Nobody working there now would consider buying a house or a car," she added. "Hopefully, it'll pick up once summer is over."

For someone whose job may soon disappear, the woman seemed exceptionally calm, and when I pointed this out, she explained that she'd been through this before. Worked ten years at a place called Maine Electronics. "I did everything there in production," she said. "Soldering, etching. The pay

was excellent. I was making nine dollars an hour. Then it closed down. If they were to open again, I'd go back in an instant."

So now she was at the shoe shop, making less—$7.77 an hour—but still working, and hoping the job would be there at least a few more years. If not, she shrugged, she'd find something else. Unlike her younger friend, who had worked in the same shoe shop more than twenty years, this woman had come to grips with the hard reality of America's new economy: it was no longer wise to allow a job to become part of your flesh and bone and soul, to define yourself by what you do eight, nine, or ten hours a day, to assume that what you do has value and meaning beyond a paycheck. For those raised in a country that continually asks its children, "What do you want to be when you grow up?" the rules had suddenly changed.

Some people had made the adjustment. They are the few who pause and breathe easily and enjoy the brief coolness on a cloudy summer day. Others mingle nervously in groups outside the factory door, fearing a future that threatens to rip away more than just their paychecks.

It is the bell that once again summons them all—those who breathe easy, and those with the fear. At 12:30 P.M., they return to their stations at the mill and, for at least another shift, become one.

Lewiston is a city of thirty-six thousand situated among the low, rolling hills of southern Maine, thirty miles north of Portland. For decades it was a city that defined itself by what it made. Lewiston was a textile town, anchored by a series of huge, powerful mills that employed thousands, mills whose careful builders incorporated features like Italianate towers and mansard roofs into their designs so that the structures would be more than simple factories. They still stand as cathedrals to the work that once took place inside, work that

attracted generations of immigrants to the town. Those immigrants lived by the rhythm of factory work and built entire communities within the shadows of the mills that both consumed and sustained them. Nearly all of that work is now gone, the communities scattered.

These days, if you approach Lewiston from the south, driving up a slight grade along Pleasant Street, you'll first pass several blocks of small but well-maintained frame houses on spacious lots. On many, wooden nameplates hang over the doors. "The Simoneaus," reads one. And another, "The Panayeurs." At the crest of a hill, downtown unfolds before you.

Lewiston is a low-flung city that slopes gently down to the Androscroggin River, which separates Lewiston from its sister city, Auburn. From Pleasant Street, which becomes Bartlett Street, you first see a wall of four- and five-story wood-frame tenement buildings in hues of white, gray, pink, and green. They have flat roofs and, on one side, wooden porches where residents hang their laundry. On a rise to the east, soaring above the tenements, are the twin Gothic towers of a light-colored granite church—the towers stand out as sharp and prickly elements in a city where nearly all other buildings are flattops. The bell tower of city hall rises several blocks to the west, above the city's downtown shopping district. A short distance away, near the river, are the textile mills—among them, the Bates Mill, the Hill Mill, the Continental Mill, the Libby Mill, the Androscroggin Mill. Five to seven stories tall and a city block in length, they are buildings of such mass and bulk that they once created their own gravity, locking the entire city in their orbit. That they still have some power to lure is a testament to their strength and endurance as places of labor.

Until Boston capitalist Benjamin Bates visited the city in 1847, Lewiston was largely an agricultural community. Bates took one look at the falls of the Androscroggin River—it drops more than a hundred feet within the city limits, forming three falls—and thought: *power*. There was enough power in that falling water to supply several textile manufacturing operations, he figured. Within a decade workers were digging canals to harness the river's power, and building mills. By the start of the Civil War, Lewiston's mills were cranking out sheets, jeans, shirts, and a variety of other cotton goods. Workers from all over Maine were attracted to Lewiston's mills and the wages they paid. Bates built tenements to house them.

Almost overnight, Lewiston became a company town. The mills were owned and operated by a small group of businessmen—Bates, Thomas Hill, and Lyman Nichols—whose names are etched in the city's history; they wielded a tremendous amount of power over the city. In addition to controlling the city's textile industry, the men also held reign over Lewiston's power company, its banks, politics (several mayors and aldermen and council members were industrial leaders), finances (textile mills were by far the city's largest taxpayers), and religious institutions (the mill's directors donated land and money to Baptist, Congregational, and Universalist churches, but not to the Roman Catholics).

Inside the mills, thousands of workers produced jeans, twills, seersuckers, shoe cloth, towels, horse covers, checkered tablecloths, napkins, even diapers. In the beginning, the work was done mostly by farm girls who would stay employed long enough to accumulate a dowry or pay off family debts. Workdays were long—up to fourteen hours, six days a week—but not overly difficult. Most of the women were operating looms, using skills they had learned at home on the farm. Finger dexterity was a necessity.

The mill's employment base changed in the mid-1870s. French-speaking Canadian immigrants, with reputations as hard workers who wouldn't

complain, were actively recruited by mill agents. They flooded into town when labor conditions were changing. Electric power and new automatic looms speeded up the pace of work and made it more strenuous. Mills became places of heat and deafening noise, places that valued mechanical ability more and finger dexterity less. Cotton dust hung in the air, choking the workers. Still, French-Canadians kept coming. In 1873 they were arriving at the rate of up to 150 a day.

Their presence forever changed Lewiston. French-Canadians congregated in neighborhoods that became bastions of French language and culture. They built churches, stores, homes, and social clubs. If you wanted to operate a business in Lewiston, you had to learn to speak French, or hire someone who did. Today, you can still see and feel and hear that presence in Lewiston. A study conducted in 1983 found that 78 percent of the surnames listed in the city's telephone directory were French.

By the early part of the twentieth century, Lewiston was falling from its place as a prominent textile center. Newer mills were springing up in the South, where labor and power were cheaper. Synthetics like rayon crowded cotton in the market, and Lewiston's mill managers were too set in their ways to adjust to the changing market.

The mills were kept alive, however, because they consumed power—lots of it. Central Maine Power invested in several teetering Lewiston mills in the late 1920s and kept them open, even when they were losing money, because the mills were great electricity customers.

In an effort to make them profitable, the facilities were modernized—the old Androscroggin Mill, for example, was outfitted with rayon looms and became one of the world's largest producers of that yarn, capable of turning out four miles of rayon each hour. Revamping the mills helped them to survive the Depression. When the country entered the Second World War, Lewiston's mills were called upon to produce parachute cloth, camouflage cloth, army duck and herringbone twills, water-repellent oxford for sleeping bags, and sheets and bedspreads for service hospitals. The big problem during the war years was finding enough workers to operate the machinery.

When peace returned, Lewiston continued to bustle. The mills were active even at night—lights in their rows of high windows could be seen from hills around the town. After finishing their shifts, workers covered with lint used air hoses to blow their clothes clean, then filed out of the mill buildings. In 1950, the Bates Manufacturing Company, which operated three mills in the city, celebrated its hundredth anniversary. The company supplied its seven thousand employees with competitive wages (the average take-home pay in 1948 was $48.87 a week) and benefits, a company magazine, and a Boy Scout troop.

But Lewiston's mill buildings were old and in need of maintenance, and the companies operating them were poorly managed. In 1957, for example, the Bates company lost $1 million; by 1968, losses of $4.9 million were reported.

Most of the mills had ceased producing textiles by the 1970s. An expanding shoe-making industry moved in, filling some of the vacant mill space and providing hundreds of jobs. Wages in these shops, however, were low. Most turned out cheap products, and they moved their operations overseas when it became convenient to do so.

Lewiston lost more than 3,000 manufacturing jobs in the 1980s (the number of positions fell from 7,356 in 1979 to 4,087 in 1991, according to the Maine Department of Labor). By 1991, the city's unemployment rate climbed to 9.3 percent— well above the national rate of 6.7 percent. A year later, the Bates Mill, Lewiston's most famous industrial building, was taken over by the city; the

company had failed to pay $800,000 in personal and real estate taxes.

Not all the jobs were leaving, however. As shoe shops and textile producers pulled out, service industries pulled in. In the 1990s, the city that once stitched and weaved became a city of telemarketers, health care workers, and social service agencies. Sons and daughters of factory workers toiled in phone banks, group homes, mental health agencies, boarding homes, hospitals, and nursing homes. The state labor department reported that between 1979 and 1999, Lewiston lost 4,482 manufacturing jobs and gained 4,283 service-sector jobs. Retail and banking jobs increased, too. Lewiston's unemployment fell to a record low of 2 percent in December 2000.

That would have been great news if not for a few sobering facts. Studies showed that many Lewiston residents were toiling harder than ever—putting in more hours, working at more jobs—while their standard of living remained stagnant. Incomes in Lewiston lagged behind the national average. In Maine, a state of low incomes (it ranked thirty-seventh among the states in per capita income in 2000), Lewiston was below the state average. And according to a study by the Maine Center for Economic Policy, wages in Maine for those at the bottom of the income scale were actually falling in real terms. The study also found that Maine exceeded the national average in residents holding jobs that were temporary, part-time, seasonal or that provided inadequate pay and few (if any) benefits. That was certainly the case in Lewiston, where hundreds of telemarketing and retail jobs lasted only during the holiday shopping season. The annual turnover rate in the telemarketing industry was 200 to 300 percent, *U.S. News & World Report* reported in 2000.

Lewiston entered the twenty-first century struggling to adjust to its new place in the economy. Its

main business corridor, Lisbon Street, had become an odd mix of quirky stores, spiffy law offices and financial institutions, porn shops, pawn shops, and vacant storefronts. On one block was Frank's House of Deals, which displayed garish paintings of Elvis and of unicorns, as well as luggage, clocks, and winter hats—all sold at discounted prices. A few blocks away, in the window of a bridal store, a wedding party of mannequins with mussed hair modeled a collection of formal dresses and tuxedoes. Scotch tape held the groom's broken fingers in place; a bridesmaid was shoeless. Places like these gave the street a certain character. The most well-maintained buildings on Lisbon were occupied by attorneys and financial institutions like Androscroggin Savings Bank and People's Heritage Bank. They had new glass in their windows and fresh paint on their wood trim, and they existed side-by-side with empty, boarded-up storefronts.

The Bates Mill, a short walk from Lisbon, had been cleaned up and renovated, and was now home to a number of small commercial enterprises—among them, a computer software firm, an Italian restaurant, a flooring company—but the conversion from factory to retail center had come at a high price. Between 1993 and 1998, nearly $9 million in grants and government money had been spent to upgrade the mammoth mill. Still, it was far from complete. Other mills weren't faring so well: the Continental Mill's elegant cupola was removed in 1999; the Libby Mill had become a hazard and was being demolished.

The structures of Lewiston's Franco-American district were quickly disappearing. Near an aging and abandoned railroad station that was once the final stop for thousands of immigrants, old buildings were being demolished to make way for new development. Around the corner from the station, Saint Mary's Roman Catholic Church, once a monument to the strength and faith of the Franco-American community in this part of town, was closed and crumbling. Tenement buildings were coming down.

City leaders touted new opportunities and new development. Millions of dollars in public and private funds were pouring in to Lewiston. There were to be new parking lots, parks, and plazas. A hospital was expanding, as was a retirement home and the local newspaper.

Caught in the middle were Lewiston's residents. The oldest of these watched their city change and cherished memories of its past. The youngest and brightest adjusted—they were versatile enough to take advantage of the new economy. Others remained in the city's aging tenements, clinging to an old way of life while being forced into a new one. They worked harder and longer and yet, unable to afford repair bills, drove rusting cars that rattled and belched smoke.

Change comes at a price—in the Bates Mill, it was $9 million and counting. On the streets and in

the homes outside the mill, the cost would be paid in deferred or demolished dreams, in anxiety over uncertain futures, in despair over a lost community, a lost sense of self, of one's place in the world. To offset the cost, Lewiston had an abundance of work that paid too little, demanded too much, and disappeared too often. I cruised through town in a car with its own worrisome rattles, spewing its own noxious fumes, and wondered: was work in itself enough? Or was Lewiston being stuck with deficits it could never hope to retire?

ii

Pleasant Street flows into downtown and becomes Bartlett Street, and suddenly you are in a tenement neighborhood, a place of small, timeless movements. I watched a family of three walk down the street—a young child in the middle, holding her parents' hands, the parents lifting the child over puddles formed by a recent rain. It is a neighborhood of corner grocery stores: Vicki's Variety, Albert's Variety, Poirier's Market, places with Pepsi logos on their signs and windows covered with cardboard ads promoting phone cards, Hershey's ice cream, Marlboro cigarettes, and Budweiser beer. I entered Vicki's Variety to buy a newspaper. A middle-aged woman with blonde hair stood behind a small deli near the front of the store, making a sandwich. "How's your mother doing?" she asked her customer, a man in his mid-thirties. "Haven't seen her in a while. Not giving up on us, is she?" Nearby, a young female cashier and a friend were doubled over in laughter after hearing a joke about false teeth.

Moving among the tenement buildings, I occasionally caught a glimpse of the spire-topped, twin Gothic towers that, from a distance, seemed to dominate this part of town. Those towers hovered above the neighborhood as if watching over and protecting a brood. I pulled to a stop at the corner

of Bartlett and Ash Streets, and Lewiston's Franco-American mother church emerged in all its glory—a great gray-granite structure of such stunning presence, grandeur, and weight that it makes the surrounding neighborhood appear plain, frail, and ephemeral.

I had seen buildings of such glory in other industrial cities. All were as much about statement as structure. Some were created by wildly successful individuals bloated by their own sense of importance and feeling their vision worthy of an ageless monument. Others were made by people weary of being pushed around and taken lightly, and so they constructed a building that became a declaration of presence and maturity that could not be ignored.

Either way, grand buildings always harbor stories that, in some way, echo a town's past. For that reason, I was happy to be starting my exploration of Lewiston at the large and very serious edifice that rose before me. I was certain it would tell me something about the city.

A sign out front revealed the name—Saints Peter and Paul Catholic Church. From news clippings and interviews, I later learned that the church was built by the French-speaking Canadians who had flocked to the city more than one hundred years ago. So many immigrants arrived that, in 1870, the bishop in Portland invited two Canadian priests to minister to them. The original Saints Peter and Paul church was constructed shortly thereafter. It was eventually replaced by the one that stands today, the second-largest church in New England.

Saints Peter and Paul's towers rise to 168 feet and its basilica is 316 feet long, but it took decades for the church to reach its present size. Construction began shortly after the turn of the century, then quickly ground to a halt with only the basement in place. For more than three decades, parishioners worshipped there.

Thirty years is a long time to be confined to the cellar. It makes you wonder: why did construction stop and then stay idle for so long? Construction was hampered, I learned, because Saints Peter and Paul splintered off in 1902, 1907, and 1923 into other Franco-American parishes. But others said there was a more sinister reason—that the Irish bishop in Portland was reluctant to be upstaged by the French-speaking immigrants and their plans for a church the size of a cathedral.

Whatever the obstacles, they were overcome by 1934, when construction resumed. Four years later, the building was consecrated. The Franco-Americans who had built lives and businesses and communities in Lewiston finally had their grand, Gothic church. It became a central part of life in the community. In its heyday, from 1940 to 1960, its priory was home to as many as thirty-five priests; each Sunday morning, fifteen hundred boys and girls attended children's Mass. Tickets were sold to the Christmas Mass, which was so crowded that seats were set up in the aisles. By the early 1990s, however, the church was crumbling, and the parish had shrunk from sixteen thousand people to less than four thousand. The parish council looked into the feasibility of razing the structure, but ultimately the council decided on a $2 million restoration.

I found evidence of the parish's Franco-American history on a sign in front of the church. "Welcome," it read, then "Bienvenu." Further evidence was found behind the church, at a red-brick rectory. Near the door was a buzzer with a sign written in both French and English: Sonnez et Entrez, Ring and Walk In.

Inside, a white-haired, spectacled man sat in a spartan office with lime green countertops and a tile floor. The room had an atmosphere of silence that overwhelmed the soft music coming from a small portable radio.

The man looked up from a thick paperback novel he was reading, *Family Blessing*.

57

"What's it about?" I asked.

"They're trying to make love now," he replied. Then he gave an embarrassed smile and shrugged. "I don't know. My daughter gave it to me. I don't have much to do here."

The man introduced himself as Robert Hamel. He was seventy-two, and he spent two days each week answering the phone in the rectory office. It was a job that left him plenty of free time. He seemed genuinely grateful to have some company.

During our thirty-minute talk, the phone rang once. Hamel answered it on the first ring, and after a brief conversation in French, said, "Okay, bye-bye," and hung up. "That was my wife," he confessed. "My big job for the day. Talk to her on the phone."

The Hamel family's experience mirrored that of thousands of others in Lewiston—his parents were Canadian immigrants who came to work in the mills, and who helped build the city's strong, French-speaking community. Robert explained that his father, Joseph Hamel, immigrated to the United States from Quebec. Robert's mother, Regina, born in New Brunswick, was Joseph Hamel's second wife—his first had died in childbirth, leaving him to deal with seven children. Joseph met Regina Collette in a Sanford, Maine, textile mill, where they both worked. They married and had an eighth child, Robert. Nine months later, in 1925, the family moved to Lewiston.

Joseph Hamel went to work in the Androscroggin Mill. Decades later, Robert can still recall the din of the mill, the constant *click-clack, click-clack* of the machinery. "When I was young, going to grammar school, I used to take my father his lunch, which was always in a black pail," Robert recalled. "He worked in the weaving room. He was a loom fixer. I remember that it was loud. You couldn't talk. You had to get right next to a person and talk into their ear. That's how loud it was. And it was hot. Steam made it hot. You could see steam

rising up to the ceiling. At first, I was kind of scared, but I got used to it. For him, it really wasn't that bad. His work station was right against the wall, by a window."

"Did you ever work at the mill?" I asked.

"After I'd been in there, I said, 'I'm not going to work in the mill when I grow up,'" Robert told me. "But I did, part-time, while I was in high school. It was in the summer, during the war. I'd go in at two in the afternoon and work four hours. They'd hire anybody because they were short of help. I was fortunate because I worked in the cloth room, where they sewed blankets after they were cut. It was cleaner than the spinning room and weaving room, and it wasn't as noisy."

Of the eight siblings in the Hamel family, Robert alone avoided making a career of mill work. "I was fortunate enough to go to high school," he said. After graduation in 1943, he landed a job at a clothing store in Lewiston, where he would work as a bookkeeper for twenty-five years. In 1945, Robert married his high school sweetheart, Cecile Comeau. Shortly after the wedding, he received some bad news—his father had suffered a heart attack at work.

"He didn't have a chance," Robert said. "The doctor told my mother that when my father hit the floor he was dead. He was sixty-six at the time. That was in 1947. My mother passed away three years later; she was sixty-three. I was in my early twenties, and they were both dead."

The Franco-American community Robert remembers from his childhood was as tightly knit as the products made in the city's mills. He recalls neighbors helping each other with projects such as building a shed or garage. English was rarely heard in the neighborhood, he said. "My father spoke a few words of English, but not enough to keep up a conversation. I went to Catholic school and learned some English, but not enough to speak really well. That changed after the war.

"While working, we always talked French to each other. There was a lot of French then. Now, it's altogether different. It's been fifty years; life has changed. My wife and I always spoke French. Our kids don't. They understand it. They don't speak it."

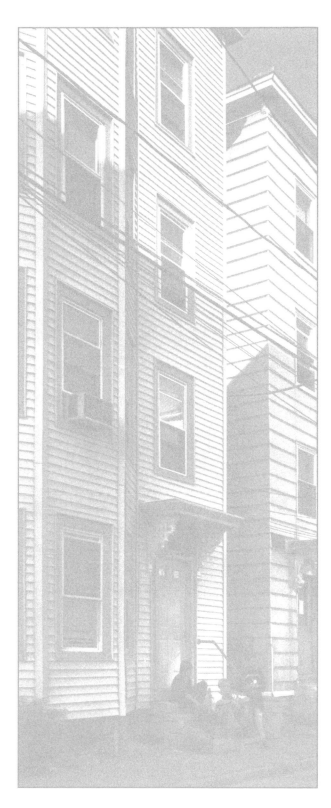

There is one neighborhood in Lewiston where you can still hear a few words of French, and that is in Little Canada. During my first day in Lewiston, several people mentioned that the area had once been teeming with immigrant life.

Little Canada is a place of narrow streets and homely, white-sided tenements, four stories tall and so close to the sidewalk that, walking by, you can't help but catch a glimpse of life inside. Through an open window, you'll see a man with his shirttail out, standing and talking on the phone, or a young girl sitting at a table drawing with crayons. In pleasant weather, there is the sizzle of chicken frying in a kitchen—you can hear it from the sidewalk, even smell it. On a warm summer evening, there is a twelve-year-old boy running along the street, hollering to a friend, "Cory, Cory, wait up," his voice rippling into every apartment. There are two men struggling to squeeze a new mattress through the open first floor window of a tenement while a third man stands in the bed of a pickup truck and laughs at their efforts. There is a mother in an upper-floor apartment screaming at a child who had damaged a borrowed book—"Look. You tore out the page. Now I'll have t' pay fr'it. Now go t' bed"—her anger and frustration cascading down onto the street.

The sights and sounds in Little Canada stand in stark contrast to those just a few miles away, along Pleasant Street, in the neighborhoods of single-family homes, driveways, and spacious yards. One sound you won't hear in Little Canada is the

coughing of gas-powered lawn mowers. In this neighborhood, there is very little room for grass. There are no backyards with fences and trees and shrubs, nothing to shield neighbor from neighbor. Little Canada's residents live with their own self-produced symphony of discussions, arguments, whispers, fights, curses, and laughter.

You can drive to Little Canada, but it's easier to find the neighborhood the way generations of immigrants found it—on foot. I parked on Oxford Street, directly in front of the Continental Mill, then walked south, crossing a busy road called Chestnut Street. Oxford resumes on the other side, though it becomes narrow and crowded. Voices laced with French accents drifted through open windows. One voice stood out; it did not carry an accent, but was saddled with weariness. I followed that voice to a small first floor apartment and found Wilfred Moreau, a twenty-nine-year-old man whose life, like his job, had taken on a stop-and-go quality. On this evening, he was definitely in a stop mode—eyes half closed, his brown hair helter-skelter, a picture of exhaustion. With a wrinkled Reebok T-shirt covering his wiry frame, he looked as if he had just crawled out of bed, though in reality he recently arrived home from his job flagging down traffic at road construction sites. Across from him sat his mother, Estelle Knight, a stout fifty-six-year-old woman with graying hair pulled into a tight ponytail. She was trying to occupy Wilfred's restless four-year-old son, Derek. Wilfred and Estelle were at a small kitchen table, smoking Marlboro and Camel cigarettes and drinking Mountain Dew from plastic cups. Wilfred reached into his pocket and pulled out an envelope. "This is better than unemployment," he said. "A paycheck. We get paid on Thursdays. You know what? They only took out fifty dollars for child support."

"That's good," Estelle said.

"I got forty-six-and-a-half hours in last week,"

Wilfred said. "I work from six in the morning to about five at night. That's good hours. I'm used to hearing of flaggers not getting their hours in. I'm getting all my hours in, so I must be doing something really good. Flaggers usually get only five dollars an hour. They're giving me five-fifty because they feel I'm worth it."

"Is that pretty good?" I asked.

"It sure is," Estelle replied enthusiastically. "It's pretty good for that."

"I'd rather get up to the seven-, eight-dollar range, though," Wilfred added.

"You will before you know it. You're moving fast as it is." Estelle seemed to always be encouraging him.

"The highest flagger right now is six bucks an hour," Wilfred said. "That's the *lead* flagger."

I asked: "Will you be able to make seven or eight dollars an hour flagging?"

"I'll have to do something else. I know they won't pay that much for a flagger. They should, because it's a real big risk on the highway. You never know, a guy could be drinking, swerve off the road and kill you, you know. So it is actually dangerous. People say it's a real easy job, but it's not. It ain't an easy job."

For a few moments, Wilfred stared at his check. "A hundred-and-ninety-seven dollars for a forty-seven-hour week. Two seventy-three before deductions."

His son, still restless, tried to climb through the open window. "No, no, no, Derek." Then, "In the next year I'd like to hit six or seven bucks an hour. . . . Don't please, Derek. . . . Five-fifty an hour is a bad place to start. I call it degrading myself. I went from a job that paid six-fifty an hour to the one I have now at five-fifty. So I only degraded myself a dollar. If you're making between seven and nine dollars an hour, you're doing really good in Lewiston."

Then, a pause.

"I have a lot of luck, seeing people, talking to them. I can get a job like that," and he snapped his fingers. "I've done construction and hard labor. I've done shoe shop labor most of my life."

"Would you ever go back to that?"

"I wouldn't want to. A lot of people talk in a shoe shop, rumors go around. People get into fights, or people don't get along. I'm glad I'm out of it, doing something different. Now, I just have to deal with traffic, slowing them down."

A stocky, elderly man with a bulbous nose and white hair appeared in the open window beside Wilfred. He stood on the sidewalk, staring in. He said nothing, but handed Wilfred a notepad on which he'd scribbled in large block letters, "Want banana."

Wilfred looked at the note, turned to Estelle and said, "Wants to know if he can get a banana."

"I'll take care of it," Estelle said. She got up from the table, retrieved a banana from the nearby kitchen, and handed it to the man, who then walked away. "That's my husband," Estelle explained. "He lost his voice to throat cancer."

Then her attention turned to Derek, "No no, get off the table. Come here. Sit over here on the chair. Be good. You'll fall over and have a boo-boo. You have to sit here."

Wilfred said, "There are a lot of older people here. At one time, this was all French-Canadian."

"Oh, but French hasn't been spoken around here for a long time," Estelle said.

"You hear a lot of older people talking it," Wilfred added.

"We know French but we hardly speak it," Estelle said. "As a matter of fact, some of the people who once spoke it and now stopped, they're losing it."

"When I was in school, they taught French."

"It's broken French that's spoken today. A word of French and a word of English."

"I do that myself sometimes. Half and half."

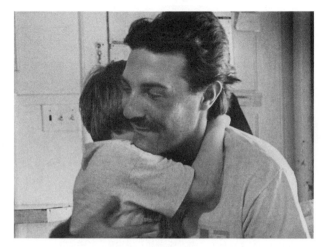

"Nobody's writing it," Estelle said. "We've lost track of how to spell it. My ex-husband does. He can write French. But there's very little of that. All the writing is English. My family came from Canada—Green River. When I first moved here I was five years old. That was in the mid-forties. Then, it wasn't wild here like it is now. Some of the streets are getting violent, people acting up. A lot of people are stabbing one another, shooting each other. Drugs. Drugs then were what was prescribed by a doctor, not the other stuff."

A young woman with long, dark hair walked into the room, sat down at the table, and joined in the conversation. She was in her mid-twenties. Wilfred introduced her as Brenda Bowie, his girlfriend.

"This is a quiet section of town," Brenda said.

Estelle agreed. "Nine o'clock at night, you can hear a pin drop."

"When we lived on Pierce Street," she continued, "there was this one guy . . . he was partying with some friends, and this guy takes a gun and starts shooting holes in the wall. That was in broad daylight, 3:30 in the afternoon. I was in the same apartment. He was on the second floor and I was on the third. It made the headlines. Another time, several guys were fighting. One guy had a baseball bat and another one had a gun. One guy almost got shot."

"He ran his mouth off," Brenda explained.

"Yes, he ran his mouth, but he don't need to be shot," Estelle said.

"They didn't kill the guy, but they beat him up pretty bad," Wilfred said.

"He called the guy a nigger," Brenda added.

Estelle's husband again appeared in the window. Written in his notebook were the words, "Coffee Paper." Estelle looked at it, said, "OK, I'll take care of it." She turned to Brenda. "You have today's paper?"

"When I first moved here, people were breaking into stores," Wilfred said. "The Laundromat was burglarized. There were a lot of robberies. There were fires. People were getting drunk and fighting all the time. It was uncalled for. I was sixteen then. Now, I'm twenty-nine. It's like one big family down here now. Everybody looks out for one another. We have to. There are a lot of older people. Lincoln Street is still pretty wild—upper Lincoln Street. Three buildings burned there this year. Three buildings in one fire."

The conversation soon returned to a discussion about work. Estelle told me she's a veteran of the mills. "I started at the Libby Mill, then went to the Hill Mill, then the Lincoln Mill, the Bates Mill," she said.

"My sister works there in one of the mills," Wilfred added. Then he reconsidered. "No, wait. They closed down. She was at Supreme Slipper and they closed down. I can usually find a job," he continued. "And if I can't I can collect unemployment and that helps out. I'll get a security guard job when flagging slows down." He paused and watched his son. "I'm actually proud of myself. I finally found something. People think it's a boring job, but it's not. You see a lot of people. I always wave when I slow them down, and say 'Thank you.' I'm proud of working. If I wasn't working, I'd go nuts, I really would. I've actually gotten depressed by not having a job. Figuring out how I'm going to

pay the bills, how I'm going to put food on the table, how I'm going to pay rent. Lights. Gas. There's a lot of people who cry poverty around here and they shouldn't. Guys that want to work, it makes us feel bad. Why cry poverty when you can just deal with life? You know, reality."

A few days later I returned for a brief visit. Wilfred wasn't in, but Estelle told me he'd gotten some good news. "He might have a security job for the winter," she said. "With the same company. He was excited about that. And last week he was excited because he got a fifty-cent raise. He was off and on working for a long time. He tries so hard to work, and so many times it turned out he couldn't work full-time.

"The other day he was wearing his hard hat, and he said, 'I feel so special with this hat on.' He laughed so hard. He sang that song, 'I'm so special, so special, everybody's special. . . .' And he's so cute when he does that."

is

While shooting pictures on Lincoln Street, a few blocks from Little Canada, I was approached by a compact, middle-aged woman drinking iced tea from a glass. She pointed out a narrow, four-story tenement building across the street. Towering over it was a two-hundred-foot, red-brick smokestack that was part of the Bates Mill complex.

"I used to live there, on the top floor of that building," she told me. "We were always afraid that the chimney would come down on us. We would look up at it, and the clouds would go by and it would look like the chimney was moving, like it was going to come crashing down."

It was spooky, she said, but just an illusion. In reality, the chimney remained while other elements of the street tumbled—victims of hard times, of progress, of simple change.

Most of the French-Canadian immigrants arriving from Canada came by rail. They took their first steps in Lewiston on Lincoln Street, at the Grand Trunk railroad station, a small, one-story brick building with a high-peaked roof. It still stands, abandoned and neglected, its windows covered with plywood blackened with age. Once off the train, many of those immigrants would never wander far. They wouldn't have to. Work and faith and family would frame their lives. The structures of all—the mills, a church, the tenements—could be found within a few blocks.

Down the street and around the corner from the railroad station sat Saint Mary's Roman Catholic Church, a granite structure of Gothic design with a graceful, soaring spire. It is a smaller and less elaborate building than Saints Peter and Paul several blocks away. Built to accommodate the area's burgeoning Franco-American community, Saint Mary's would take more than two decades to complete. Construction began in 1907; by the end of that year more than 840 people packed into its roofed basement, equipped with a two-thousand-dollar organ. Lincoln Street had, by then, become a vital part of the city's immigrant life. It would remain so for decades.

Across the street from Saint Mary's was the Continental Mill. Two blocks northeast were the Bates and Hill Mills. Down by the river sat the Libby Mill. Between and around these mills—and lining Lincoln Street—were the tenements the immigrants called home.

By 2001, Lincoln Street had lost its people, its vitality, and its importance. Tenements were being razed. Lincoln was a street of parking lots, vacant lots, and a few small businesses—a one-story auto parts store, for example, an auto service center, places that sold used furniture and used hardware, a hair salon.

A few blocks away, Saint Mary's sat silent and empty. The Roman Catholic Diocese of Portland had closed the church and turned over ownership to a group of citizens hoping to convert the building into a Franco-American museum and heritage center. Mortar on the church's walls was crumbling—an estimated $500,000 was needed for repairs. Heating the building to fifty-eight degrees in winter was costing fifteen hundred dollars every two weeks.

When I first visited the street in the summer of 1996, a small diner called Rita's was located in the first floor of one of the street's four-story tenements. Inside Rita's, I sat at the counter and ordered a one-dollar hot dog from a man who wore a baseball cap imprinted with the name "Bob." Rita's was part store and part diner, supplying lunch as well as groceries, snacks, beer, greeting cards, flashlights, and duck-hunting caps that read, "If it flies, it dies." A small television in one corner was tuned to "The Bold and the Beautiful."

The man with the hat introduced himself as Bob Davis. He was a heavyset man, fifty-five years old, and he owned Rita's. He sat on a stool, sipped bottled water, and occasionally walked over to the cash register to ring up a sale. His customers were mostly men clad in blue jeans and T-shirts. They arrived in pickup trucks or older, American-made cars, on their way from one job site to another, and paid for their cigarettes and sodas with wadded-up one-dollar bills and a few coins pulled from their pockets.

"This place started out as just a restaurant," Bob told me. "But I had to supply the needs of the street just to survive."

And survival in this city, he said, wasn't easy.

"Lewiston is going downhill—fast," Bob said. "We've lost two shoe shops here recently. One went down to the Dominican Republic, where they pay fifty-five cents an hour. The other went to New Hampshire. That's hurt me a lot, hurt my business. Not long ago, there was a steam plant across the

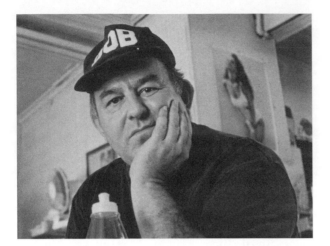

street. They had twenty-two guys working there. I did a couple hundred dollars worth of business with them every day, selling cigarettes, beer, and food. Then Central Maine Power bought out their contract and closed them down. Those guys over there didn't know about it until forty-five minutes before they left."

Bob stared out the window at Lincoln Street

"This used to be a really good street. Now, it's a lot of alcoholics and so forth. Sometimes people will steal. I've got to go to court on the twenty-second of this month. A guy tried to run out of here with a thirty-pack of beer a while ago. I knew who he was. It was pretty stupid of him. I just looked out the window and saw where he was going, saw the building he went into, and sent the cops there. I got it all back, except for two beers were gone."

Davis recalled that his father, Bertrand Davis, had earned thirty-five dollars a week tending cows on a farm near Auburn. His mother, Rita, tired of the farm life and moved to town when Davis was eleven. He had two brothers and a sister. The kids moved with Rita. Dad would visit on weekends and bring groceries. At age twenty-one, Davis was drafted and sent to the war in Vietnam, where he was a cook, then a guard on a ration truck. While there, Davis's mother died of lung cancer. "She smoked Philip Morris ever since I knew her," he said. "She was only fifty-three. I was disappointed in my family. They didn't let me know she was sick until right before she died. She died when I got to California. All I could do was make it back for the funeral." Ten years later, Bertrand Davis died of prostate cancer.

I asked Davis if he had any connection to the town's industrial past.

"Back in the sixties I worked in the mills," he said. "Ninety hours a week. There were factories all over here. You never had a problem finding a job and keeping a job. Mostly I worked in the Bates Mill. Wages were above minimum—it was unionized—so I made around, clear, $250 a week, with overtime. I was there about three years, then I was drafted. I stayed in the army and retired in '88. Then I got a job at Wendy's for a couple of years as a manager. I wanted my own business, but I didn't have the experience. After a couple of years at Wendy's, a friend of mine bought this place. He called me and said he wanted me to run it, so I did. Back in '92 I bought him out for $24,000 and kept the original name. For a while, business was going pretty good, until everything around here started closing. As a matter of fact, when I first started, we had four employees. Now we're down to me and one girl who works part-time. I work ninety hours a week now. It's come full circle. When I was eighteen years old I worked ninety hours a week. And now I work ninety hours a week, just to make ends meet. There isn't no American dream right now. It's like Ross Perot says: You've got to work two or three jobs if you've got a family, just to make ends meet."

Ross Perot, the Texas billionaire, had recently been in the news. His attempt to establish a populist political movement had appealed to many blue-collar folks who felt trampled. They liked the way he cut through all the fat to identify a problem, even if his solutions were vague.

Sometime during our conversation, a slightly rumpled, white-haired man wearing shorts and dark socks had entered Rita's. He had eased himself into a seat.

Bob asked the man:

"Any word on whether Bob Dole can make it?"

"The odds are very slim," the man replied.

"Are you talking about Bob Dole the former senator and Republican presidential candidate?" I asked.

"Yeah," Davis replied. "I'm trying to get Bob Dole to come to Rita's lunch."

The white-haired man, whose name was Richard Begin, helped coordinate Perot's 1994 presidential bid in Maine. He was contacting people in Dole's camp to see if they could get Dole to make a stop at Rita's.

"We can draft a letter to them," Begin said, but, he added, "the odds are very slim."

Politics had a home at Rita's. Maine's governor, Angus King, had visited during his 1994 election campaign. Bob even named a sandwich after him. The Angus King sandwich—you could find it on the menu, alongside the "New Toss Salads" and hot dogs—was a real artery clogger that could be had for $2.95. It was basically a double cheeseburger with Swiss and American cheese, Thousand Island dressing, tomato, lettuce, and fried onions.

During the campaign, Bob explained, King would occasionally drop in and chat with the customers. "When he was down in the polls, down in the dumps, he'd come to Rita's so the customers could cheer him up," Bob said. "That's when I decided to have a poll."

"A poll?"

"Oh, yeah. I run my own political poll, called Bob's Soda Pop Poll. I'll go to city hall, get the names, make up a ballot. Any customers who come in, I put the ballot in front of them and they fill it out, who they want for office.

"Follow me," he said, and we walked to the back of the store, where a failing fluorescent light flickered erratically. Mounted to a wall, above stacks of empty Pepsi bottles, was a green chalkboard. At the top were written the names of the three major presidential candidates—Bill Clinton, Bob Dole, and Ross Perot. Below, Bob had etched a mark for each vote the candidates had received in his poll. "This is where I keep the results of the poll," he said. "We'll keep this going until a few days before the election."

A quick count revealed that Clinton was leading, with sixty-two votes. Dole was second with fifty-three. Perot had garnered twenty-five.

Bob himself is a Dole man. "I'm a war veteran, he's a war veteran," he explained.

"I got into politics a few years ago," Bob continued. "I've got pictures of myself with a lot of candidates. They're over there, hanging on that wall. Angus King is up there. Jerry Brown is up there, too. George Mitchell. And some local ones."

Politics, Bob explained, "is my way of surviving. I get some publicity—the television news people come in every now and again, and the newspapers—and I perform a public service."

I left Rita's that day and walked down Lincoln Street past the lonely tenements close to the Bates Mill smokestack. Those buildings would not survive—they would be torn down a few years later. Bob Dole would lose his campaign for the presidency, having never visited Rita's. And Bob Davis's fortunes would take a wild ride.

In March 2001, I returned to a more vacant Lincoln Street. Rita's was empty. A For Rent sign was taped to the window. I telephoned the number listed on the sign, and a man told me Rita's had been closed for a number of years. After a bit more sleuthing, I found Bob Davis. He was at work, at a giant supermarket in a suburban section of Auburn. While teenage cashiers in green shirts manned checkout lines, Davis stood at a small

65

booth, counting out change. He wore a gray sweat-shirt, casual slacks, and tennis shoes. Without his "Bob" hat, I could see he was balding, with strands of dark hair combed back behind his ears. "You see what happened," he said. "I went out of business."

By winter 1996, Davis explained, business at Rita's was down to a fraction of what it had been at its peak. On the evening of December 3 of that year, he put a sign in the window that read, "Sick." Then he walked around the store one last time, closed up for good, and went home. Rita's was no more.

Davis was depressed. He began drinking and smoking marijuana—something he had never done before. "A couple of times I ended up in the drunk tank," he said. "They never arrested me, just took me to the hospital and watched me overnight. Once I woke up at 3 A.M. not knowing where I was at. I'd been robbed. Had fifty dollars in my pocket. They took every cent. I got a voucher for a taxi to go home. After that, I quit drinking. I thought, I'm going too low, now. It was terrible. I'd never felt so sick."

Davis was out of work for a year—he lived on his military retirement pay. Then he pulled himself together and, with the help of a woman he had once hired at Rita's, got a job at a supermarket chain called Shaw's. Davis was paid $5.75 an hour to round up grocery carts in the parking lot of the chain's Auburn store, which is located on land once occupied by the farm his father worked. It was winter and on some nights temperatures dipped below zero. Could a man in his mid-fifties do this type of work? Davis wondered. It was tough, but he managed—in fact, he said, it was good exercise. Soon, Davis moved to a cashier's job. Within three years, he'd been promoted to supervising cashiers and was making $8.50 an hour. From his job, and his military pension, he received a total of about thirty thousand dollars each year.

"Life is much better now," he said. "At least I got a few dollars in my pocket. I'm working a lot less. People respect me [at Shaw's]. Someone my age can go all the way up to assistant manager. That's forty hours a week, thirteen dollars an hour, eight weeks of vacation. It's a whole new career. Only place I've got to go is up."

A lot of new drywall, fresh paint, and government funds have been thrown at the old Bates Mill. More than 140 years after it was built, the mill looked like a genetic mutation, part suburban retail complex, part aging industrial facility. In that way, the building firmly connects past with present. You could walk into this place and buy party supplies, pick up a refurbished computer, or eat an Italian dinner, but the building showed enough of its ancient brick to serve as a reminder that it is a place where thousands once labored to fill the country's need for bedspreads, sheets, and table-cloths.

The feeling was strongest on the top floor of the mill, in an area yet to be reached by contractors. It was an eerie place—quiet, cavernous, and mostly empty. "Warning," read one sign hanging from the ceiling. "Cotton dust work area. May cause acute or delayed lung injury." As if to emphasize the point, cotton dust clung to electrical conduit snaking nearby. A few old machines remained. The year 1902 was stamped on one twenty-foot-long metal contraption sitting alone in the middle of the floor.

I received a tour of this area early one evening, thanks to two entrepreneurs in their early twenties who owned a small computer business located in the Bates Mill. Kevin Landry and Shawn Tobin told me how they had started their company eight months earlier, buying refurbished computers and selling them locally. Business had been so good they had quickly outgrown their original location.

Both loved the idea of working in the old mill building. Its history drew them, especially Kevin.

We took a noisy freight elevator to the top floor, and within minutes Kevin was studying an old wooden chair squeezed among several boxes stored in the middle of one giant room. "I wonder if my grandfather sat in this chair?" he asked. "He worked here for fifty years. Came down from Canada when he was fourteen and worked until he retired. The only job he ever had was at the Bates Mill."

Kevin paused for a minute. His mind was spiraling back through time.

"Did he walk through here, through this area? In the course of fifty years, he must have. I just can't imagine what the working conditions were. It must have been horrible. So hot. And my grandfather put up with that for fifty years. I never heard him complain. He went to work, came home, went to work the next day. Did that for fifty years."

Almost as an afterthought, he added, "It's ironic that I've started a business here."

Kevin Landry had made the connection, tying his past to his present simply by hopping on a freight elevator and pushing the "up" button. Once on the top floor, he could sense his grandfather's sweat, his toil. Maybe he could hear the din of the machines, a decades-old echo, or hear his grandfather and his colleagues shouting into each other's ears. Maybe he could breathe deep and feel the cotton dust choking his lungs, let his skin dampen in the heat. Maybe he could take the stairs and feel the weight of years of work and responsibility on his shoulders as he headed for another shift. He knew his grandfather had done this and accepted it, even as he yearned for something better, perhaps looked out the window on one of those cool autumn days when you know summer has abandoned you, and wish you could be anyplace else but on the clock.

But Kevin Landry is a business owner who is doing quite well thanks in part to a grandfather who stayed on the clock. Kevin went to college, got a degree, learned things his grandfather could never have dreamed of. Perhaps as he pondered the chair and his past, Kevin was also thinking of the future and all of its potential.

It was thrilling to watch Kevin make the connection to family, to work. How nice it must be to enter a building where you can see and feel a chunk of your past, which at once seems so unpleasant and so perfect, and to know that your future is full of promise, a future that could not have been so much as a dream a few generations ago. Kevin Landry can see the trajectory of his life, and it is not a downward one. It is a flight that was begun decades ago by his grandfather. Kevin can think of his own children to come and of their children, and of the path their lives may take. Is there anything more important than that?

For a few moments, I thought about my own grandfathers. Both remained mysterious figures, having been claimed by death before I was old enough to know them well, to know their lives, to know what they did and why they did it, and to know how their actions would lead to other actions—my father, Mike Mellon, leaving his eastern Kentucky home to travel northward, for example, where he met Wanda Jean Wilson and married her, eventually producing three children, with me in the middle. And how the life that couple made together, their struggle into middle class, would give me certain choices (college or work?), my decisions stacking one atop the other until, eventually, nearing my fortieth year, I found myself in an old Lewiston textile mill on an August afternoon.

It was a tenuous connection, but the only one I had, and with it I felt some kinship with Kevin and his grandfather.

In many ways, Kevin and Shawn represent one possible future for Lewiston. They're young, ener-

getic entrepreneurs who believe in the city's ability to find new life in the remnants of the old. They started their business in Kevin's home months earlier, setting up and demonstrating computers on the kitchen table. They moved their business to the Bates Mill because they saw potential in the mill's bricks, its yellow pine framework. "We believe this is going to be the center of the Lewiston-Auburn area again," Shawn said. Their office on the remodeled first floor of the Bates Mill was a collection of gutted and assembled computers, a place not yet complete.

"At least now we have a showroom," Kevin told me. Then he looked around and reconsidered. "Well, kind of a showroom."

The two started by selling refurbished computers—they were cheaper, and that appealed to the people of Lewiston. After several months their business changed direction—clients wanted Shawn and Kevin to upgrade older computers, make them faster and more powerful. Most of the technical work was done by Kevin—he's the computer expert. Shawn is the salesman. The difference is reflected in their attire. Kevin wears a T-shirt and shorts; Shawn wears white pants and a sport shirt.

The enterprise is an effort by the two to take charge of their futures and escape what they see as the trap of working for someone else. "My dad works for a large corporation here in Maine," Shawn said. "He goes to work and wonders if he's going to have a job the next week. You just don't know. He's miserable. He hates his job. He comes home and he hates his life because he knows he has to get up the next morning and go to his job. I see a lot of people like that and I didn't want that.

"I was brought up to work hard, to know if I worked hard I would get benefits," he added. "But I'm not going to do it for some guy who's just going to get productivity out of me so I can make $4.50 an hour and not get so much as a pat on the back. To heck with that. I want to determine my success, not some guy who's getting paid $100,000 a year to stand there and yell at people who aren't making $20,000 a year."

Shawn, Kevin, and I talked for a bit about the history of Lewiston, about the downfall of the textile industry, and the domestic shoe manufacturing industry that followed it. "Sure, you can make a cheaper shoe by farming it out to a Third World country," Shawn said. "But this is what you get—a town full of empty mills and . . . the lowest income rate of the whole state, probably the whole of New England."

Shawn saw his community's broken dreams, its struggle to survive the collapse of its industrial base, and it made him angry. He learned to channel that anger and its energy, to make it productive, and in the process he helped build a business and a future for both himself and, in one small way, for Lewiston.

The Bates Mill is a big place, capable of housing all manner of business, and so it wasn't much of a surprise to find a photography school called the Creative Photographic Art Center of Maine squeezed into one portion of the top floor. On the day I visited, it was a quiet place since class was not in session.

J. Michael Patry, the man who converted this space into a photography school, wasn't in, but one of his employees, Dorothea Witham, was there doing paperwork and preparing for the upcoming semester, scheduled to begin the next month. Dorothea is the school's executive director, and she took a few minutes to show me the darkroom, studio, and small photo store, where students can buy film, photographic paper, and other supplies.

"It took a lot of work to get this place up to snuff," Dorothea said. Before renovation, she told me, holes in the ceiling allowed both sun and rain to pour in. "It was really bad. You could see right through to the outdoors. They had big sheets of

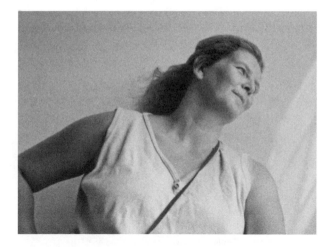

plastic tunneling down into fifty-five-gallon barrels to catch the rain. They still had machinery and stuff all around. It looked like a good place for a Stephen King movie. Now, if you're here by yourself, you'll hear a lot of creaking and stuff. It's the mill settling. The beams. Especially if it's windy outside. You'll hear noises."

Dorothea knew something about the old building's previous life. For years she worked in Lewiston's shoe factories. "I used to work in that mill, just down the street, the one with the clock on it," she said. "I operated the sole-making machines. Rubber soles for sneakers. That was back in '76, '77. I worked third shift. It wasn't too bad."

She moved on to other shoe shop jobs, but by the early 1980s, the jobs were disappearing. "There were summer layoffs, winter layoffs. Not enough work. Sometimes for vacation, they would just lay you off, so they wouldn't have to pay your vacation time.

"After the shoe mill, I went back to school. This was about 1986. I got some training in computers, stuff like that. I ended up at a print shop. I worked there nine years, and I loved it. I wouldn't have left, but they closed. I was a typesetter and a prepress person. I did stripping and darkroom stuff. After they closed, I stayed out of work for a while, then I went back to school again."

Through one state-sponsored training program, Dorothea was hooked up with Lewiston photographer J. Michael Patry and was hired to work at his studio. Eventually, she was moved over to the photography school.

"I've seen a lot of changes in Lewiston," Dorothea said. "It goes through trends where things will pick up, then you'll get a burst where things will go down. You'll get a rash of fires. A couple of years ago, it seemed like every week there was a block that would catch fire and burn down. That got a little bit scary. At that point I wanted out. But then it calmed down."

ri

Next to the Bates Mill is the Hill Mill, a big, deserted-looking place that shows its age in a way that makes the building appear ominous, not frail. Its rows of high windows are no longer uniform. Some have been bricked over; some have been filled in with plywood so they can accept smaller, modern windows or vents. A rusty, unprotected fire-escape ladder shoots straight up, five stories. In a few places near its base, the building has settled and bricks have been pushed down at odd angles.

Still, the Hill Mill, which closed as a textile production facility in the early 1970s, appeared brawny and tough, like it was determined to stick around, no matter what changes were forced upon it. Stand in its shadow and you'll feel tiny and insignificant. In that way, the mill serves as a lifeless reminder that most of us could be crushed at any moment, not because anyone has it in for us, not because we aren't liked or because we don't work hard, but simply because *it happens*. In the world of industry and business and finance, the world we look to for jobs that we hope will give us a sense of purpose as well as a paycheck, people seem insignificant.

The mill is a simple pile of bricks that had inhaled thousands of people—first, young farm women who had come to the city to work and help out their struggling families; then French-speaking immigrants from the Canadian north and, still later, their sons and their daughters. They had given the building life and noise and energy. They argued and joked and sweated and bled inside its brick walls. Robert Hamel's father dropped dead in a building like this. In the end, however, the Hill Mill exhaled and never took another deep breath. In the end, the Hill Mill didn't need energy and life and noise, didn't need jokes and sweat and blood and people working themselves to death in its dark corners. The Hill Mill didn't need anyone to survive. Most of the people were gone, yet this pile of bricks and mortar remained, having survived more than a hundred nasty Maine winters, two world wars, a Depression, even the collapse of the industry for which the structure was built. As I stood in its shadow, the mill reminded me in mocking tones that it would outlast me. I was expendable, insignificant, and long after I was gone, the Hill Mill would remain, as cold, as unfeeling, as soulless as ever.

On the day I visited the Hill Mill, Lewiston was in a bit of a funk. A banner headline across the top of the local newspaper read, "Custom Stitchers Goes Under." The sketchy article told of a local shoe manufacturer that provided as many as two hundred local jobs, but had been in trouble since losing a major client.

Losing that many jobs would have its consequences—few of them would be good. Perhaps a handful of people would land better jobs, or start small companies, or do whatever Americans are supposed to do when their lives are turned upside down. *Buck up and make the best of the situation*, or something like that. Most, however, wouldn't be so fortunate. Because they wouldn't feel so good

about themselves anymore, they'd yell at the kids, be impatient with their spouse, drink too much, spend too much time in front of the television. They'd learn to live with less, take odd jobs and get paid in cash so everyone could avoid the tax man. Then a decent full-time job could come along— paying less money than their last one, of course— and they'd take it and go to work every day wondering if this will be the day the boss says the company's lost a big client, the business climate has changed and, well, *we just have to face reality*.

For the most part, the Hill Mill looked empty. Above one door was a sign: Supreme Slipper Mfg. Co. Inc. A few floors up, a man leaned out a window. I hollered out to him, "Is this company still in business?" He replied, "They're in Chapter 11. Bankruptcy." Then the man disappeared into the building. I walked to the other end of the mill, where a sign above another entrance read, Fancy Stitchers. Perhaps there was still some life in the building, after all.

Entering through the main doors, I heard the whir and clatter of several small sewing machines. They sounded like mechanical insects calling out to each other. Sitting at the machines were a few dozen women. No one paid any attention to me— their concentration was on the task at hand. I was approached by a slender man in his mid-thirties with closely cropped dark hair. He was dressed casually, in shorts and a T-shirt, and introduced himself as Don Allen, the general manager of Fancy Stitchers, the company occupying this small corner of the huge mill.

Don was friendly and laid back, and he agreed to give me a brief rundown of his business. It was a family operation, started by his father. "Cutting and stitching is all we do," Don said. "We supply the labor only. Our clients ship all the materials to us. We've done car mats, handbags, we've done items for L. L. Bean, Lands' End. We've made

guitar cases, kite bags. Now we're doing felt caps. If it needs stitching, we'll do it. One guy came to us to make sexual restraints. Hey, I'll show you the catalog."

Don led me to his desk, not far from a time clock near the entrance, and while he hunted through the drawers for the catalog, a middle-aged woman who was standing nearby said to me, "You can't imagine some of the different restraints." She was Claudette King, a supervisor at the company, and she told me that, at a previous job, she was called upon to make spanking paddles for fetish-prone adults.

Don handed me the catalog. "Rachel's Premier Leather Wear," it read. Then he pointed out the page illustrating the "love links" his company had assembled. They were made of nylon webbing with foam and Velcro. The three of us—Don, Claudette, and I—chuckled a bit, then Don continued:

"We have sixty to seventy people working for us. Fifty here and twenty home workers. At one time, six years ago, we had five to six hundred people in here. We were doing only handbags then. This factory here was the largest domestic handbag manufacturer. We were doing about twelve hundred dozen a day. We had one customer for seventeen years. The agreement was that this customer would look no where else to get the work done; we would not look for any other work. It was a good marriage, then the customer decided to go to China.

"When we scaled down, we kept the cream of the crop," he added. "We have experienced stitchers here. They're very reliable. I have one of the lowest absentee rates of any company in the area. Losing too many sick days is never a problem. Business has been steady, but it will never be what it was. We've had to diversify. If you come in here next week, we'll be stitching something different. It's a little niche that we've found. We survive but nobody's getting rich here by any stretch of the imagination."

Don has been through his share of ups and downs over the years. A decade ago, he worked as a manager at a shoe manufacturer in the Dominican Republic. The company was sold and the new owners decided American employees were too expensive, so they were let go. Don returned to Maine and opened a chain of handbag stores. Then the retail market nosedived. He got out of the handbag sales business and returned to Fancy Stitchers, a company his father started. He was completing a circle of sorts, since Don used to come to the factory as a boy, to sweep and do odd jobs.

Don says that it is difficult work, sitting at a sewing machine all day. He expressed an affection for the workers that seemed genuine. Later, while the women were filing out at the end of the day, several stopped to chat and laugh. Don introduced me to several workers.

"This is Kathy," he said, introducing a short woman with graying hair. "Her father, mother, daughter, all worked for me. All were hard workers. They have a great work ethic in that family."

The woman beamed. People in Lewiston take pride in their commitment to work. As Kathy headed to the door, Claudette said, as if reassuring her, "We'll work all day tomorrow and Saturday. There'll be lots of overtime."

"I thought this would only take a second," the man complained, and then he raised a cigarette to his mouth, and I could see that his hand was shaking. He was thin and wiry and nervous, pacing back and forth, a young man so full of impatience it made his body tremble. My questions were slowing him down when every cell in his body was telling him to move, move, *move*. For a second, he glared at me, sized me up. Then his attention turned to the woman. "C'mon," he said to her, "let's get out of here, go get some coffee."

The woman had pale skin and dark hair, and she wore a black T-shirt and black pants that were stylishly too short, showing light gray socks that slipped into bright red shoes. She looked down at those shoes for a second, patiently riding the man's restlessness like a wave, which passed when he saw an acquaintance walking several yards away. The man hollered out to his friend, then ran to catch up.

"He's worked in the shoe shops all his life," the woman explained as the man jogged away. "He's been out for a few months, and he's afraid he'll never be able to find work again."

The woman and I talked about how the man could retrain himself, learn another trade, another skill. *Perhaps,* I thought to myself, *he can eventually run fast enough to catch up with those who, at that very moment, were riding by in cars that cost more than he'd ever made in any given year and talking on cellular phones to colleagues who, one could imagine, were sitting in front of laptop computers and drinking a cup of cappuccino.* It was an optimistic thought. I knew—and I'm certain the man knew—that, in his late twenties, with only a high school education, he could find his way into a retraining program and possibly make a decent living, but that he would never wear two-hundred-dollar leather shoes or impress clients by paying a dinner tab with the company's American Express

card. The world just doesn't work that way. Not most of the time, anyway, not for young men who find themselves wearing blown-out tennis shoes and hanging around the state Department of Labor office on a Thursday morning, with a resume full of low-skill, low-paying jobs. That knowledge can give anyone the jitters.

I had come to the labor office to find out exactly how many unemployed people inhabited this city. In the mid-1990s, Lewiston's unemployment rate exceeded the national and state averages. That turned around in the latter part of the decade when a number of service-sector jobs came to town. By December 2000, the city's unemployment rate had reached a record low of 2 percent.

Still, one report warned that throughout the state some groups continued to have difficulty finding decent jobs. Unemployment rates count those holding jobs that are temporary, part-time, or seasonal, as well as jobs providing inadequate pay; they don't count those who have gotten discouraged and have stopped looking for a job. And there were other problems, according to the report by the Maine Center for Economic Policy. For those whose education ended with high school, the unemployment rate was significantly higher. The average statewide seasonally adjusted rate for 1996–1999 was 3.8 percent; it was 6.7 percent for those with only a high school education. For males with less than a high school education, the rate was 14.8 percent. (There was no significant data for women with less than a high school education.)

Before leaving the unemployment office, I picked up a brochure, "Surviving the Pink Slip." The brochure listed 116 pieces of advice for those who had lost jobs. The list was diverse—sometimes it read like a practical manual on how to live if you're broke, at other times it read like a pep talk for those experiencing a real downer. "Think about

renting that extra room to a boarder," read number 15, while number 33 suggested that "Change can be difficult and depressing. Think of it as an opportunity for something better."

I walked out of the office, flipping through this brochure, when I saw the young couple leaning against a car, chatting. A few minutes earlier, they'd been inside, talking to an employee who sat behind a counter.

The man was tight-lipped—"I'm Dan," he said when I introduced myself. "Just Dan." The woman was open and talkative—her name was Vivian, age twenty-six—and she seemed to understand the man's nervousness. She, too, had been unemployed for several months since losing a waitressing job.

"Four-twenty-five an hour doesn't pay the rent and bills," she said. "Then we had a recession in the early nineties, late eighties, and the tips dried up. In the waitressing business, you see less tips, less money during a recession. When everybody is working, they're going out, spending money tipping waitresses. But if they're earning base pay, they're thrifty about the money they give to the waitress. Nobody has money to spend. I didn't even earn enough to qualify for unemployment benefits."

Over the years she's worked for temporary employment agencies, fast food restaurants, grocery stores, banks—"not as a teller, though"—and shoe shops. "I've been doing the job hopping. I've got a long list of past employers," she said. "One time the business I worked for closed. I went into work one day and they said, 'Sorry, we're shutting down.' Only they didn't give me any warning. They didn't tell me they were going to close."

Unlike the man, she spoke with no sense of nervousness or anger or animosity. It was simply the way things were. It must be difficult to have no job for such a long time, I said.

"It's one continuous, long week," she said. "It never ends. You don't get a sigh of relief where you can say, 'I've earned five days of pay, and now I can kick back and enjoy the weekend.'"

By now, the man was anxious for coffee, to get out of the parking lot and to get on with the day. I would delay them no longer, but I needed to ask the woman one more question. "How can you stay so calm?" As they slid into the car and began pulling away, the woman replied, "I take one day at a time."

It is a familiar phrase, maybe even a cliché. Later, flipping through the brochure picked up in the unemployment office, I saw it listed as suggestion number 35. *One day at a time* kept the woman calm, unlike the man, who swallowed his bad days by the mouthful and washed them down with a cup of coffee.

viii

One morning I wandered up and down Lisbon Street and, out of curiosity, entered a watch repair shop. A recorded version of an old country classic was playing inside. Jim Reeves was crooning, "Put your sweet lips a little closer to the phone." The shop was an odd place, the type that gives struggling downtown shopping districts a bit of character. Thumbtacked to the wall were unframed pictures of horses—they looked like they were torn from a giveaway calendar, compliments of a local bank. Behind the counter stood a polyester-clad man who was mostly interested in talking about his father, who was injured while fighting for General Patton in the Second World War.

"Where was he hit?" I asked, thinking anatomy.

"I think he got hit someplace in France," replied the man, thinking atlas.

Later, I asked why he had applied clear packing tape over the seams in the thin wallboard separating his establishment from a neighboring store. He answered, "The place next door, they have the stink

that comes through the wall, so I put up that tape to keep it out. It's terrible, the stink, you don't want to smell it."

A few blocks south I walked into to a cluttered pawnshop, where two men sat behind a counter and complained about drunks they said staggered up and down the street all day. The smaller man jumped from his seat and walked to the window. "You should go talk to the guy who owns that place across the street," he said, nodding in the direction of a storefront. "See a guy named Paul. He's been around a while. He's been in politics."

I crossed Lisbon and entered a small clothing store the man had pointed out. Hanging from the ceiling was a sign that read Working Headquarters. Paul Poliquin seemed to take that as a commandment rather than as the advertising slogan that it was. He was in constant motion, sorting the denims and work shirts stacked on the counter, answering the phone, which cried for more attention than a newborn baby, and greeting customers who walked in off the street. He said he'd talk to me if I didn't mind the interruptions.

Paul was in his early forties and dressed casually in light slacks and a short-sleeved shirt. He spoke quickly and directly, in a manner that reminded me of Mike Stout, the print shop owner I'd met in Homestead, Pennsylvania, several months earlier.

"The guys across the street said you were in politics," I said.

"I've been on the city council, and I was council president for ten years," he replied. "I just got off in December. It was just too demanding to do that and run this business, too." Paul's business was selling work clothes—a risky profession in a city that had lost, by his count, more than a thousand blue-collar jobs in the past eight months. Still, he was doing well. In fact, he had considered expanding into a vacant space next to his shop, but

changed his mind after a couple of shoe manufacturers closed up their Lewiston shops.

"We've lost our mills—we used to employ eighteen hundred at the Bates Mill—and most of our shoe shops," Paul said. "This was a big shoe shop area. At one time we had eight shoe shops, maybe more, all running full. The workers used to go in and if they didn't like the boss, or the boss didn't like them, they'd quit and go downstairs to another shop in the same building and have another job the same day. That's how many jobs there were.

"That's the big reason why the downtown stood strong. There were a ton of people walking in the area. They didn't use their cars. So we were doing very good business. Now what's happened, from January until now, three more shoe shops have left. They went overseas. We really only have one or two left that I know of. One is doing very badly. The workers are down to two or three days. The other one is holding its own."

Paul told me he'd been in business for four years. Before that, he worked for a local clothing store that had been an institution in downtown Lewiston. That store has since moved out. I asked Paul if he had ever worked in the mills or the shoe shops. No, he said, but those jobs had nonetheless shaped his life. He explained:

"I have four brothers and six sisters. That's a big family. So my father did whatever he could to get by. He worked in the Bates Mill, he worked in the shipyards at Bath, Maine. I learned a lot from my father. The poor guy, he had eleven kids. He was always working—odd jobs, cleaning cellars, he'd do whatever it took. He had his own truck and started a cleaning service. I used to help him. I saw what he was doing. I said to myself, 'All those jobs!' Out of eleven in my family, only three graduated from high school. All of them, when they were sixteen years old, immediately went into the shoe shops. That was the American way back then. And all of

them got beautiful jobs. They were making good money. I didn't want to do that. I wanted something better for myself.

"I'd hear my sisters, and I'd hear my brothers, and they'd say, 'Boy, it's tough. It's hard work.' Not that I didn't want to work hard. It just wasn't my cup of tea. I'd go visit them, and I would see what they did—standing by a machine for eight hours, cutting leather. I said, 'No, not going to do that. I don't care what kind of work I get but it's not going to be shoe shops or mills.'"

Paul said he hopes a new industry will come to town and offer good-paying jobs to those who were raised in a mill town culture, where one could secure a decent future without a college degree.

Even if that doesn't happen, Paul believes, Lisbon Street will survive, and perhaps even thrive in coming years. What else can he believe? He has attached his future to Lisbon Street's future. I admired his tenacity and energy, his willingness to stay in an area that needed him more than he needed it.

"You know, I've lived here a long time and I've seen a lot. In the sixties and early seventies, everybody was on this street. It was the place to go—like the malls are today. And what's happening—I'm telling you I've seen the transition—business owners can't afford those rents in the malls anymore. They're coming back to downtown. But it's a slow transition."

Paul was an optimist struggling with Lewiston's realities. "Everybody is feeling the pinch," he told me. "People now are more negative than they've ever been. But I always tell people, if you can make it through the tough times, when the good times come, you'll do very well. Just think about that."

I left Lewiston on a Friday afternoon, drove south on a toll road whose northbound lanes were clogged with out-of-state people dragging kayaks, campers, and bicycles into Maine for what was one of the last weekends of the summer. Thousands were headed to the state's vacation lands, rewarding themselves after five days of toil, and in doing so they would cruise past a city where thousands would spend the weekend thinking about their work, or worrying about it, where an exhausted Wilfred Moreau sits in his apartment, drinks Mountain Dew, and hopes for a security job that will tide him through the winter; where Bob Davis rings up sales behind the counter at Rita's, the depression, drinking, and the new job all ahead of him; where a young woman named Vivian wishes she, too, could work five days and reward herself on the sixth and seventh; where Paul Poliquin is in constant motion, always optimistic; where two young entrepreneurs dealing in new technology feel the weight of history on themselves and their families; where demand for an unlikely assortment of items (including felt hats and sexual restraints) keeps a small group of women employed; where Robert Hamel sits in a sparse office and waits for the phone to ring so he can speak to his wife in a language most of the city can no longer understand. All had plenty of time to ponder their futures and their pasts. Saturday began a long weekend, the last of the summer, the celebration of a holiday known as Labor Day.

Matewan, West Virginia

For years, I never lost a minute of sleep over anything I saw as a news photographer. The things that should have bothered me—the murders, the grisly auto accidents, the fatal house fires—I was able to quickly erase from my memory. I considered it a skill, something every objective journalist needed to master.

Later, nearing middle age, I would lose the ability to cover tragedy without being burdened by its images for several days. For a decade, though, I was so efficient at purging my brain of nightmarish scenes that, to this day, I can't recall most. If I concentrate, I can remember some of the weird stuff: a man once stuck a huge needle through the flesh of his forearm to prove to me he could use the power of his mind to control the bleeding. He couldn't. And several years ago I saw a severed human thigh in the back of a Pittsburgh city garbage truck. It was one piece of a murder victim who'd been sawed to bits. The rest of him was found in a Dumpster on the other end of town. I made no pictures of the unconnected thigh, not because I was bothered by the scene, but because I knew the newspaper would never use such a gruesome image.

Another time I was sent to Pittsburgh's North Side to photograph the aftermath of a shooting. It

was late at night, warm. The cops tried to keep everyone at a distance, but I remember people— probably the victim's family members and friends— inside the area marked with yellow crime scene tape. From where I stood, I could see the victim illuminated in the bleak, green glow of streetlights. He had collapsed in the entryway of an apartment building and was lying on his back, his body propping open the door. Both arms were extended outward and his head was pushed down by the doorjamb so that it looked as if he was examining his chest wounds. Blood had pooled on the warm concrete. One woman cried loudly. A young man cursed and stomped, flinging his arms about. "Goddamn," he kept saying. "Goddamn." The dead man was young, maybe twenty or so. I photographed the scene as best I could—it was dark. Using a flash in such a situation is unthinkable. Its light is too sudden and harsh and obtrusive. So I held my breath, opened the shutter, and hoped the streetlights would provide enough illumination. I believed then, and still do, that it is important to cover such events. News outlets have an obligation to remind the public that senseless violence rips apart families, people, and communities.

But why do I remember this particular shooting? I'm not certain. I've seen the aftermath of many. I have the old, tattered newspaper clippings to prove it. At the bottom of the pictures is the credit line: *Steve Mellon/Staff Photographer.*

Oddly enough, the one image that haunted me through those years was from an event I did not witness, and from which there are no photographs to draw details. Yet the picture, complete and sharp, was seared into my mind. If I happened to think about it at night, it would haunt my dreams. Sometimes the image would pop into my head while driving. When that happened, I turned off the radio and drove in silence.

The image was of my father, Mike Mellon. Here's the scene: It is early Sunday morning and my father is slumped into his favorite green chair. He is fifty-two, still trim and muscular. The years have turned his hair salt-and-pepper gray and have creased the skin on his face, but he is still a dark-skinned and handsome man. He is wearing work jeans and a white T-shirt. And on this day, at this moment, he is dying. My mother, her short brown hair mussed from sleep and her face wearing the shock of waking too suddenly to tragedy, is kneeling beside him, holding his hand. He appears unconscious. My younger brother Jeff is calling an ambulance. Jeff is outwardly calm, but inside he is in turmoil. He was awakened just minutes ago by the screams of my older sister, Debbie, who saw the heart attack, heard the gasping for air. Debbie has since described to me the noise my father made as he died. I will not describe it here. It is a sound that takes me too close to the reality of that day and unleashes a torrent of memories I did experience—the wild rush to the hospital in a silent car, the look of shock on my mother's face, then returning to my parents' house, which was no longer a home but, instead, the scene where a tragic event had taken place.

This happened in 1983. My mother, my brother, and my sister saw my father die in October of that year. I was asleep, twenty miles away, where my wife, Brenda, and I lived. The telephone rang, Brenda picked it up. To this day, we both jump when the phone rings at odd hours. We know it has the power to dump the contents of our lives onto the floor. It has done so in the past, and it will most certainly do so again in the future.

An ambulance rushed my father to a nearby hospital. His obituary in the local newspaper reported he'd died there. I wrote a different obituary that said he died at home, in his wife's arms, and published it in the small newspaper where I worked. For me, that's where he remained, in a chair, in the

home he struggled to pay for, a physically powerful man whose heart was overburdened by years of worry over his job in a depressed business.

Mike Mellon was the sales manager for an automobile dealership. High-pressure sales, commissions, and monthly quotas framed his professional life. The job shaped him in ways that made him uncomfortable—the often cagey and deceptive business of selling cars troubled his sense of fairness, of morality. Over the years he made several attempts to become something else. He invested in a print shop (and lost fifteen hundred dollars), took night classes at a Louisville Bible school and worked as a lay minister on Sundays, and started a loan company, which folded when he died. None of these efforts were immensely profitable. For a while he talked of opening a shop that sold pies and coffee; that, too, was just another unrealized dream. The simple truth was this: there were few alternatives for a high school–educated man with a growing family and a sense of duty to be a good provider. My father had no special marketable skills, so he got up every day, put on a suit and tie, and went to work at a Chevrolet dealership in Jeffersonville, Indiana. He was, in many ways, no different than millions of other Americans.

During the early and mid-1970s, he did fairly well. American-built cars were popular—a record 9.7 million were sold in 1973. One year my father earned thirty thousand dollars—in his eyes, a fortune—and with bonus money he received, took his family on a shopping spree. I bought a BB gun and spent months plinking tin cans in our backyard. Mike Mellon moved his family to a new suburb. He had his piece of the American dream.

An oil crisis in 1973 caused a hiccup in the domestic auto industry. Big American cars that gulped gasoline started to give way to small, more efficient Japanese-made automobiles. But that crisis passed, and American car manufacturers recovered. Then, as the 1970s drew to a close, oil prices shot upward again, sparking a recession, and the automobile sales business went sour. My father's income dropped to less than twenty-five thousand dollars. He and my mother struggled to pay bills. They had one son in college, and another who soon would be. They cut expenses, refinanced loans, then considered selling their house.

Nearing age fifty, my father began what seemed an urgent and quite literal effort to reshape himself—he began lifting weights. After work, he'd visit a local gym and enter a world of clanging barbells and sweat. He formed a kinship with a group of health-obsessed men half his age and became a mentor to many. My father was the gym's "old man," admired for his self-discipline, determination, and physical strength.

In 1983, at age fifty-two, my father competed in a Mr. Indiana bodybuilding contest. He was, by far, the oldest competitor—the only man on stage with strands of gray in his hair. Most others were in their mid-twenties. He wasn't named Mr. Indiana, but in his mind, Mike Mellon had succeeded in reframing his life, in becoming something other than a car salesman. He was a middle-aged bodybuilder—a celebrity in the small world of southern Indiana muscle men. His was a story sought out by at least one local television sports reporter.

But no level of human strength, no amount of reshaping, could stem the auto industry's steady decline or prevent my family's bills from piling up month after month. My father's worries continued unabated.

I last saw him alive on a Saturday evening, about eight hours before his heart suddenly stopped beating. He wore the clothes he would die in—the jeans and T-shirt—and said little during my visit. He had taken a week of vacation to do some repairs on the house, and the work had made him weary and sore. Maybe, he said, he was catching the flu.

I have many pleasant memories of my father—playing touch football on sunny afternoons, driving for hours on Sundays so he, as lay minister, could preach to a congregation of twenty or thirty parishioners in a tiny northern Kentucky town. I learned to drive a car on some of those Kentucky roads. Quite often, he would let me take the wheel, but he never relinquished control of the radio, which he kept tuned to a Louisville country music station.

The image that elbows its way to the front, however, is that of my father in his moment of death—a death I'm convinced was at least partly precipitated by years of worry and frustration over a job that allowed him to realize some of his dreams but not to grip them firmly, a job that made him but also damaged his spirit. Despite my absence from the event itself, the picture and all its detail remains sharp.

That image followed me into southern West Virginia, as I drove toward a small town called Matewan on a cloudy May day nearly fifteen years after my father's heart attack. Matewan is tucked into the hills of Appalachia, in a region where coal mines have long been bored deep into the earth. My father was a product of this region—he was raised in a small eastern Kentucky town called Prestonsburg, about forty miles from Matewan. He grew up, moved north to Indiana, started a family, and never came back. I have a black-and-white picture of him as a young man, standing on a Kentucky hilltop with members of his family. In the background you can see other mountains and clusters of homes.

I searched for pieces of my father in Matewan. I looked for his reflection in the eyes of the men I met, listened for his echo during conversations. In the stories I heard, I recognized my father's compulsion to work and provide, and the distress that accompanied the inability to do these things effectively. There, too, was the yearning to be something

more than what an employer or a job declared you could be. And since these are attributes a father passes on to his son, I discovered shards of myself in Matewan.

But pieces and shards were not enough for forming new pictures. After five days in West Virginia I continued to be haunted by old and disturbing images. So I drove into Kentucky, to the mountains that shaped the man who, until his dying day, so desperately wanted to remold himself. There, I heard stories of violence and family loyalty—stories similar to the ones I had been told days before in West Virginia. This time, however, the stories were about my father, and his father, and his father's father. This time, it was Mellon blood spilling in the mountains.

I learned a great deal about my father's family, and how its members had endured and responded to tragic events. Those events, and eastern Kentucky culture, shaped my father in odd ways. He seemed to reject his family's violent past. When, as a young man, he saw his life spinning out of control, he turned inward instead of lashing out. The turmoil nearly destroyed him; his eventual salvation was spiritual but not physical. Try as he might, he could not separate himself from what he did for a living, from his responsibilities and worries. Those things became tangled in his weakened heart, which could endure fifty-two years of this life, and no more.

I have for most of my life been a runner. As a boy, I ran for pure pleasure. Back then, it was nothing for me to run five miles or more. I loved the way crisp autumn air burned my throat and filled my lungs. I loved the sting of sweat in my eyes on humid summer afternoons. These sensations made me feel alive and vital. As a grown man nearing middle age, I continued to run, but for different reasons. I ran *from* things—from my family's history of weak hearts, for example. I ran not to feel alive, but to stay alive.

Four hours after leaving Pittsburgh, I guided my car off I-79 in Charleston, West Virginia, and onto the increasingly smaller and narrower roads that took me deep into the state's mountainous southwest corner. For an hour I negotiated twisting ribbons of asphalt. Much of that time was spent dodging huge, lumbering coal trucks that seemed to lurch around every curve. If there is an angry god loose in these hills, he needs no thunderbolts to wreak havoc—the growling trucks hurling down West Virginia's narrow mountain roads will do his bidding.

As I drew closer to Matewan, I tried to set aside personal thoughts and focus instead on the job at hand—I was making the trip to learn about Matewan and how it was dealing with the questions of its own past, its own searing images of death.

The town of Matewan is quiet, isolated, and tiny—its downtown has only three streets and is less than three hundred feet long. Wedged into a narrow valley between the Tug Fork River and a mountain, Matewan was established in the late 1800s when the Norfolk and Western Railroad came to the Tug Valley and provided access to the region's coal, which was fueling America's Industrial Revolution. Matewan became a rail stop, a place where the surrounding mine communities could obtain supplies.

A century later, Matewan (population 600) still had the look of a supply town. The railroad tracks remained, as did a block-long row of low-flung commercial buildings, most of which dated back to the early part of the century. Nearly every building had been renovated to look as it did in the 1920s. Some buildings were unique in that they had two fronts: one facing the town's main road, Mate Street, the other facing the railroad tracks, which years ago brought passengers and goods to town. These days trains roar past without stopping.

The storefronts along Mate Street were occupied by a handful of businesses: the Matewan

Heading into Appalachia, however, I began to feel as if I were once again running *to* something, not *from* anything. I felt as if I were going to a place that was vital and life-affirming and yet full of pain and tragedy. Can a place, or a people, or families, embrace all of these things without being torn apart? Is it possible to be at once haunted and heartened by the past? Mountains loomed ahead. In the valleys between them, I hoped to find answers.

Bank, a restaurant called the Depot, Nenni's Department Store, a visitor's center, hair salon, gift shop, flower shop, barber shop, insurance office, and the Blue Goose Saloon. A few spruced-up storefronts remained vacant. On the east end of the street was a seed store housed in a two-story building that stood out because it was a clapboard structure (other buildings were red brick) that had not been renovated. On most days, few people wandered the town's elevated sidewalk. Most were regulars, though on occasion a tourist passed through. The emptiness made Matewan look a bit lonely and forlorn, like it had gotten dressed up for a date that had not shown up.

Matewan is a peaceful place. It hasn't always been so—the town's history is replete with violence and death. In the late 1800s, two nearby families, the Hatfields and the McCoys, were busy killing each other in a long-running feud that brought national attention to the area and eventually became the stuff of legends. But it did not draw me here. I had come to learn about another deadly confrontation, a shoot-out in 1920 between coal miners and hired thugs who did the bidding of mine owners. Ten people were killed in that incident, making it one of the deadliest gun battles in U.S. history, and it set in motion a series of events that lead to the West Virginia Mine War of 1920–1921. Older residents in some parts of Mingo County remember the war: they crawled along the floors of their homes to keep from getting shot. Scars of that era remain. A lady who lives near the Kentucky border, in a village called Blackberry City, can take you into a backroom in her small house and show you a fireplace mantle pocked with bullet holes. You can run your fingers over those scars, feel the splinters.

Once all the shooting stopped, the silence began. For decades, nobody talked publicly about the Matewan killings. The images of violence and death were purged from memory—and history. It

was an amazing feat. The shoot-out could easily have defined Matewan. But the people said no, and so they began to deliberately and actively forget what was, in the end, a failed attempt by desperate people to wrest some control over their lives. Matewan accepted its fate as a company town.

This refusal to remember was puzzling. Why was it so important to remain silent? The answers reveal something about the hazardous nature of life in the West Virginia mountains, and about the character of those who made the mountains their home.

Matewan's effort to forget its violent past ended in 1987. That year, a filmmaker named John Sayles released a critically acclaimed movie about the gun battle and the events leading up to the confrontation. The film *Matewan* pulled the town's history from the shadows and, to a degree, cleaned it up. A story that for decades had been regarded as haunting and morally ambiguous suddenly became a tale of good against evil. Union miners and their sympathizers were heroic underdogs. Mine owners and their enforcers, agents of the Baldwin-Felts Detective Agency, were ruthless and cold. In one scene in the movie, Baldwin-Felts agents evict a miner from his company-owned home, tossing his family's belongings into the street. Later, the agents murder a teenage miner by slicing his throat. Who could blame the miners for standing up to these thugs? The film was a mix of fact and fiction, and it set in motion a series of events that would forever change reality in the West Virginia mountains. For a detailed and objective account of the shoot-out and its immediate aftermath, I turned to *Thunder in the Mountains,* written by a former reporter, Lon Savage. The book offers a stark and depressing view of a miner's life in the 1920s. Working in damp holes hundreds of feet underground, coal miners squeezed themselves into impossibly confining spaces and used short-handled picks to

chip away at narrow coal seams. Then they used dynamite to blast free the remaining coal. They entered the mines before sunrise—about 6 A.M.—and emerged after sunset, their faces black from the coal dust that would also choke their lungs. Their wages were low (miners at the turn of the century earned about two dollars a day) and the work was dangerous. Each year, nationwide, about sixteen hundred miners were killed on the job. They died in explosions of gas and coal dust or were crushed when mine roofs collapsed. Once their shifts ended, miners spent the meager remains of the day living lives controlled by someone else. Coal operators owned the miners' homes and held power over entire towns—stores, schools, lawmen, doctors, even preachers, were beholden to coal companies. Death was no escape. Miners were buried in company cemeteries.

By 1920, miners in many parts of the country had been pushed to the limit. They banded together to form a union called the United Mine Workers of America, which fought for and won recognition by the coal operators, and they were negotiating for an unprecedented 2 percent wage increase. But in the isolated region around Matewan, deep in the hills of southern West Virginia, efforts to organize the miners were less successful. Coal operators there were staunch in their opposition to the UMWA. They forced miners to sign "yellow dog" contracts that banned union activity. Those that did join were fired from their jobs and evicted from their homes by detectives from the Baldwin-Felts Detective Agency, which had become notorious for its strong-arm tactics.

Still, the UMWA pressed on. By May, hundreds of Mingo County miners had signed up with the union. Those miners, with no work or homes, moved with their families into tent cities the union had organized along the Tug Fork River.

On May 19, a Wednesday marked by occasional rain, thirteen Baldwin-Felts agents arrived by train in Matewan to continue their evictions. Angry miners watched as the armed detectives emptied a miner's house. One man in particular felt fury rise inside him and decided to do something.

That man was Sid Hatfield, Matewan's twenty-seven-year-old police chief. To the miners, Hatfield was something of a hero. He had grown up in the West Virginia mountains and, before becoming police chief, had worked in its mines. Hatfield was a handsome man, with high cheekbones, light brown hair, and big ears. In photographs, his face seems too big and well defined for his five-foot-six, 150-pound frame. As the town's top law enforcement officer, he kept the miners out of trouble, broke up their fights, and stood by them when the Baldwin-Felts men came calling with their heavy-handed tactics.

On this day, the detectives evicted six families. Stories circulated through town that the agents were forcing into the rainy street families with sick children, even pregnant mothers. Miners became alarmed. Sid called the sheriff's office in the county seat of Williamson and learned the Baldwin-Felts men had no authority to throw families out of their homes, so he asked for warrants for the detectives' arrest. Those warrants were to arrive on the five o'clock train, the same train the detectives had planned to take on their return trip to the Baldwin-Felts headquarters in Bluefield, West Virginia.

Sid confronted the agents in front of a hardware store in Matewan near the railroad tracks and told them he had warrants for their arrest. Al Felts, brother of the agency's head, Thomas Felts, responded with a warrant of his own, for the arrest of Sid.

Tensions grew as Sid argued with the agents. Several armed miners had gathered and were stationed in and around the area—in the hardware store, in the doors and windows of nearby buildings, on the patch of ground between the stores

and the railroad tracks. The town's mayor, a tubby man named C. C. Testerman, arrived on the scene, looked at the warrant for Sid's arrest, and declared it bogus.

At this point, the facts get a bit muddy and difficult to sort out. According to Lon Savage, as the men glared at each other, the shooting started. Who fired first is one of Mingo County's greatest mysteries. Sid said it was Al Felts. Others said it was a miner. The Felts family claimed Sid shot first.

Al Felts and Mayor Testerman fell to the ground, both mortally wounded. Suddenly, the air was thick with bullets. The detectives tried to flee. A few were killed running away. Lee Felts, Al's younger brother, was shot and killed by a man named Reece Chambers, whose name would pop up in several conversations I was to have in Matewan. The shooting would haunt Chambers the rest of his days. Detective J. W. Ferguson escaped to a nearby house, where miners tracked him down and killed him. C. B. Cunningham, the agent third in charge behind the Felts brothers, drew his pistols and began returning fire before being hit and killed.

Two miners were killed. One was fifty-three-year-old Bob Mullins, who was fired earlier that day for joining the union. He was unarmed and was shot while trying to run from the scene. The other miner was Tot Tinsley, who was shot in the head.

When the five o'clock train arrived with Sid's warrants, passengers saw a street littered with bodies. Seven detectives and two miners were dead. Mayor Testerman was dying. He'd caught a bullet in the stomach. He was paying the ultimate price as a public servant—giving his life in a cause that, decades later, would save his town.

The battle, which later became known as the Matewan Massacre, made Sid Hatfield a legend in the coalfields. To the miners, he was the man who had stood up to the Baldwin-Felts agents, had

given them a taste of their own medicine. He and twenty-two others were tried on charges of murdering Al Felts, but a Mingo County jury would find none guilty. Having failed to secure punishment in the courts, the Baldwin-Felts men took matters into their own hands. In August 1921, they ambushed Sid Hatfield, gunned him down while he was walking up the steps of the McDowell County Courthouse in Welch, West Virginia. His friend Ed Chambers, Reece's son, was also killed. Hatfield had been set up, brought to the courthouse to answer charges he had attacked nonunion miners the year before. Sid's friends had warned him not to go, and he should have listened. Though he had promised the two men's safety, the McDowell County sheriff was conveniently out of town when Hatfield and Chambers, both unarmed, walked into a trap set up by Baldwin-Felts detectives and Charlie E. Lively, a spy who had infiltrated the miners. Five bullets struck Sid. He fell backwards down the steps and landed a few feet from the street, dead.

Sid now rests on the Kentucky side of the Tug Fork River, in a cemetery on a hill overlooking Matewan. The cemetery was one of my first stops. After the long drive and the thoughts about death that I had wrestled with for hours, it seemed appropriate to visit a resting place for the dead.

The cemetery was beautiful, despite the collapsing cinder-block wall near the entrance, the empty fast-food cups scattered about, and the old, wilting flower arrangements that had been discarded and piled next to the cemetery's narrow lane. The road was mostly dirt and mud with a smattering of gravel too deeply imbedded in the earth to do any good.

I followed the lane a short distance, then turned and walked up a hill to the top of the cemetery. The view there was stunning—trees and hills and valleys that have always amazed visitors to the Appalachian Mountains.

It took little time to find Sid's grave. His six-foot monument towers over its neighbors. "Defender of the Rights of Working People," it reads, "We Will Never Forget." Mayor Testerman is buried nearby, as is Ed Chambers. Scattered about are more ordinary tombstones bearing names such as Brown, Wright, Chaffin, and Hoskins.

The day of my visit was sunny and comfortably warm, but on the day Sid and Ed were buried, the rain came down in sheets, temporarily interrupting the funeral service. Two thousand people marched in the procession through Matewan's muddy streets, across a footbridge and up a hill to this cemetery. "Even the heavens weep with the grief-stricken relatives and the bereaved friends of these two boys," the eulogist said as the rain fell. He was putting his best spin on the day, but for the miners, it must have seemed as if even God Almighty had turned against them. How many of them would sacrifice their lives for coal and end up here, one of Sid's neighbors, with their lungs so clogged with coal dust that they would spend their last days gasping for air and coughing up what one woman described to me as black whipped cream? How many would have their skulls crushed by falling rocks? Did these miners sense hopelessness that day? One man had stood up to a coal company and its security force and had paid a brutal price. I wondered about that day, the anger and confusion the miners must have felt. Surely the miners saw themselves in a lawless and frightening place, one where there was little hope for the future.

From the top of the cemetery, near Sid Hatfield's grave, I could look out over Matewan and see what the future had brought. Coal was still important to the region, but not so much to its people or its towns. Mining was now done largely by machines; fewer miners were required. Between 1988 and 1998, Appalachia lost forty-two thousand coal-mining jobs while production rose from 443 million to 455 million tons.

With a bit of help from the movie industry, however, Sid's shoot-out with the Baldwin-Felts agents had saved Matewan, albeit more than seventy-five years after the event actually occurred. Sayles's *Matewan* had sparked interest in the town's history, and as a result, millions in federal, state, and private dollars had poured in. Matewan had been rebuilt to look like the 1920s town it once was, and a gigantic flood wall now protected it from the Tug Fork River, which had a habit of rising up out of its banks. A new town hall was being built—I could hear the whining of circular saws when I walked along the main street. A certain level of prosperity had arrived. No doubt those lying in the ground—Hatfield and Mayor Testerman among them—would be surprised at all this. My thoughts were interrupted by the growl of a heavy truck making its way down a nearby hill and into the town. It was a reminder of one constant in this out-of-the-way corner of the world: the hills were still giving up their coal.

Because it is isolated (fifteen miles of treacherous mountain roads separate the town from Williamson, the Mingo County seat), Matewan is a place of long and expectant periods of silence. It is the type of silence you experience in any major city at 3 A.M., when the streets are dark and deserted and the only sound is the *buzz-click* of the traffic signal going through its motions every sixty seconds. It is a quiet that is always bracing itself, waiting to be violated by the machinery of transportation that hauls out heavy loads of coal and, in the process, rattles windows and treads over conversations and thoughts. The trains and trucks passing through Matewan are like rude guests who storm away from a dinner party with the hosts' silverware clanging noisily in their pockets.

Even history is violated. On the Matewan National Bank building, near the scene of the 1920 shoot-out, there is a red button you can push to

hear a recorded description of the battle. But the tinny voice telling its tale of abuses, evictions, threats, and death is so often obliterated by the roar and whistle of passing trains that the development office has begun offering typed manuscripts of the recording so tourists can at least read what they can't hear.

The town's skittish silence returns as soon as a train rounds a bend or a coal truck crests a hill. In these moments, it is quiet enough to hear someone unlocking a car door a block away, even in mid-afternoon. It has been like this for a century—silence, then brutal noise, then silence again, keeping its head down, waiting. It is a habit, a way of life here, one that extends into the homes tucked into the valleys and hollows around Matewan. Decades ago, silence became a necessity for the people of Mingo County. For some, it very nearly became religion, something they'd need to practice devoutly in order to survive a harsh life in Appalachian coal country. Quite simply, people here learned to keep their mouths shut. It kept them alive.

From the beginning, those who heard the crack of gunfire in 1920 and who knew what happened said nothing. The reason was simple: bad things happened when people talked. Consider the case of Anse Hatfield, a Matewan hotel owner. After the shootings, he testified against Sid at a grand jury investigation and was scheduled as a key witness for the prosecution at the shooters' trial. But one evening, while sitting outside his hotel, a sharp report broke the silence and a bullet pierced Anse Hatfield's chest.

Others kept quiet because they feared bullets from the other side. Miners involved in the shoot-out considered themselves marked men, and in that overheated and violent time, it's easy to see why. The Baldwin-Felts agency was a powerful force in the West Virginia mountains—its gunmen had caught up with Sid Hatfield and Ed Chambers

in Welch and murdered them on the courthouse steps in front of several witnesses. It seemed Thomas Felts would stop at nothing to avenge the deaths of his brothers. For the Matewan shooters, paranoia set in. Reece Chambers certainly felt it. He was the father of Ed Chambers and the man credited with gunning down Lee Felts. Elderly folks in town remember Chambers as a grumpy, skittish old man who hid every time a train passed—he feared being picked off by a rail-riding sniper in the employ of Baldwin-Felts.

"After the massacre, people were still killed, murdered, silenced in the coalfields," explained Robert McCoy, Jr., a former Matewan mayor whose grandfather, Hallie McCoy, was one of twenty-three defendants charged in the shootings. At age fifty-two, McCoy is old enough to remember a time when talk could have reopened the case, brought more indictments, perhaps another trial. At least that was the fear. So McCoy was told by his elders: "Don't talk about the shootings. Keep quiet." As a result, he said, the shootings became "whispered history."

A large, rotund man who served as the town's mayor from 1972 to 1985, McCoy ran an insurance business out of a Mate Street storefront. In fact, just a few walls separated his office from the space where another former mayor, C. C. Testerman, once sold jewelry, eyeglasses, ice cream, and tobacco. McCoy was one of several in Matewan wanting to turn this "whispered history" into shouted history, to buck the trend of silence and let the world know what had happened in this town, and why. Perhaps by raising a racket about its violent past, Matewan could avoid becoming irrelevant. Talk could bring tourists. Perhaps prosperity could come to tiny Matewan.

Robert McCoy decided long ago that silence was an inadequate weapon against the forces dragging down small, isolated Appalachian towns. He'd been

a driving force behind much of the recent progress in Matewan—the new flood wall, the refurbished downtown. Things didn't always go smoothly. The town's leaders often butted heads with federal officials, especially those with the Army Corps of Engineers. Current mayor Johnny Fullen said that during one meeting, McCoy ended an argument over the amount of money being spent on a portion of the flood wall by barking at the corps representatives, "Hell, you guys spend more than that every week on toilet paper."

Leaning against the wall in the corner of McCoy's office was a two-foot-wide picture of the Matewan massacre defendants, an image made the day they were acquitted. Actually, this picture was a fairly accurate pen-and-ink rendition of the original photograph, which I later saw in its true form. The men are arranged in two rows—those in front are kneeling; in the back row, everyone stands. With the defendants is the jury foreman, a graying, mustachioed man named Jim Maggard. A few of the defendants have proud grins on their faces; others appear stoic. Sid Hatfield is in the back row, dead center. He's one of the stoic ones, a real poker face. Reece Chambers's wide, suspicious face stares out, also from the back row. On the other side of the picture is his son, Ed Chambers, wearing a mischievous, crooked grin and hair so unruly it seems to be suffering its own private hurricane. In pose and expression, the group looks like a local softball team that had just won the first round of a big tournament, but had yet to face the really heavy hitters.

McCoy lifted the picture onto a small table so we could get a closer look. "This is my grandfather right here," he said. Hallie Chambers is in the front row. In the photograph, he's wearing a hat that sends a shadow over half his face. The pen-and-ink guy took some liberties—he removed the hat and its shadow, softening Hallie's appearance just a bit.

Hallie's father, Jim Chambers, was not indicted, but he was wounded in the shoot-out and "was crippled for the rest of his life," McCoy said. "He was shot through the hip. Actually, for historical purposes, I understand his testicle was shot off, too. He really gave up a lot for the union cause. They called him Flunky Jim Chambers after that."

We continued to examine the picture. McCoy's finger wandered over to a slender man in the back row whose head is cocked slightly. "This man, Claire Overstreet, became postmaster for the town." Then, to a round-faced man in the back row—"Charlie Kiser, who was a schoolteacher when he came here, became a union organizer. A lot of these people never worked in the mines again. They were on the blacklist."

It may not seem like punishment—banishment from a job exposing you to coal dust that would eventually rob you of your breath, to risk dying in an explosion or a rock fall—but it was, and that says something about the lack of opportunity in the mountains once the coal barons took over, and about why the miners were willing to kill for a bit of control over their work and their lives.

Before railroads came to Mingo County in 1892, most of the area's residents were farmers. That changed quickly, because trains ushered in the mining industry. Soon the once lovely West Virginia mountains were scarred, black dust covered everything, and streams were brimming with acid runoff. Industrial noise lacerated the mountain silence. Coal companies bought up land rights, and farmers who'd spent their days in the sun suddenly found themselves plunged into dark, damp holes several hundred feet underground, performing dangerous work. Hallie Chambers, for example, had lost sight in one eye as the result of injuries he'd sustained in a rock fall, the most common killer of miners.

Miners and their union wanted improved safety, but safety wasn't free. It took time and money to

ventilate dangerous and explosive gasses out of mines, to properly support mine roofs. Coal operators balked and kept their money. Miners continued to die, and still they went into the holes, day after day. What choice did they have?

So when coal operators reacted with a heavy hand to the miners' organizing drive, miners got miffed. They got tired of having no control, no freedom, got tired of being powerless. So they picked up their guns and assumed some power. Took out their frustrations on the Baldwin-Felts men, the very symbols of the coal barons' ruthless ways. You'd think the miners, by playing David to the coal operators' Goliath, would have been local heroes from day one. They weren't.

In Mingo County a story untold by the silent miners underwent a metamorphosis and emerged as a simple tale that coal operators and their allies were willing to tell: the miners were cold-blooded murderers whose deed had become a shameful blot on an otherwise peaceful and industrious town. "We bought into the idea that these were low-life killers," McCoy said.

Then came the movie, 142 minutes of cinema that turned bad guys into good guys. Sid Hatfield and his boys finally got their hero status. Suddenly strangers began showing up in Matewan. They had video cameras and questions about the battle, about Sid and the miners. Where are the bullet holes? they wondered.

Town leaders like McCoy saw this sudden interest in the Matewan's history as an opportunity—a rare thing in a town stuck in the middle of nowhere—and so Matewan reinvented itself. A development center was opened, grants were secured, old buildings were renovated to look like they did in 1920, disruptive traffic was rerouted, and the Army Corps of Engineers built its $60 million flood wall, keeping the Tug Fork in check.

After decades of economic struggle, the town was poised to make some money, to finally enjoy a bit of success. Was it all real? Would people really steer their minivans off the interstate and drive an hour on tangled roads to see this quaint town, to see its bullet holes and hear its story? And if they did, what would follow? When the trains came, the coal industry followed and brought with it a little piece of hell. Would one hundred years of progress simply replace the scars on Mingo County's landscape, trading Happy Meal boxes and brightly lit 7-Eleven signs for ugly mine holes and black coal dust?

If there is a way to avoid repeating mistakes of the past, David Reynolds hoped to find it. I discovered Reynolds a few doors down from McCoy, in the Matewan Development Office, where Reynolds was director. With pictures of Sid Hatfield, C. C. Testerman, Devil "Anse" Hatfield, and others from Matewan's past staring down at us, Reynolds said, "We need to make sure we preserve this downtown historic district, which I see as one of the keys to any sort of economic prosperity. I don't want to fly golden arches over the massacre scene. It's hard to convince the town of that. They're so hungry for development that there's a real danger they'll take anything they can, whatever is first."

But Reynolds's perspective was that of an outsider (he was from California), a somewhat young (age thirty-two), well-educated professional who had options in life. What if all you've ever known and tasted are the hills and valleys of southern West Virginia, a place that has few options? Reynolds had the difficult job of convincing a very hungry patron to pass up a hamburger on the mere promise of something a bit more healthy, something that won't eventually bring grief.

While we talked, another train roared by on tracks just several yards from where we sat in air-conditioned comfort. Reynolds talked on—like all

people in this town, he's used to the trains. Then the quiet returned. I left minutes later, walked out into the heat of a late spring day and heard a new sound, one less familiar and weaker than that of the trains. It was the whine of a power saw, and it was followed seconds later by the pounding of a hammer. Workers a few blocks away were completing a new town hall. Oddly enough, I found the sounds pleasing. Unlike the frenetic cacophony of noise from the trains, which reminds me of my insignificance, how quickly I could be crushed if I stood in the wrong place, the construction noise was human in pace and scale. Blocks away from the action, I could close my eyes and build an image from the sound: someone measures a space, cuts the wood, nails it in place, begins the process again. From where I stood on Mate Street, the noise seemed sweet, almost musical.

ii

The mayor of Matewan had stepped into the kitchen of his house to take a phone call, his voice muffled a bit through the walls. His wife, Sue, and I were nearby in the living room, sitting in chairs and talking about a meeting she'd arranged between some local honors students and a West Virginia congressman. We paid no attention as the mayor hung up the phone, then rattled around a bit in the back of the house. Finally, he returned, and our conversation ground to a sudden halt. Johnny Fullen is a big man—six-feet, four inches tall—with tufts of wild hair on the sides of his head, and even when he's dressed in his after-work attire (shorts, a T-shirt, and house shoes), as he was on that day, his presence can be intimidating. When he carries a rifle, as he was doing as he entered the room, the effect is shocking.

For a second, there was silence. Then Fullen held the rifle before him, like a proud papa holding a baby to be christened. He stared at it lovingly.

"Now, *this* is some history," he said.

Without flinching, Sue picked up where she had stopped and quickly finished the story about her students' meeting with the congressman. "And they were just really thrilled," she said before relinquishing the floor to her husband and his baby.

"This was used in the massacre," Fullen explained as he walked to a stool in the center of the room and took a seat. "Someone years later pawned it to my grandfather. I can't remember who. I have a pistol, too. It's around here someplace."

The single shot rifle was simple in design and looked tiny in the hands of such a large man. It was a small caliber gun, the type used to hunt rabbits or to plink tin cans. "Stevens Regular U.S. Patent Office" was stamped on it.

"What kind of rifle is that?" I asked.

"Now, you're talking to the wrong person," he replied. "I don't know anything about guns. That's what's funny. I was born and raised in these hills, and I don't know nothing about fishing, don't know nothing about hunting, nothing about guns. I don't even know how to start a fire."

I examined the gun closely while Fullen held it, then I reached out to touch the wooden stock. Fullen pulled the firearm closer to his body. It was a quick but subtle move, just enough to let me know he was protective of this piece of family history, of Matewan history. You can look, he was telling me, but don't get too close. And no touching.

It was a common response to an outsider asking questions about the 1920 shootings. The sons and grandsons of those who were downtown that day hinted at what they knew, what they had been told. I would hear an anecdote and then, after writing it down in a notebook, would look up and see the eyes of the storyteller boring in on me. They would watch me closely, measuring for trustworthiness. Coal and history are Mingo County's most valuable

resources. The coal was blasted and ripped from the earth, then hauled away, along with the profits. No mansions can be found in Matewan. Instead, there are bad backs, blackened lungs, a few bullet holes, an unemployment rate that hovers just under 15 percent, and plenty of stories. Large veins of stories. Deep, rich veins. You can mine a few, if you take your time, work carefully, slowly, show that you respect the story and the teller. But you'll not get the full load. People here are quickly learning the value of their history—it has already paid off in the form of a flood wall, new roads, and a rehabilitated downtown. This time, however, the resource will be carefully measured out. There will be no blasting, no ripping and running, as there was with coal.

Still, there is plenty to be told. Johnny Fullen said that in 1896 his grandfather, John Brown, moved from Virginia to Mingo County. He was a teenager and one of the first blacks to move into the Matewan area. Brown found work in some of the downtown businesses and, by the late 1910s, had become a business owner himself, operating a dry cleaning establishment and a restaurant called the Do Drop Inn.

Brown was warned that there would be trouble in Matewan on May 19, 1920. He was downtown when the shooting started, and he apparently witnessed something that made Sid Hatfield very nervous. Hatfield put out the word: John Brown would be silenced. At the time, people took such threats seriously. It was easy to get killed in the West Virginia coalfields. So Brown left town, went south into Virginia, and stayed there until things cooled down. Fullen's not certain how long the exile lasted, perhaps a year. By mid-August 1921, the issue was moot—Hatfield had been silenced himself and lay buried on a Kentucky hillside.

Brown returned to Matewan. The businessmen respected him and wanted him to come back,

Fullen explained. But his troubles weren't over. In 1924, the two-story wood-frame building that housed the Do Drop Inn was burned in a fire that killed one boy living with a family in an upstairs apartment. Fullen hints that the fire was a message to Brown to keep quiet about what he knew.

Nearly seventy years later, the grandson would receive his own hint. It was in the early 1990s, Fullen was mayor and the town was looking for ways to take advantage of the sudden interest generated by the movie *Matewan*. In Fullen's mailbox one day was an unsigned postcard. "It was just telling me, in essence, to let it all die," Fullen said.

It was the silence of an earlier generation, trying to impose its will on its children. "All through high school we had West Virginia history," Fullen said. "We never read anything about the Matewan Massacre."

Such stories were kept in the family. Sue Fullen said that a reporter from *Time* magazine stopped by one day in the late 1980s and interviewed John Brown's wife, Mary Brown, but didn't get much information. "John here is the only one she ever really opened up to," Sue said.

And just what did Mary Brown tell her grandson? I asked him several questions, but he told me nothing I hadn't heard before. "I'm probably guilty of saying only so much, then holding back," he admitted. "Yeah, I know I'm probably guilty."

Fullen talked often about his grandparents. He was very close to both John and Mary Brown. "They took me the day I was born," Fullen explained. "They raised me, named me, everything."

Mary Brown was present the day Fullen was born (the event took place in a two-story brick building next to his current home on Mate Street). When news of the birth reached John Brown, he left his dry cleaning business, "and he came down and took me, just took me," Fullen said.

"And your parents?" I asked.

"My mother is named Helen," Fullen said. She was very much dependent on her parents and had no choice but to give up her baby, he added.

"And your father?"

"I don't even mention my father," Fullen responded, gesturing with a chopping motion, indicating that the discussion on the subject had ended.

Johnny Fullen, in addition to being Matewan's mayor, works as an assistant superintendent at the Mingo County Board of Education. One day at work he got a phone call. On the line was the son of President Warren G. Harding, Fullen said. He was calling from Long Beach, California.

"Was it his son, or his grandson?" Sue tried to remember.

"No, it was his son," Fullen responded. "He was in his seventies." Fullen couldn't remember the man's name.

President Harding had sent federal troops to West Virginia in September 1921 to quell the miners' rebellion sparked by Hatfield's murder a few weeks earlier. Thousands of West Virginia's miners had grabbed their hunting rifles and gathered near Charleston, then began marching south toward Mingo County, where martial law had been declared. Their intent was to free the county's beleaguered miners from the grip of greedy coal operators.

At Blair Mountain, halfway to Matewan, the miners were met by another ragtag army formed by Logan County Sheriff Don Chafin. On Wednesday, August 31, the shooting began. The clash, along a ten-mile front, involved an estimated ten thousand men. It was a bizarre battle. Bullets whizzed all over the mountain, but most of the shooting was inaccurate. Anything that moved was a target. A miner quoted in Savage's book said participants were as likely to be shot in the back by their own troops as by the enemy. At one point, a biplane buzzed over the miners' lines and dropped a make-shift bomb—actually, a pipe filled with TNT. It exploded, but no one was hurt.

By the weekend, however, the war had died down. Harding had sent federal troops to the area, and the miners couldn't bring themselves to battle the U.S. government. They surrendered in large numbers. Some voluntarily gave up their guns. Others simply left the area, disappeared into the mountains, and went home on foot. Harding's action helped to destroy the drive to organize miners in Mingo County. For the next decade, union membership in West Virginia plummeted. The UMWA wouldn't take firm hold until the 1930s, when the Depression gripped the country and Franklin D. Roosevelt occupied the White House.

I asked Fullen what Harding's son had to say to the mayor of a small West Virginia town.

"He wanted to apologize," Fullen said. "He talked a long time, told me a lot of history about his father and said, 'My father never really wanted to send in troops in West Virginia, but there was so much big money. The coal industry was pushing and so he did it.'"

And what prompted this sudden apology, so many decades after his father's death?

He'd just seen the movie *Matewan,* Fullen said.

As a member of one of the oldest black families in Mingo County, Fullen was in a unique position to discuss race in southern West Virginia. In Matewan, at least, his race is seldom even discussed. An opponent in a mayoral race once tried to make Fullen's skin color an issue—"He used the N-word a lot," Fullen said. But the attempt backfired and Fullen won the election. The Ku Klux Klan once planned a march in Matewan. But on the chosen date, no one showed up.

"Race relations in this little community is probably better than in any other community in West Virginia," he said. "You know what I attribute it to?

People came here at the turn of the century, they all went in those mines, they worked hard—if you didn't go in the mines and work hard, you had a business and you worked hard—and for some reason, the people just seemed to get along. The work seemed to bind them together. Now there was racism, you better believe it, actual real racism, but I think it was a little better here, I really do."

iii

When he was a boy, Hiram Phillips went to his father's house and said, "Poppy, give me two dollars to buy a pair of shoes to go to school." The father didn't say no. He didn't have to. "Money is hard to come by these days," was all he said. So Hiram turned around and walked out the door, never again asking his father for anything, the father never offering.

So what was the son to make of that? For more than seventy years he rolled it around in his head, where it remained, crowded next to the knowledge that his birth may have been partly to blame for the downward spiral of his father's life. Hiram was the last of thirteen children his father and mother had brought into the world, and it was his father's frustration with his inability to care for such a large brood that finally drove the father away.

After his parents split, Hiram said, his father became mean, crabby, and hateful, a poor man who ate from a tin can and eked out a living as a door-to-door salesman, pedaling salt, sugar, and flour. The old man died of a kidney ailment in 1935 with thirty dollars in his pocket. It was a bad time for the family. That same year, one of Hiram's older brothers would die of wounds suffered in a knife fight.

Now the youngest son was himself an old man, much older than his father had ever been. For decades Hiram carried these pieces of his father, memories of abandonment and bitterness, just as

he had carried his father's name. As the son talked, I waited for the bitterness to pour out. Surely it would come.

Only it didn't and I wondered why. Perhaps it was because Hiram Phillips understood. He had worked in the mines, like his father before him, and he knew how the work could physically break a man. He knew his father endured the loss of two of his children, who had died as babies. He knew his father watched as Baldwin-Felts agents tossed his family from its home. Then there was the life in tent cities, and the madness of the coal wars of the early 1920s, when a machine gun on the Kentucky side of the Tug Fork sprayed bullets into Blackberry City, a small West Virginia village that was home to a few union sympathizers. The Phillips family lived there, too. Hiram was just a young boy at the time, but the memory of whistling bullets remained with him.

How much was a father to endure before bolting from his family, receding into himself, and showing his coldness to everyone, even his youngest child? Hiram realized his father's actions were not honorable or endearing—perhaps they were even disgusting—but every man has his breaking point.

"I remember one time he cut my fingernails," Hiram said. "I stood up between his legs and he cut my fingernails. That's as near as I ever got to him."

Hiram had inherited a bit of his father's crabbiness. At least that's what I'd been told by those in town. Hiram himself will tell you—"They say you're supposed to speak to everybody," he said. "I say, 'To hell with these people.' Me, I don't speak to 'em."

But Hiram proved he could be charming. A small man with a long, narrow face, deeply creased with age, he tends to look at the ground when he talks, and his voice is soft, almost a whisper, not harsh.

When I asked if he had seen the Sayles movie

that made the town famous, he replied: "I went to it. I stayed through half of it, just half of it is what I stayed for, and I got tired of it. I said, 'Shoot, this ain't nothing,' so I left. I paid five dollars and I seen two dollars and a half of it."

He remembers Reece Chambers, who came into his store one day and complained about the sorry state of the tomato plants on display.

"If they don't look so good, then don't buy 'em," Hiram shot back.

"You don't know who I am," Chambers said.

"I don't give a damn who you are."

"I'm Reece Chambers."

"I've never even heard of Reece Chambers."

And after that exchange, Chambers became a regular customer. "We got along good," said Hiram.

When I asked what he knew about the 1920 shootings, he leaned forward in his chair and said softly, "One man told me—I guess I shouldn't say this—but he told me, 'I was there . . . and it was pure, bloody murder.' He said them Baldwin-Felts men had already put their rifles in their cases and put them on the train. Now, I guess I'll get hung for saying that."

Then Hiram leaned back in his chair. He reveled in his role as the town's crotchety old man, an iconoclast who winked when he played the part. In

his effort to keep a bit of the father within him, he could summon his own attitude, but he knew he lacked the stockpile of failure that fueled his father's bitterness.

A measure of success had come to the younger Hiram Phillips, had made him an easier man to know, but that success took a meandering route. He quit the mines after seventeen years, moved out to California and worked in an automobile factory for one month. Then he moved to Columbus, Ohio, and worked in a factory that manufactured tablecloths. After two months there, he went someplace else— "I forget where it was," he said— and finally moved back to Mingo County, the lure of the mountains and home being too much to resist. After a few years of odd jobs and unemployment, he bought a seed store that had been operating in Matewan and, he said, "made a killing" selling everything from baby chicks to tomato plants.

More than three decades later, his business had dribbled to nothing. The building was going to seed and was mostly empty. It didn't matter. Hiram was in his eightieth year, and he had invested wisely enough in stocks to draw a thousand dollars a month, an amount that allowed him to live quite comfortably in Matewan. Despite the poor example of his father, Hiram had managed to maintain a marriage and raise three children.

I found Hiram in the back of his store, behind a makeshift wall of flattened Hotpointe refrigerator boxes standing on end. Flimsy walls inside a flimsy building. He was sitting in a rocking chair next to his wood stove, and surrounding him were empty pop bottles, crumpled candy wrappers, and books authored by people obsessed with the apex: *Surviving at the Top,* by Donald Trump, and *Over the Top,* by Zig Ziglar. Hiram wore blue jeans, a denim jacket, and a baseball cap with a tag dangling in the back: "$2.98," it read.

Later that day, the spring air became warm and

Hiram left his cardboard room and moved to his store's porch where he was surrounded by flowers planted in large ceramic pots. As I left town for the day, I saw him there, a man in faded denim sitting in a sea of red, pink, and white blossoms.

is

I summoned another story of fathers and sons and survival by ringing a bell, one of those bells attached to a door that rings once when the door is opened and again when the door is closed. The bell jarred a young clerk behind the counter from her daydreams of anyplace but this small department store on Mate Street. On a brilliant spring morning, she was surrounded by basketballs, long johns, pantyhose, batteries, cowboy boots, and virtually anything else someone in the West Virginia mountains may need. A radio played heavy metal music by a band called AC/DC, the singer screaming something about money and love, and the young lady mustered a smile as if the song suddenly reminded her of why she was there.

For her, the answer was simple. In Mingo County, you work where you can, and you're damn happy about it. For the man I met a few seconds later, the man standing in the back of the store and dressed impeccably in a brown three-piece suit, the answer was more complex. His name was Eddie Nenni, and though he was only sixty years old, the path that led him to this place was ninety years long. He recounted the journey in forty minutes, the amount of time that passed before the next customer walked through the door and set off the bell. Eddie Nenni's story was fascinating. It included tales of driverless Model T Fords—Eddie calls them "T Model Fords"—that maneuvered the area's rutted roads, of harmonica music that summoned broken shoes, of college educations, and dreams cut short by nervous breakdowns. His was a story of fathers who passed attitudes and at-

tributes to sons, of a family that struggled and succeeded in defining itself through its work, but in doing so paid a heavy price.

And about the town's most famous incident? He related one anecdote, about a woman from Alabama who stopped by the store shortly after the Sayles movie was released. She told Eddie that she had seen the movie, and when she returned home from the theater, she began describing the movie to her family, only to have her grandfather correct her on the details. Turns out the old Alabama man was in truth an old West Virginian, and he knew quite a bit. "I was in the shoot-out," he said. "I was in one of the upstairs windows, and I killed me one of them Baldwin-Felts detectives. I moved down here and hadn't said nothing about it until today because I feared for my life."

Of course, that's typical of the information I heard about the shootings—anecdotal, impossible to corroborate. Eddie Nenni did say his father had witnessed the shootings. Attilio Nenni ducked under a building when the bullets began to fly. But the son never asked much about what happened that day. Far more interesting to him were the stories of his grandfather's and father's successes and failures. And he began to tell these tales as soon as I showed an interest, his Appalachian tongue squeezing and bending the words, but not so much as I had heard elsewhere in Matewan, where the first part of each sentence is flung out quickly and the second half trails behind, coming out slower and slower until the final words collapse as soon as they leave the mouth. Eddie Nenni's words came quickly, and his sentences were tightly edited—he had told these stories before, enough times to become efficient in recounting them. They offered a glimpse of what life was like in the early 1900s for immigrants who brought unique skills and energy to the West Virginia coalfields.

"Grandfather brought his family here from a

little town outside of Rome, Italy," Eddie Nenni told me as we stood in the back of his store. "He had two children and a wife when he came to Matewan in 1909. They were here for about a year and decided to go to Chicago. They went up there and spent one winter. That was enough for them. They came back. He tried to go in the coal mines, grandfather did, and that lasted two or three days. He didn't want nothing to do with that."

Once out of the dark mines, the grandfather, John Nenni, took up a trade he had learned in Italy—shoe repair—and opened a business. It was a success, mostly because Nenni was an energetic and cunning entrepreneur. Then all the kids came along—six boys and seven girls. Nenni put them to work. "Grandfather took all the money," Eddie Nenni said. "It was for the family. That's the way they did it in those days." Eventually, the Nennis expanded and opened a transfer business, a beauty shop, a restaurant, and a department store, all based in tiny Matewan.

In the early 1920s, Eddie's father, Attilio, was assigned to travel to the different coal camps and communities to pick up shoes that needed repairs, to deliver those that had been fixed, and to collect payment. Though he was only about twelve years old, Attilio drove a Model T Ford to make his rounds. He awoke at five o'clock each morning, stacked books in the car seat so he could see out the windshield, and set off to work. "There was one camp he would go to, where all these Spanish people, Italian people, and Germans lived," Eddie Nenni recalled. "They told him, 'Now, when you get up here, there's no use in you knocking on all the doors. There's three songs we want you to learn on the harmonica. You just park your truck at the foot of the holler and play that harmonica and we'll bring the shoes down to you.' So that's what he did."

In the summer, the muddy roads would dry and harden, leaving deep ruts where automobiles and horse-drawn buggies had traveled. Attilio

Nenni could put his car in low gear and let it chug along in those ruts at a few miles an hour while he ran from house to house to do business. "One time he went somewhere up in North Matewan and somebody hollered at him, 'Hey, Atillio, your car's in the creek.' Well, it had jumped the rut and gone in the creek. And he had to drive it back out."

Customers looked out for young Attilio. A woman stopped the boy one day and asked if he had eaten lunch.

"Yes," Attilio said, "my mom fixed me a sandwich."

How can this boy survive on a sandwich? the woman wondered. Then she saw the sandwich—it was gigantic. A loaf of Italian bread more than a foot long had been hollowed out and filled with different meats, vegetables, and cheeses. "There was supper on the bottom, lunch in the middle, and breakfast on top," Eddie Nenni said. "He ate that sandwich all day."

For a moment, Eddie Nenni was silent and the music on the overhead speakers thrust us forward, from the 1920s to the 1960s—somebody singing, "Still in Saigon," a song about a veteran struggling with his nightmares of war. Then Eddie Nenni launched into a story about his family's first foray into the transfer business.

"Daddy said they had a family at North Matewan that wanted to be moved to Logan County, and he didn't know how much to charge these people because this was their first job. So he called Hogan Transfer and Storage in Williamson and said, 'Now, if you had a family in New Town and they were going to move to Logan and they had two truckloads of furniture, what would you charge?' They said ten dollars. Daddy said, 'Well, if they can charge ten dollars and make money, I can too.' So he called them back and said, 'We'll move you for ten dollars.'

"Now, when they left they had to back their

truck over the mountain here in Taylorville. They didn't have fuel pumps on the motors in those days and the motor would die if you drove forward at a steep angle, so they had to back it over the mountain. And another thing: it took a week to get to Logan. I told my son this and he said 'A week? Why, daddy, we went over in a Corvette and we were over and back in a couple of hours.' I said, 'Todd, they didn't have roads. You had to drive the truck in the creek, all the way over there and all the way back. They took beans in cans, and poured them on cardboard and ate them, and they drank creek water.' And of course, you can imagine what a six-year-old would say. He said, 'Why, Daddy, I would have just stopped at a Wendy's or something.' Anyway, it took them two weeks to move the family. Dad figured up, with expenses and everything, it cost them twelve dollars to move that family."

Eddie Nenni followed the story with a quick and infectious, high-pitched laugh. The family eventually learned to make money in the transfer business, he said, as they did in most of their ventures, but success exacted a price, especially on Attilio, the oldest of the thirteen Nenni children. He had a nervous breakdown in 1957—the result, doctors believed, of the lifelong pressure of working and supporting the family. The breakdown was not the first Attilio would suffer, nor was it the last—his first breakdown occurred in 1940, and he had at least two after 1957—but it was this one event that would forever change the son's life.

"I was at Marshall University at the time," Eddie Nenni said. "Mother called me. She said, 'You're going to have to come out of school.'"

So Eddie Nenni left the school in Huntington and returned to Matewan to help pay a five-thousand-dollar hospitalization bill. "That's how I got stuck in the store," Eddie Nenni said. "I probably wouldn't even be here, but I kept coming back here to help him. We needed to pay off the five grand. So I just kind of got stuck. And mom needed me.

The most important thing in life is if you're needed. You ever notice this? If you're needed somewhere you have a tendency to stay. That's what I'm doing here today."

Still, Eddie Nenni has made the best of the situation. He was a member of the Matewan town council. He managed to keep the last of the Nenni businesses afloat in a town punished by floods, isolation, and a shaky economy dependent upon the coal business. In his spare time, he played saxophone in a doo-wop band that performed at school dances and class reunions. He seemed a happy man, content with his life the way it was.

But before leaving, I had to ask one final question: Did he have any regrets that his life had turned out this way, that he had become the caretaker of his family's dwindling business?

"No, might as well not," he told me. "What's the use in it? Life's funny. You're dealt a hand and you play it the best you can during that time."

Wesley Houston Ward went to Europe to fight Hitler's Nazi regime. Then, his body whole, he returned home to Mingo County and worked in the coal mines. After nearly twenty years, he left the job but he couldn't leave the mines—remnants of the dark holes were with him to the end. In the last days of his life, he coughed up a dark foam. Wesley's wife, Mary, knew what it was. "There was still coal down there, in that one lung he had left."

By then, Wesley Ward's lungs were shot. One was useless, the other barely functional. Wesley gasped for breath while black lung, the scourge of coal miners, slowly took his life. He could only scratch his head at his luck: he'd survived World War II, but the mines would finish him.

He died on December 13, 1979. He was sixty-two years old, and he had lived with black lung for eighteen years. His was very much a coal miner's

death—each year black lung disease kills almost fifteen hundred people who have worked in the mines. And his life very much represented a mid-century coal miner's life—at the end, there was tragedy; in the beginning, violence.

His widow, Mary, had evidence of both. One moment she held a $122 check—black lung benefits for a miner's widow. The next moment, she held a picture of her husband, made when he was a baby. In the upper left corner was a bullet hole, a sign of the violence and desperation that gripped that part of the country eight decades earlier.

I talked with Mary on my third day in Matewan. A plump, white-haired woman, she lived in a small, one-story wood-frame house in Blackberry City, which is really a village, about a mile from Matewan. A drizzling rain had fallen all day, and low-hanging clouds had settled on the Appalachian Mountains, bringing with them coolness and gloom.

It was a day just like this—wet and dismal—in the spring of 1921 that all hell broke loose in Mingo County. Tension was high in the coalfields. Hatfield and his fellow defendants had been acquitted and, to the dismay of the coal operators, Hatfield had converted Mayor Testerman's old store into a gun shop. The UMWA was in the midst of a campaign to organize the area's miners, many of whom had armed themselves. There were rumors of a planned assault on nonunion mines; nonunion miners prepared for a fight.

Gunshots echoed in several mining communities around Matewan in the early morning hours of May 12, according to Savage's book. For three days, the battle raged. Union and nonunion forces blasted away at each other. The shooting became so intense in some places that it sounded like a continuous roar. Deputies across the river in Kentucky, a few hundred feet from Mary Ward's home, set up a machine gun and peppered Blackberry City. People dove into their basements and stayed

there, crawling on their stomachs if they needed to go upstairs for food or clothing. Bullets tore through telephone lines and houses. One day a bullet flew into the house Mary Ward and I were now standing in and pierced the image of a very young Wesley Houston Ward. Mary held the picture in the air and said with a chuckle, "They killed a poor little baby picture."

The shooting was brought to a halt when word spread that officials were considering sending in federal troops to restore peace. I'd heard about the conflict, known as the "Three Days War," from several people. It was a smaller action than the Battle of Blair Mountain, which would take place more than three months later. Mary Ward didn't remember the shooting—she was four years old in 1921—but she had hard evidence. We talked briefly in her living room, and then she said, "Follow me." We walked down a short hallway and into a small, cluttered room in the back of the house. Mary apologized for the mess—"I got a woman that's going to come and clean house," she said. Then she pointed out a simple wood mantle, painted white, on a far wall. It was punctured with four holes large enough to stick your finger in. "That's the evidence," she said. Gunmen on the Kentucky side of the river had a direct line of fire into the room.

For a few minutes we examined the mantle. Bullets had also blasted through windows and mirrors in the room. There may have been other bullet holes in the walls, Mary said, but dark paneling installed years ago had covered everything.

Mary's house was warm and inviting and the bullet holes only added to the charm of the place—proof that violence sometimes becomes fascinating, even attractive, as it ages. Up close, it's a bit uglier. I was reminded of a scene I had photographed in the early 1990s, when gangs in Pittsburgh's East End were terrorizing the area's residents. It was August and temperatures were in the

nineties. In one run-down apartment I met a wheelchair-bound woman in her seventies who sat in a room with boards over every window opening. The glass had been shot out a few days earlier during a gun battle on the street outside, and the boards were meant to stop any more bullets from coming in. The boards also kept out any light or fresh air, making the room so dark, stuffy, and hot that it felt more like a medieval prison cell than a bedroom.

Perhaps in time that dark, stuffy room would acquire its own charm. On the day I was there, I could sense only the dread of the woman hunched over in her wheelchair watching "The Price Is Right." Standing in Mary's house, I tried to recall that sense of fear and dread, and apply it to the room with the bullet-riddled mantle. It didn't work. I couldn't imagine a terrified mother crawling across the floor of this house. Mary's family pictures, the portrait of Jesus hanging on the wall, and a color television got in the way and reminded me that this was the home of a pleasant eighty-year-old woman. Finally, I gave up and asked Mary, "Why did they shoot into this house?"

Mary said her father-in-law, Thomas Ward, owned the house at the time, and he was a union sympathizer. In fact, he and other prounion miners held meetings here. Such meetings were always kept secret. Mary said that, when she was a girl, four or five men would sometimes come at night to her own family's house in a coal camp not far from Blackberry City. Her father, Willard Smith, would send her to bed, then lower the green window shades and the quiet, urgent voices could be heard through doors and down hallways. "See, my daddy was an organizer," Mary explained.

Though Mary had no memories of bullets crashing through houses, she certainly recalled the threats and intimidation aimed at those who wanted a union. One memory in particular stood out. When she was five years old, she and her

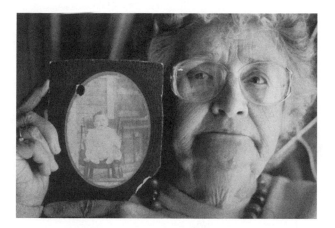

father walked along a railroad track not far from their home one day, and they were approached by a state policeman hostile to the union cause. The policeman glared at Willard Smith. "If you didn't have that little girl with you, I'd kill you right now," the policeman said. That event left its mark on Mary, and she easily remembers a few key details of that day: the policeman's leggings, his polished boots, and especially the bright, shiny stock on his rifle. As a little girl, she was learning a simple lesson, one that would be reinforced decades later when she watched her husband's long, slow decline and eventual death, "a torturous death," as she called it. The coal mining business could be cruel and mean, giving freely only of its bullets and its dust.

Mary talked with pride about how she learned to survive in a town dependent upon coal. It was a life of pinto beans and corn bread, she said. It was a garden out back, a privy in the corner, and a toolshed on one side the house and maybe a cow and a mule out back. "You see, it's farming," she said. "You have to farm a little bit because coal miners are off sometimes for weeks at a time."

Labor disputes and lack of demand for coal often brought hard times to the communities, she explained. "I was taught to work and I knew how to preserve foods, how to can foods, how to dry food,

to prepare for winter and all that. A woman can throw more out the door with a spoon than a man can bring in with a wheelbarrow. You have to manage things. I know how to manage. I was taught by my mother. She was pretty handy with an old Singer sewing machine, and she made our clothes, most of them. I watched her take pants, old pants my daddy wore out, and she'd take the bottom of the leg apart and make a girl's skirt. And then what was left she'd make a quilt."

Too many years had passed, and whatever woke Franklin Mounts on that cool March morning in 1945 was now a mystery. Why was he up and out of bed at 3 A.M.? Was it nature's call? Was it a noise in the West Virginia wilderness just outside his bedroom window? Or could it have been the inner turmoil caused by the news the family had learned by telegram the day before, the news that one of its sons, Franklin's older brother Quinten, was reported missing in action while fighting the Japanese on a piece of volcanic rock called Iwo Jima?

The answer was forever lost to time, but what Franklin Mounts did remember, fifty-five years later, was this: He walked into the family's living room on that dark morning and saw his mother, Ethel Mounts, on her knees next to the fireplace, praying for the missing son. He remembered her words: "Lord, I know no matter where he's at, you'll be with him." A thirteen-year-old boy sees his mother grieving, and it's an image he cannot forget.

A week later there was a man in uniform at the front door of the family's Blackberry City home, and the news became official. Quinten Mounts was dead at age twenty. Through it all, Ethel remained calm, prayerful, seeking strength in her church and in her faith. Life in West Virginia's coalfields had taught her how to deal with tragedy and violence. Her first husband had been crushed in a mine

accident in McDowell County, south of Matewan. She then migrated north to Mingo County and married her second husband, a man who would be tried and acquitted, along with Sid Hatfield and several others, for killing the Baldwin-Felts men in Matewan. And she would endure the 1921 fusillade at Blackberry City.

Franklin Mounts unfurled these memories of his mother while he and I sat in a small dining area in the middle of a supermarket near Williamson, West Virginia. Through overhead speakers we heard mindless pop music, occasionally punctuated by dry female voices announcing, "Price check on aisle three," or "Assistance on aisle one, please." We, however, were firmly fixed on an earlier generation, a time when Appalachian families pulled their produce from backyard gardens, not from supermarket grocery bins.

I had sought out Franklin to learn about his father, Ben Mounts, who had been dead several years. Ben is embedded in Matewan history—in the picture of the Matewan defendants that hangs in Robert McCoy's insurance office, Ben Mounts kneels in the front row. Talking to the son of one of those acquitted in the trial was as close as I would come to meeting an actual participant in the shootings. I had hoped to learn what information—and attitudes—the father had passed to his son.

But it was his mother's story that dominated our conversation. She had endured a lot in her eighty-eight years: the long hours forced upon her husband, the work stoppages and the resulting economic hardships, the occasional violence. In those conditions, Ethel Mounts raised eleven children. Her youngest was now a man with white hair and sixty-five years of life behind him, and as I sat and listened to him talk at length about his mother, dead since the early 1980s, the famed 1920 Matewan Massacre receded, until Franklin and I both had nearly forgotten it was the reason we had met. Finally, we dragged the massacre back into

the conversation, but only because we felt obligated to discuss the incident that made the town famous.

It makes you wonder: Is the decades-long silence over the Matewan Massacre due only to fear and shame? Or had the event simply found its natural, quiet place in the memories of a people who had suffered more than their share of tragedy and violence? In the years immediately following the shootings, there was certainly a danger and a very real fear that the Baldwin-Felts men would return to take their revenge. But as the years passed, other crises arose. It's difficult to imagine the Mounts family sitting on their porch and talking at length about the killing of a few Baldwin-Felts men, men who represented everything miners loathed about big coal companies. After all, there were children to be birthed and raised, hogs to be slaughtered, gardens to be tended. Then came the Depression and, after that, World War II, which took its share of Mingo County sons. At home, there was the occasional senseless act of violence, like the killing of one of Franklin's cousins, Bay McCoy, who was shot by Matewan police in the mid-1940s.

And so the Matewan Massacre was nudged into a back corner of the county's collective memory, an event mentioned only on occasion, only by the area's oldest men, who spent their time whittling and chewing tobacco. But there are other young men resting in graves, put there too early by mines, guns, illness, accidents, wars, and worry. No movie tells their story. It is only the fading memories of parents and brothers and sisters who keep them from being lost to time.

When she came to Blackberry City around 1917, Franklin Mounts's mother was known as Ethel Lambert. She had four children, some furniture, a few hogs and cows and some chickens. What she didn't have was a husband. Hiram Lambert, the man she had married years before, had been crushed in a rock fall in a mine near Coalwood in McDowell County. So Ethel bought train tickets for herself and her children, leased a boxcar to haul her possessions (including the assorted farm animals), and headed north to Mingo County, where her mother worked in a boardinghouse.

Ethel got off the train and bought a newly finished house for eight hundred dollars, using her husband's death benefits and money she'd made from the sale of the family's car. It was a simple house—"four rooms and a path," Franklin liked to say. "There was no bath. They used to kid me when I was growing up. They said, 'Frank, did you have running water when you was growing up?' I said, 'Yes, they'd give me a gallon bucket and say, *Run to the creek and get a gallon of water.*' Now, *that's* running water."

Once settled, Ethel met and married Ben Mounts, a widower himself, and the couple had seven more children.

The day after our first meeting, Franklin and I drove to the old Mounts home in Blackberry City. It has stood empty for years. Franklin remembered a time when he could sit on the front porch and watch trains pull into the old Matewan depot, watch the people coming and going, but overgrown brush and trees surrounded the place and blocked the view.

For a while, we poked around outside the house. The doors were locked, and Franklin had no key, but we were able to enter the basement through a side entrance and explore the area where the Mounts hid during the fusillade of the early 1920s. Inside, it was dark and musty. "Hope I don't get bit by a snake," Franklin said. Wooden shelves held glass jars, once used by Ethel, a prodigious vegetable and fruit canner. We also found an old meat grinder and a shelf full of seashells. It was odd to see evidence of a vacation and escape in a house firmly entrenched in a past in which those things were all but impossible. Overhead, gravity had coaxed pink insulation from its moorings in the joists, and here and there it draped downward.

For decades, the building had no real protection from the cold, Franklin said. He remembered sleeping in the "boys' room" with his brothers and watching snow blow in through spaces in the uneven walls. On those nights, the Mounts children would seek warmth under thick, feather-stuffed quilts. Christmas in those days meant a box of clothes from a Montgomery Ward catalog—usually a pair of brogans, overalls, and a wool shirt.

Ben Mounts remained a coal miner his entire life, Franklin said. He never owned a car, always walked to and from work, even though it was sometimes several miles. After he retired, Ben walked to downtown Matewan, sometimes two or three times a day, to visit friends and hang out. The old man died in 1980 at age ninety-two and is buried with Ethel, who lived to be eighty-eight, on a hillside a short distance from the house.

Quite often Ben Mounts would pass his leisure time on the porch, where he'd sit with friends, mostly fellow coal miners. The men would tell stories, sometimes drink moonshine whiskey from a jar, and chew tobacco. "All the men would chew that tobacco to moisten their mouths with spit," Franklin said. Frequent spitting kept coal dust from building up in a miner's mouth.

It was during those porch meetings that Franklin learned about the Matewan Massacre and the bitterness and resentment that led up to it. Franklin recalls hearing stories of families being put out of company houses, of men being denied pay after working a two-week pay period. The contracts that miners were forced to sign—the "yellow dog" contracts that kept miners from organizing—and dangerous working conditions added to the frustration.

Franklin said he wasn't told many details about the gunfight, but he remembers his father telling him, "It was pitiful the way the bodies were strewn here and there." Ben Mounts was in town when the shooting started, and he told his son this one story: After the initial gunfight, a wounded Baldwin-Felts detective cried out for a drink of water, apparently hoping for an act of kindness. He was sadly mistaken. One of the miners walked up to the agent, said, "I'll give you a drink of water," then shot him.

"Now, is that cruelty, or is it bitterness?" Franklin asked.

Franklin left Matewan to join the army in 1947 —he lied about his age to get in—and returned after five years to work a brief stint for a coal company. Then he went north to Chicago, where he worked for a tool-and-die factory and a trucking company. Then he moved to Columbus, Ohio, where there were so many Appalachian coal miners seeking factory work the locals joked that a West Virginia education included the three "R's": reading, writing, and Route 23, for the U.S. highway that carried them north.

In 1957, Franklin returned home, where he took a job with a railroad company. He stayed there thirty-four years.

Franklin and I poked around the old Mounts property for several minutes, wading through knee-high grass and weeds, looking at an old well and a small barn Franklin and his father had built. Then

the sky darkened and rain began to fall, lightly at first, then in sheets. We sought refuge in my car and, while rain pounded on the windshield and distorted our view of his former home, Franklin told me about his strongest memories of his parents.

He remembers his mother caring for others, for the sick, those who needed help. Before funeral homes became common, she sometimes helped neighboring families bathe and dress their dead, prepare them for burial. But Franklin's most powerful memory is that of his mother on her knees, her shoulders bent in prayer. She prayed throughout her life, and in later years her white hair was pulled in a tight bun.

His father, Ben Mounts, was a difficult man to know, even for the son. Franklin told me he remembered his father sitting in front of the house and singing hymns like "Amazing Grace." When I asked if Ben Mounts was a religious man, Franklin told me, "Later on in years, he probably was. But when he sat there in front of the house and drank moonshine, he wasn't." The drinking, he said, came every two weeks, at payday.

And like many men of his generation, like many of the fathers I'd learned about in my brief time in Matewan, Ben Mounts kept his secrets, doled out bits of himself only on special occasions, if at all.

"See, I've got kids and I tell them I love them all the time," Franklin said. "But I never heard him tell one of us that he loved us. I mean, it wasn't that he didn't, but he was not an outgoing person."

There was one exception. It was fleeting and it was silent, and it occurred in the late 1940s, while Franklin was returning to his military duties after a furlough. He'd gone to Williamson to catch a train for Norfolk, Virginia, where he was to be shipped overseas, and as the train passed through Matewan and then Blackberry City, Franklin looked out the window, toward his family's home, to see if his father would be at his usual spot on the front porch.

"He was there, whittling," Franklin said. "He looked up and he saw me, and he waved bye-bye at me, and you could see his lips working, 'I love you.' He never told me that in all his life except that one time."

vii

Ruffert Hollow is a narrow mountain valley a few miles north of Matewan, and meandering through it is a road barely wide enough for one car—if a vehicle approaches from the other direction, one of the cars has to back into a driveway to let the other pass. Tree-covered hills rise up on either side of the hollow, about a hundred yards apart. Driving into this place can be a bit claustrophobic. After half a mile or so, I began to wonder if the hollow would become so narrow and confining that I'd get wedged in and never get out.

Floyd Burgraff got wedged in. At least a part of him did. He grew up in the hollows of Mingo County and left in 1969, when there were few decent opportunities for a man in his early twenties. Like thousands of other West Virginians, he went north into the flat, open land of Ohio. There, he found a job in a Toledo glass factory and lived in the middle of the city. But the part of him that was stuck in the hollows of Mingo County could be stretched only so far, so long, and in the end, after more than three years, the tug became too strong and he went back home. He said he got tired of living in a place in which he knew none of his neighbors. Odd, how people in the city live so close, yet keep such a distance.

Back in Mingo County, in 1973, Burgraff landed a job driving a truck for a lumberyard. A year later, he was hired to work in a coal mine owned by U.S. Steel Corporation. It was a big break, and he knew it. Burgraff can still remember his starting date: February 1, 1974. The work paid well—coal mining continues to be one of the top-paying industrial

jobs available—and Burgraff grew to love working underground. His life became defined by tight spaces—the hollow in which he lived, and the rock walls of a hole hundreds of feet deep. He started in the mines as a general laborer and after six years found himself operating a device that drives bolts into the mine roof to keep it from collapsing. Mining was in his blood, Burgraff would say. "It's amazing. I love the mines."

Then, on November 9, 1991, Burgraff injured his back while trying to repair a broken conveyer belt. His boss told him to go take a rest, sit out the rest of the shift. Probably just pulled a muscle, the boss said.

The pain persisted, so Burgraff went to a hospital, where he was given some pills—he doesn't remember what was in those pills, but they took care of the pain. Burgraff returned to the mine, and continued to work. Eventually, though, the magic little pills were all gone, used up, and the pain resumed. He could barely walk. One day, his wife had to help him climb the few steps up to his house. His doctors told him he had four damaged disks. On December 26, Burgraff left the mine and never returned.

Five-and-a-half years later, Burgraff sat on the porch of his home in Ruffert Hollow and watched his six-year-old grandson play with friends. The children chased each other across the lawn and screamed, their voices bouncing off the hillsides. "Hey, hey. Y'all are too loud. Y'all settle down," Burgraff said to them. It seemed more of a request than a command, his words coming out slowly, bent into a West Virginia drawl. A few screaming kids were no big deal. The mountains are full of noises, especially during the day. Over the next hour, Burgraff would be bombarded with sound: roaring chain saws, the crowing of an obviously confused rooster alerting the hollow that it was mid-afternoon, a motorcycle, Santana songs blaring from a boom box across the road, where several

teenage boys tinkered under the hood of an old Dodge. Each sound bounced off the hills and became larger than itself. During it all, Burgraff never flinched. The noise didn't even cause him to pause in conversation—his voice rose and fell with the noise level, like a boat riding waves.

It was early afternoon, and I had spent a portion of the day looking for someone who could tell me what it was like to work in a modern coal mine. The local United Mine Workers Association hall in North Matewan was empty, so I walked to a nearby post office to ask if there were any coal miners in the area. A woman there directed me into the hollow, to Burgraff's home. He can tell you all about the mines, she said.

I found Burgraff sitting in a chair on his porch, working a new screen into an old window frame. I asked him what it was like to work in a mine, and answering the question gave him pleasure. He talked about the awesome power of today's coal-mining machinery, especially the "continuous miner," a metal monster with a large, seemingly misshapen, tooth-filled head that cuts into a coal seam and eliminates the need to use dynamite. Seeing one at work for the first time was frightening, he said. Would send a chill down your spine. He told me in detail about the different types of bolts and pins used to secure the mine roof, then pointed to his garden, where a few four-foot pins were being used as tomato stakes. Burgraff told me about the elevators that have made it easier to get into the mines. "It's just like mining a motel," he said. "Held twenty-two people, went down 222 feet." He told me about the hours and the money—he worked 8 A.M. to 4 P.M., and was paid between $140 and $150 each shift—and about the camaraderie that developed among those who worked in the mines.

Within twenty minutes, though, the mood of the conversation changed. Burgraff stopped working

rate hovering just under 15 percent, it all
e damage control. Gone forever are the
bbs that fathers and grandfathers held until
er retired or died. Fred Burgraff believes it,
Stone. Even the politicians believe there is
al left in these mountains. Would some-
else come along, another industry to replace
ne that had, for decades, maintained such a
plex, often violent and destructive, relationship
the people of this region? With its new flood
ll, its new downtown, Matewan seemed to em-
dy hope that the seemingly impossible can hap-
en. Such hope trickles slowly into the hollows,
where people sit around kitchen tables watching
their checking accounts dwindle, doing the math
over, then doing it again, trying to figure out what
kind of life is left for them after the one they've
known for years has slipped away.

Like those a generation ahead of her—Bob Stone,
Franklin Mounts, Fred Burgraff, countless oth-
ers—Christine Harmon left Matewan when she
was young, tasted life outside the embrace of
southern West Virginia, then returned. Like the
others, she can recount a family life defined by the
business of extracting coal from holes bored into
the earth (her father, like his father, was a miner,
and had been hurt by the mines). There, however,
the similarities end. At age twenty-seven, Christine
had youth and optimism. Her life was taking shape,
its lines and patterns becoming defined, but it had
yet to harden into a fixed and finished form.

Christine grew up a few miles north of town and
graduated from Matewan High School in 1988.
The job prospects at home were bleak, so in March
1989, she moved to Falls Church, Virginia, a town
of ten thousand a few miles from Washington,
D.C. She lived inside the Beltway, with its multiple
lanes of traffic, cars circling the nation's capital

like moths zeroing in on a flame. It was a big
change for a young woman who had never been out
of the West Virginia mountains, except to go to the
beach or to the Dollywood amusement park in
Tennessee on vacation.

Once settled, Christine landed a job as a bank
teller. She worked hard and eventually became a
loan officer. It wasn't always easy, but Christine
adjusted to a new way of living. She made friends
easily, and that helped. Every now and again, she
would make the eight-hour drive home to see her
family.

One day, in March 1995, two men entered the
branch where she worked and yelled "This is a
robbery!" It was just like the movies, Christine
said. One man brandished a gun and ordered all
customers to lay on the ground. Christine was at
her desk. "Don't move," the employees were told.

Two months later, in May, it happened again.
Two robberies, back-to-back. Living in a metropoli-
tan area had its good points—it was more conve-
nient, for one thing. You could go anywhere and
get anything at any time, day or night. You could
find a job with decent pay, good benefits. You could
have choices, meet new people every day. There
were hundreds of restaurants, dozens of radio
stations. But city life had its bad side, too. The
pace could be frenetic. Everyone was always on the

on the window. His hands fell still and he stared
blankly into the tree line twenty yards away. And he
began talking about not working in the mines,
about leaving a job that had helped define his life.
That hurt, he said. When he talked about pain—
"You wouldn't believe the pain. There just ain't no
pain like it"—he was talking about mental and
emotional anguish, not damaged disks.

"I told the old lady, 'I don't even own a gun, but
if I'd had one, I believe I'd used it,'" he said. "I
swear, I never hurt so bad in my life. No relief, you
couldn't get no relief, I don't care what you done.

"It got so bad I had to go to a psychiatrist and
they put me on medications, because I was going
to do something. I just couldn't sleep. I'd look out
windows. Three o'clock in the morning, I'd still be
sitting there, looking out the window. If they hadn't
got me when they had, got me under control a little
bit, helped me, I probably would have killed my-
self. That's the God's truth."

Valium was helping to control the anxiety, Bur-
graff said, and a drug called Zoloft kept the de-
pression demon away. Pills would not solve every
problem, though. What about the financial strain?
I asked. He gave me this history of his income: In
1991, before he was hurt, Burgraff brought home
about $1,300 every two weeks. That was cut in half
when he went on disability, which was discontin-
ued after five months when a physician ruled that
he had "reached the maximum improvement on an
injury." Burgraff then signed up for a miners'
benefit called "S&A"—sick and accident—and
received $203 every week for about one year. Then
that benefit expired. "My wife worked, and my
family helped, her family helped," he said. "It was
just tough." Finally, doctors ruled he would never
work again, so he signed up for Social Security,
which paid him $1,200 a month. He also drew
$398 in pension.

Burgraff wasn't starving, and he still had his
house—it was a fairly new home, a one-story,

wood-frame structure he built in 1991 before he
was injured. Though he'd never again work in the
mines, he would continue to live in Ruffert Hollow.
Burgraff owed a lot to the union, and he knew it.
"I've been a member for twenty-two, twenty-three
years," he said. Served as the chairman of the local
safety committee until he got hurt. Now, he simply
goes to the meetings. "I never miss a meeting," he
told me. "I go if I have to crawl."

I'd met several people in Matewan who felt
unions were outdated, that workers had garnered
too much power and were driving American busi-
nesses into the ground. Burgraff wasn't one of
those people. He was a die-hard union supporter,
perhaps because his family's roots extend deep into
the earth (both his father and grandfather had
pulled coal from the ground) and into the early,
violent attempts to organize Mingo County miners.
The name Fred Burgraff comes up often during
discussions about the Matewan Massacre. It is a
different Fred Burgraff, though, not the soft-
spoken, blue-jeaned and T-shirted man of forty-
eight that I spoke with. His great uncle is the one
standing next to Sid Hatfield in the picture of the
Matewan Massacre defendants. That Fred Burgraff
had a knack for being near the action—he was
tried and acquitted with Hatfield and the rest of
the crew in 1921, was later freed, along with Reece
Chambers, after a separate trial ended in a hung
jury, and was a suspect in the shooting death of the
hated hotel owner Anse Hatfield. Shortly after that
killing, a state police trooper found Burgraff
nearby, a rifle in his hands.

I asked Fred if his relatives had told him any-
thing about those violent days. "I don't remember
my grandfather that much," he replied. "I was about
seven or eight when he died. I can remember my
great uncle talking about it, but I was so young. . . .
The one Fred killed was the one that had already
been shot. The Baldwin-Felts man went on a porch
and sat in a rocking chair. Fred shot him in the

on the window. His hands fell still and he stared blankly into the tree line twenty yards away. And he began talking about not working in the mines, about leaving a job that had helped define his life. That hurt, he said. When he talked about pain—"You wouldn't believe the pain. There just ain't no pain like it"—he was talking about mental and emotional anguish, not damaged disks.

"I told the old lady, 'I don't even own a gun, but if I'd had one, I believe I'd used it,'" he said. "I swear, I never hurt so bad in my life. No relief, you couldn't get no relief, I don't care what you done.

"It got so bad I had to go to a psychiatrist and they put me on medications, because I was going to do something. I just couldn't sleep. I'd look out windows. Three o'clock in the morning, I'd still be sitting there, looking out the window. If they hadn't got me when they had, got me under control a little bit, helped me, I probably would have killed myself. That's the God's truth."

Valium was helping to control the anxiety, Burgraff said, and a drug called Zoloft kept the depression demon away. Pills would not solve every problem, though. What about the financial strain? I asked. He gave me this history of his income: In 1991, before he was hurt, Burgraff brought home about $1,300 every two weeks. That was cut in half when he went on disability, which was discontinued after five months when a physician ruled that he had "reached the maximum improvement on an injury." Burgraff then signed up for a miners' benefit called "S&A"—sick and accident—and received $203 every week for about one year. Then that benefit expired. "My wife worked, and my family helped, her family helped," he said. "It was just tough." Finally, doctors ruled he would never work again, so he signed up for Social Security, which paid him $1,200 a month. He also drew $398 in pension.

Burgraff wasn't starving, and he still had his house—it was a fairly new home, a one-story,

wood-frame structure he built in 1991 before he was injured. Though he'd never again work in the mines, he would continue to live in Ruffert Hollow. Burgraff owed a lot to the union, and he knew it. "I've been a member for twenty-two, twenty-three years," he said. Served as the chairman of the local safety committee until he got hurt. Now, he simply goes to the meetings. "I never miss a meeting," he told me. "I go if I have to crawl."

I'd met several people in Matewan who felt unions were outdated, that workers had garnered too much power and were driving American businesses into the ground. Burgraff wasn't one of those people. He was a die-hard union supporter, perhaps because his family's roots extend deep into the earth (both his father and grandfather had pulled coal from the ground) and into the early, violent attempts to organize Mingo County miners. The name Fred Burgraff comes up often during discussions about the Matewan Massacre. It is a different Fred Burgraff, though, not the soft-spoken, blue-jeaned and T-shirted man of forty-eight that I spoke with. His great uncle is the one standing next to Sid Hatfield in the picture of the Matewan Massacre defendants. That Fred Burgraff had a knack for being near the action—he was tried and acquitted with Hatfield and the rest of the crew in 1921, was later freed, along with Reece Chambers, after a separate trial ended in a hung jury, and was a suspect in the shooting death of the hated hotel owner Anse Hatfield. Shortly after that killing, a state police trooper found Burgraff nearby, a rifle in his hands.

I asked Fred if his relatives had told him anything about those violent days. "I don't remember my grandfather that much," he replied. "I was about seven or eight when he died. I can remember my great uncle talking about it, but I was so young. . . . The one Fred killed was the one that had already been shot. The Baldwin-Felts man went on a porch and sat in a rocking chair. Fred shot him in the

head and killed him, finished him off."

Violence never completely disappeared, even after three-quarters of a century. Late one night in the mid-1980s, during a bitter fifteen-month-long strike against the largest coal operator in the area—A. T. Massey Coal Company—a loud boom rattled Burgraff's windows. An attempt had been made to blast one of the company's tipples out of existence. "They didn't succeed," Burgraff told me. "I reckon they didn't use enough dynamite."

It was a time when roads were littered with jack-rocks—nails bent and welded so that one sharp end always sticks skyward, to puncture the tires of trucks delivering "scab" coal. Some trucks were fitted with Plexiglas instead of glass so that rocks and other objects aimed at drivers wouldn't break through. The strike ended with the union becoming a weaker presence in West Virginia's coal mines—some miners went back without a contract, others identified as troublemakers did not.

"There's still hard feelings," Burgraff said. "I had friends"—then he paused briefly—"the guy who got me a job in the mine, I thought the world of him. But I wouldn't help him now for nothing."

"Why?" I asked.

"He's one of the main men that run over top of these pickets, run over the top of the union," Burgraff said. "I like him, but I don't want nothing to do with him. Here's where I am: If I go down the road and see what I call a scab running a place of business, he won't get none of my money. I'll go twenty miles away before I spend a dime with them. That's just the way I am. Always have been. The old lady gets mad at me, but that's just the way I am. I'm union. Been union all my life."

For a few minutes, we watched the children play. What future do these hollows hold for them? I wondered.

"Most of the younger people will have to leave," Burgraff said. "Your older people, the ones that are disabled, the ones that are retired, they'll probably stay here. There just ain't nothing here. There ain't going to be no big jobs no more, what you call lifetime, retiring at the mines. Ain't going to be like that no more. They're gone."

viii

Bob Stone knew luck had been with him, and he mentioned it quite often—by my count, four times in a sixty-minute conversation. I met Stone on an afternoon in which day-long rains had darkened every hard, porous surface—concrete walkways, dirt, brick facades. Coal trucks accelerating on state roads threw up a fine, dirty mist that trailed off behind them. From a distance, they looked like ugly, Earth-bound comets. Up close, driving behind them, I saw only huge black tires and a gray tailgate. Then the mist swallowed me until the windshield wipers returned on the backbeat.

I met Stone at the door of his house, about half a mile from downtown Matewan. He invited me into the living room and said, "Too cold in here for you? I could turn on the furnace." He switched on a lamp and from across the room I could see that his hair was white and the skin on his jaw was just beginning to sag.

Stone then told me about his luck. It had actually come in a batch—all at once, it arrived, some of it good, some bad. The bad occurred seven months ago, he explained. On October 10, 1996, Old Ben Coal Company announced it was shutting down the mine in which Stone worked. You've got sixty days, the miners were told. The next day, the boss said this is it, there's no more work here. We're closing down immediately.

Stone signed up for unemployment and, like thousands of others, began to wonder what to do with himself. He had spent twenty-one years of his working life in the mines. Who would hire a fifty-seven-year-old miner? Where would he go? K-Mart for five or six dollars an hour? What kind of job is

that for a man who, for more than two decades, went into a work environment where "everything is always against you, the bottom, the top, everything," and, every day, came out a survivor. Coal miners endured confining space, dangerous electrical wires, moisture, gasses, deadly dust (Stone's father had suffered from black lung and received his first black lung benefit check on the day he died), and earned enough money (nearly fifty thousand dollars on average) to support a family. There was satisfaction in that, and some tradition. It gave them a feeling they had a place in the world.

Stone was out of work for a month, then his good luck kicked in and he was offered a job as an outreach worker with the Farm Resource Center, a not-for-profit, Illinois-based agency that helps the families of farmers and coal miners who are dealing with crisis. The offer itself proved to be a savior for Stone. "I don't know what I'd have done if this job hadn't come along," he said. "Oh, yeah, I was very lucky."

Stone now assists others with the problems he briefly faced months ago. He meets with laid-off miners and their families, helps them cope with the stress, depression, and financial problems that result from unemployment. Often, he'll link families with other agencies—if the family needs food, for example, he'll connect it with a food bank. If a miner dies, he'll help the survivors fill out the appropriate forms so they can receive benefits.

Stone is uniquely qualified for the job. He knows about paperwork and bureaucracy, knows about pensions and benefits—for years, he was active in the United Mine Workers Association and headed several committees. He spent two years as a lobbyist in Charleston, the state capital. And he'd experienced much of the turmoil his clients endured. He knew about divorce (his first marriage ended years ago), about financial stress, knew the wreckage unemployment could cause.

"It's devastating," Stone said, "because the

husband most of the time withdraws to himself, okay? He's been used to working, bringing checks home, bringing money home to his family. He withdraws from his wife . . . he won't even answer her questions. It brings a lot of stress. A lot of these guys get divorced before it's over with."

It's easy to lose hope, to feel trapped, he explained. Sometimes it's too much to handle. I thought of Fred Burgraff. He had told me about his problems with depression and anxiety, and how close he had come to considering suicide. Burgraff's case isn't unusual, Stone said. Half of those he assesses have suicidal thoughts. Stone couldn't discuss specifics—information about clients is confidential, he explained—but said one of his clients had gone as far planning his own death. Stone got the man professional help.

For some unemployed miners, leaving the state in search of work is the only answer—it's a decades-long tradition, one that Stone followed years earlier. (A McDowell County native, he held a number of jobs in the Columbus, Ohio, area when he was in his twenties and early thirties.) Others end up losing cars and homes, then file for bankruptcy.

"You take a person that's worked all his life, had a good job and a house, or a trailer or whatever, cars, maybe a truck, got clothes, and all of a sudden you don't have any money—they can't get any help," Stone said. "There's nothing out there for them. Because you've got a house with property, got an automobile, you don't qualify for nothing. So you lose everything you've got."

"So what advice do you give?" I asked.

"I tell these guys, when they first get laid off, not to sit around on their couches. Get down to the bank, get your bills consolidated, you know what I'm talking about? You can't wait till everything breaks up on you."

Such action can cushion the financial impact, give the unemployed a bit more time to find new work. Still, in a county with few jobs and an unem-

105

ployment rate hovering just under 15 percent, it all seems like damage control. Gone forever are the mining jobs that fathers and grandfathers held until they either retired or died. Fred Burgraff believes it, so does Stone. Even the politicians believe there is little coal left in these mountains. Would something else come along, another industry to replace the one that had, for decades, maintained such a complex, often violent and destructive, relationship with the people of this region? With its new flood wall, its new downtown, Matewan seemed to embody hope that the seemingly impossible can happen. Such hope trickles slowly into the hollows, where people sit around kitchen tables watching their checking accounts dwindle, doing the math over, then doing it again, trying to figure out what kind of life is left for them after the one they've known for years has slipped away.

Like those a generation ahead of her—Bob Stone, Franklin Mounts, Fred Burgraff, countless others—Christine Harmon left Matewan when she was young, tasted life outside the embrace of southern West Virginia, then returned. Like the others, she can recount a family life defined by the business of extracting coal from holes bored into the earth (her father, like his father, was a miner, and had been hurt by the mines). There, however, the similarities end. At age twenty-seven, Christine had youth and optimism. Her life was taking shape, its lines and patterns becoming defined, but it had yet to harden into a fixed and finished form.

Christine grew up a few miles north of town and graduated from Matewan High School in 1988. The job prospects at home were bleak, so in March 1989, she moved to Falls Church, Virginia, a town of ten thousand a few miles from Washington, D.C. She lived inside the Beltway, with its multiple lanes of traffic, cars circling the nation's capital like moths zeroing in on a flame. It was a big change for a young woman who had never been out of the West Virginia mountains, except to go to the beach or to the Dollywood amusement park in Tennessee on vacation.

Once settled, Christine landed a job as a bank teller. She worked hard and eventually became a loan officer. It wasn't always easy, but Christine adjusted to a new way of living. She made friends easily, and that helped. Every now and again, she would make the eight-hour drive home to see her family.

One day, in March 1995, two men entered the branch where she worked and yelled "This is a robbery!" It was just like the movies, Christine said. One man brandished a gun and ordered all customers to lay on the ground. Christine was at her desk. "Don't move," the employees were told.

Two months later, in May, it happened again. Two robberies, back-to-back. Living in a metropolitan area had its good points—it was more convenient, for one thing. You could go anywhere and get anything at any time, day or night. You could find a job with decent pay, good benefits. You could have choices, meet new people every day. There were hundreds of restaurants, dozens of radio stations. But city life had its bad side, too. The pace could be frenetic. Everyone was always on the

Keith had told me earlier about his relationship with Florence, how the two had met at an auto body factory back in the 1930s. She was employed in the sewing department; he was a physically small man struggling to keep up with the ever-maddening pace of auto assembly work. They got married in 1934. "She was a pretty woman," Bob Keith had said. "Still is. She's ninety-two and she has her hair done every other week. Regular." Then, as proof, he opened his wallet to show me a picture of an attractive woman with white hair, perfectly coifed.

Nearly three years after the wedding came the sit-down strike, an event that helped trigger the formation of unions throughout the country, and the Keiths were right in the middle of it. Bob was holed up in the plant, cooking eggs by the crate for his fellow workers who were staying put until General Motors decided to recognize the United Auto Workers; Florence was at home, trying to keep things going with no money coming in. It was tough, but they did it. The UAW came of age in Flint, and the Keiths reaped the rewards, climbing into middle class and staying there. Keith spent twenty years on the line, mostly spraying auto bodies. He spent another twenty as an inspector before retiring. Worked his last day on March 10, 1968. "Got the date marked on a calendar at home," he said.

In retirement, the Keiths traveled. Drove through every state west of the Mississippi. Averaged twenty thousand miles a year. Florence read Zane Grey westerns and especially loved to visit ghost towns in Arizona.

Bob Keith and I arrived at his car, a monstrous Olds '98. "Time to get going," he said. "Got to look after my wife." We shook hands—Keith had a firm grip—and said good-bye. I sat in my car for several minutes, reading over the notes I had scribbled during our conversation. Keith emerged as someone whose life had bridged extremes—a farm boy who spent his working life in a factory; a devoted and faithful man in a city that knows what it's like to be forsaken, to be abandoned; a man asked to fondly recall the past (he's one of the few surviving veterans of the sit-down strike), yet troubled by the future. Would it haphazardly separate man from wife after more than sixty years of marriage? Or would there be some poetry in the inevitable passing? Keith had his own wish: "I just want to outlive her by one day. I don't want her to go to into a nursing home. She wouldn't last any time in there. She needs me."

Sadly, not every relationship is based on such devotion and love. In Flint I saw the ugly results of a dysfunctional marriage on a grand scale. It was a union not of man and wife, but of the small city of Flint and a giant company called General Motors.

The relationship began in the early 1900s. At the time, Flint was a small town whose people built carriages and wooden road carts—about a hundred thousand a year rolled out of the city's factories. One of those carriage builders, a man named Billy Durant, saw opportunity in the newly emerging automobile business. In 1904 he took over an ailing concern called Buick Motor Company, which had moved to Flint a year earlier. Durant proved to be a brilliant salesman. At the time, there were hundreds of car manufacturers across the country, most of them small, but by 1908 Durant and Buick were outselling them all, including the big ones, Ford and Cadillac. That same year, Durant brought together a number of automobile companies to form General Motors Company. The new company quickly grew to include suppliers of automobile parts—paint, glass, spark plugs—as well as car manufacturers like Cadillac and Oldsmobile and Oakland (later to become Pontiac).

Durant, however, proved better at selling than buying. Many of GM's purchases were ill advised,

and by 1910 a group of bankers had to rescue the company from a cash crunch. Subsequently, Durant lost control of GM. He regained it six years later, then lost control for good in 1920. The man whose vision, optimism, and energy gave birth to the world's largest corporation died in 1947, having spent his final years running a Flint bowling alley.

As the automobile industry grew, thousands of people poured into Flint, seeking work in General Motors' factories. The city's population ballooned from 13,000 in 1900 to 156,000 in 1930. The corporation thrived and Flint became the archetype of a company town, a submissive partner in a relationship built on dependency. General Motors was rich and powerful and its wishes became those of the city's politicians, police, and priests. The company line was unerringly carried by the local media. The city's partner had enchanted everyone—everyone with a title, power, or influence. Others were less enthralled. "General Motors owned everything in Flint," one labor writer said in the mid-1930s, "with the exception of the people; all they owned of them was their implacable hatred."

Workers despised the company because of the "speed-up." At the time, assembly line employees were paid by the unit—a few cents for every car on which a worker completed his assigned task. General Motors had a habit of increasing the pace of assembly line work, pushing employees to toil harder and faster, while at the same time dropping the amount paid per unit. The result for GM was increased production without increased cost. One by-product was a bone-weary workforce. "Flint workers had a peculiar gray, jaundiced color which long rest after the exhausting day's work did not erase," wrote union activist Henry Krause, who documented the strike in *The Many and the Few.* "Even on Sunday when they wore their best and walked in the open, one felt that one was in a city of tuberculars."

On December 30, 1936, that weary and jaundiced workforce turned militant. Employees took possession of GM's Fisher Body plants, demanding recognition of their union, the United Auto Workers, and control of the speed-up. The sit-down strike was a bold and innovative tactic—employees occupied the plant, making it impossible for the company to resume production with strikebreakers—and it worked. After forty-four days, the unshaven strikers emerged from GM's Flint facilities. They had victory and their union. Mass production work changed dramatically over the next several years. Unions sprouted throughout America's industries. Wages and working conditions improved, and millions of blue-collar families moved into middle class. They built new suburbs, bought automobiles and appliances, televisions and second cars. Sometimes they sent their children to college and into the white-collar world. For those sons and daughters without degrees, there was always the shop. By the late 1950s, wages in Flint were considerably higher than the national average, and the city was being called "The Happiest Town in Michigan."

Things began to change in the mid-1970s, however. An oil crisis sent gasoline prices soaring, and suddenly those huge, fuel-guzzling cars that Americans once loved—the kind of cars made in Flint—were out of vogue. Americans wanted vehicles that were smaller, less expensive, and more fuel efficient. They found those qualities in Japanese-made imports.

In twenty years, GM would lose a third of its U.S. market share and cut its workforce in half. In Flint, the effect was devastating. In 1978, GM employed seventy-eight thousand workers in Flint; by 1998 that number had shrunk to thirty-three thousand, and plants would continue to close. General Motors was pulling out, and Flint had become a town of shuttered businesses and declin-

ing neighborhoods. Crime rose to record levels. In 1998, FBI statistics showed that Flint had the nation's highest burglary rate. Three of every one hundred homes were broken into. Flint was, in 1995 and 1996, one of the nation's ten most dangerous cities. Such lawlessness was the by-product of a crumbling marriage between city and company.

Flint's politicians talked of diversifying the city's economy, of being less dependent upon General Motors, still the city's largest employer. But Flint floundered. Without GM, the city lacked jobs, real leadership, even an identity. An attempt to cash in on the forsaken city's historical connection to the automobile had been an embarrassing failure. Flint dolled itself up and tried to seduce tourists with an $80 million theme park called AutoWorld, described by the city's mayor as "a combination Disneyland and automobile museum." But no one was interested in an aging town that wanted only to talk about its former lover. AutoWorld was housed in a giant, sky-lit domed structure in downtown Flint, and among its attractions were a "musical assembly line" that traced the history of automobile manufacturing, old cars like the Stanley Steamer and Model T, and a giant V-6 engine three stories high, with special cutaway sections that allowed visitors to view its inner workings. Expectations were high when it opened in July 1984. "AutoWorld symbolizes a new beginning for Flint," the town's hopeful mayor said, "one full of growth and prosperity."

Within a month, however, newspaper stories began reporting problems at the park. People simply weren't coming, weren't willing to pay the $8.95 admission price. So the park was spruced up, entertainment was added, and ticket prices were cut. Still, few came. Flint's residents were unwilling to fork over their money and time to get a close-up look at the automobile industry. "I lived with that shit in the shop," said one auto worker

who had spent more than a dozen years on a GM assembly line. "Why would I pay to go see it?" Within a few years, AutoWorld closed.

Then, in 1989, the film *Roger & Me* documented the disastrous effects of downsizing on Flint, and filmmaker Michael Moore's unsuccessful efforts to get GM's then-chairman Roger Smith to visit the city. *Roger & Me* is at times hilarious, at times sad. Flint comes across as a city of abandoned storefronts, crumbling homes, evictions, empty factories, and emotionally devastated workers. Smith and GM are heartless and abusive. The film won a number of awards and made a ton of money for Warner Brothers. Millions of Americans learned about the ugly marriage in Michigan.

Suddenly, Flint was no longer a city; it was an icon. Flint was a busted dream, a broken promise, a padlocked factory gate, another morning-long wait at the unemployment office. It was a thousand parents waving good-bye to sons and daughters pulling out of a town with no jobs. It was the sudden and jarring sound of someone banging on your front door, someone with an eviction notice. It was an embarrassing and futile attempt to try something new. The city's leaders struggled with Flint's image as a shuttered town. Larry Ford, the president of Flint's chamber of commerce, said *Roger & Me*'s portrayal of the city was "devastating." But Ford was an optimist. "There is an old adage in politics that says, 'Call me anything, just spell my name right,'" he said. At least Flint was no longer unknown. "I remember when I used to go out and travel around the country. People would ask me where I was from and I'd say, 'I'm from Flint, Michigan,' and they'd say, 'Where's that?' That doesn't happen anymore."

I drove to Flint on a day so wet with rain that the defroster in my car gave up and allowed fog to creep up the side windows. It took five hours to get there, and by the time I arrived, in late afternoon,

the clouds and rain had dissipated and sunlight was casting a golden glow on Saginaw Street, Flint's main downtown thoroughfare. The city, with a population of 140,000, is located along the Flint River, sixty miles northwest of Detroit. In the mid-1800s, while the area's vast forests of white pine were being recklessly exploited (and exhausted), Flint was a small town noted for its lumber mills. Though no longer small and no longer a town—it is Michigan's fourth-largest city—Flint still had a humble appearance. I saw a downtown that was unassuming and unpretentious. Most buildings were plain and simple structures, two and three stories high. Only half a dozen rose to ten or twelve stories. Some were new, with lots of glass; others were older but more elegant.

The business day had drawn to a close in Flint, and downtown workers were heading home to the neighborhoods and suburbs that surround the city. Cars buzzed over the cobblestones on Saginaw. This portion of the street was home to a mix of social and legal services, vacant storefronts and businesses like Jewelry World, Paging Plus, and Family Dollar.

Parking wasn't a problem. I quickly found a space and shoved a few coins into a meter. Then I walked north on a wide sidewalk, past a store that sold pipes and tobacco. I peered through a hole in a painted facade. Behind it was nothing but a vacant lot. Further north was the Mott Foundation Building, a multi-story art deco structure that bears the name of former GM board member and Flint mayor Charles Stewart Mott. Mott once told Studs Terkel the sit-down strikers should have been forced by National Guardsmen to evacuate GM's facilities. "And if they didn't," Mott said of the workers, "they should have been shot."

Past the Mott Building were the modern brick structures of the University of Michigan-Flint, a regional campus with six thousand students. Its newest addition was a steel and glass pavilion that housed a food court, shops, and a bookstore. Inside, clusters of students sat at small tables and sipped soft drinks from paper cups. Across the street was a new Ramada Inn and a Citizens Bank. This was the most ambitious portion of the city's downtown.

I continued a short distance until I crossed a bridge over the Flint River and entered a park near the water's edge. Along a paved path stood a twelve-foot-high monument commemorating the fiftieth anniversary of the sit-down strike. It was adorned with painted tiles depicting scenes from the strike and life within the factory, but in several places the ceramic had flaked off and lay in pieces on the ground. I could hear the river rushing by, and a stiff breeze whipped a rope against a nearby aluminum flagpole, sounding a relentless *bong-bong-bong*. This section of the park was eerie and lonely. Flint had watched the UAW grow from a small, insignificant organization to the world's largest industrial union, but the monument along the Flint River looked more like a tombstone than a celebration of beginnings, longevity, and achievement.

Several feet away, traffic continued to move along Saginaw, a north-south route that bisects the city, extending more than six miles within Flint's borders. Along the street's length, I would find places where people huddled and talked about the things they had lost (or were soon to lose) and about their work (or what was left of their work). Sometimes they laughed and joked or simply smiled, and I wondered if they knew something I didn't. The most thoughtful understood that struggle was like a second skin; you'd never be rid of it. It didn't matter if your city was an icon or an unknown. Struggle was always there and always would be. You had no choice but to deal with it. But how? You could laugh, you could cry, you could burn with anger. You could numb yourself with drink, flee, lean into hardship as if it were a stiff

wind and forge blindly ahead. You could open your eyes and look into your past, see how your parents and grandparents had struggled, how they had succeeded and failed, and see how their decisions and hardships and efforts had brought you to this point, to your own struggle. You could see how the same would happen with you and your children, and theirs. Perhaps in that way you could embrace the struggle, and your place in it, and accept it as the price for a certain grace.

The day after arriving in Flint, I met Bob Keith at a UAW hall on the city's south side. He looked like a man determined to defy mortality—thin, wiry, and energetic. I thought to myself: this ninety-plus-year-old man is a better monument to the UAW than the neglected concrete and ceramic monstrosity by the river's edge. Clad in polyester, his shirt buttoned to the top, Keith was a picture of neatness. His eyes were brown and clear and he had a large, weathered nose that extended out and downward, almost to his lips, as though it yearned to touch his chin. He was anxious to talk, so he marched into the office of the local's president and asked if we could use the space to chat. The president replied, "Anything for you, Bob." As we sat at a small round table, Keith told me about his life. His voice sometimes competed with that of the president, who made a series of phone calls at his desk a few feet away.

Keith was born in 1908, one of fifteen children raised by parents who grew cotton and corn on a number of farms in Oklahoma and Arkansas. The father, Charles Franklin Keith, refused to keep the family in one place for very long. Keith learned at an early age to bind chickens' legs together so they wouldn't run off or fly away during a move. "My mother used to say we moved so much the chickens could sense it coming, and they'd come up and cross their legs so we could tie 'em," Keith said.

By age seventeen, Keith had found work in a

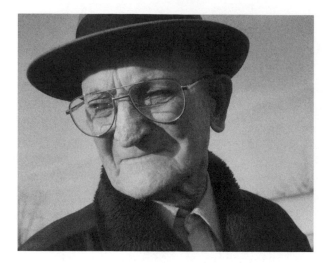

it. He was hired as an oil sander at Fisher Body No. 1, a sprawling factory that supplied GM with car bodies. Every day, Keith wrapped sandpaper around his hands and rubbed an oil mixture over painted auto bodies. Oil sanding added shine and polish to an automobile's finish, but the work could be quite painful. The oil used in the process had a tendency to burn workers' skin; Keith remembers how each nine-hour shift left his hands stiff and bleeding. And there was another, more vexing problem: At 135 pounds, Keith was simply too small to apply the proper pressure on the sandpaper. "You had to be a big man to do that work," he said. "I wasn't any bigger than I am now. I just couldn't do the work. I'd give out by two o'clock, and I'd give my jobs away to some of those big, husky guys. They'd get the money. I'd make six dollars a day; they'd make nine or ten."

After several months, Keith's life got a bit easier—he was moved out of the oil sanding department, and he eventually landed a job spraying paint on car bodies.

In 1933 Keith was introduced to a young woman who worked in the cut and sew department at Fisher Body. Keith thought she was pretty, so he asked her for a date. "She was a little leery of going out with me," Keith recalled. "She thought I was too old. That hot wind on the Oklahoma prairie made me look ten years older." A romance blossomed into marriage: Bob and Florence Keith were wedded in March of the following year.

Thirty-three months later, Fisher Body was on strike. Bob Keith was sleeping at the plant, making a bed out of car seat cushions. Florence was at home, making do with the money brought in by her eleven-year-old daughter from a previous marriage, who worked part-time at a drug store. "Maxene would come home and throw her money on the table," Keith said. "That's what we'd live on. Five or six dollars a week."

cotton gin, handling those heavy bales and driving a truck, but seasonal work simply wasn't enough. Three years later, he joined the hordes of young men leaving farms in the South and Midwest for jobs in Flint's growing auto industry. Rumor was, a man could earn five dollars a day in the factory. Keith made the trip in a Model T Ford with his brother-in-law and two other men. They drove in shifts, never stopping to sleep. Crossed the Mississippi River at Cairo, Illinois, aboard a paddle-wheel ferry that struggled in the current and had trouble landing on the flooded shoreline.

The car broke down in Indianapolis, so the men made the final leg of the trip in a bus, which dropped them off in Flint on a cool August night. Keith had only the clothes he wore and eleven dollars—ten of which he would give to his brother-in-law so he could retrieve the broken car.

Keith immediately set out to find work. He went from one employment office to another, stood in lines that extended for blocks. Turnover in Flint's auto factories was high, he said. The noise, pace, and monotony of "the shop" was too much for some of the farm boys who had migrated to Flint, and many departed after making enough money for the trip home.

Keith had trouble adjusting, too, but he kept at

The strike that began on December 30, 1936, was not the first at Fisher Body. In July 1930, workers walked out over a reduction in pay. Eventually, most of the plant's 7,600 employees took part, but the action lasted only eight days. Police harassed the workers, broke up picket lines and gatherings, and the strike was defeated. Those who took part were blacklisted. Another strike in 1933 suffered a similar fate.

Then came 1936, with its boiling summer heat and continuing speed-ups. Krause, the labor writer, described one week in July in which temperatures every day exceeded one hundred degrees. "The assembly lines pounded away mercilessly while many workers fell at their stations like flies," he writes. "Deaths in the state's auto centers ran into the hundreds within three or four days, and the clang of hospital ambulances was heard incessantly to and from the factories in Detroit, Pontiac and Flint."

Worker frustration at GM was reaching a high point, and late that year the sit-down strikes began. In November, there was a strike in Atlanta. Less than a month later, a plant in Kansas City went down. On December 28, a GM plant in Cleveland sat down. Two days later, the sit-downers hit GM at its birthplace, forcing the closure of Fisher Body No. 1 and the smaller Fisher Body No. 2. Strikes soon spread to other GM facilities in Flint.

Strike leaders inside the occupied plants emphasized discipline among the workers and set up a few rules—no alcohol, for one, and no damage to company property. Labor writer Mary Heaton Vorse visited Fisher Body No. 1 during the strike and described the factory as an "orderly little world" where men played ping-pong, listened to an improvised band, performed skits, and took classes in economics, labor history, and public speaking. Through it all, the unfinished cars on the stilled assembly line remained, "like crouching elephants," she wrote.

Strikers divided up daily chores. "I was one of the fours guys that did most of the cooking," Keith said "They had a little cafeteria in the basement and we cooked there. I scrambled so many eggs I got sick of them. Cracked them by the crate."

Because he owned a car, Keith was picked for another chore, one that sent him out into the community, where he heard what others in Flint thought of the strike. He drove his 1927 Chevrolet throughout the city, seeking help from grocers who could supply food on credit for the strikers. "Those merchants gave me such a hard time," he said. "They cussed the union. They'd say, 'Why don't you go to back to work if you want something?'"

As the strike dragged on, everyone seemed to expect violence. "Flint is so nervy that people jump at the sound of a siren," Mary Heaton Vorse wrote in February 1937. Governor Frank Murphy had called out the National Guard, with cavalry and machine guns. Workers at one Chevrolet plant in Flint were beaten and gassed when they tried to shut down their line and join the strike—a women's brigade rushed to the factory and broke windows to let in fresh air. The action was, in reality, a diversion by the union. While police and company thugs were busy at that plant, workers shut down a crucial Chevrolet plant some distance away, where motors were made.

And at Fisher Body No. 2, located a few miles from Fisher No. 1, police and strikers clashed on January 11 in what was later called "The Battle of Bull's Run." Fourteen strikers were shot and several police officers were injured when authorities tried unsuccessfully to take control of the plant.

Many credit Governor Murphy with preventing violence from erupting on a grand scale. He refused to order guardsmen to take control of the factories and kept pressure on General Motors to negotiate with the UAW. On the forty-fourth day of the strike, GM surrendered. The company an-

nounced it would recognize the union and negoti-ate hours, wages, and the speed-up.

Keith was at home when he learned of the agreement—he had returned there for a visit and a bath. Florence told him he had better return to the plant. "They might need you," she said. At Fisher No. 1, a factory whistle blew at five o'clock, and the evacuation began. Once outside, the workers joined thousands of supporters in a two-mile pa-rade that descended upon downtown Flint. Within a year, factory wages were increased—in some cases, from thirty cents an hour to a dollar an hour—and the UAW grew from thirty thousand members to half a million.

On Labor Day 1987, Flint again celebrated with a parade—this one to mark the fiftieth anniversary of the strike. Keith rode in a float and waved at a crowd estimated at more than sixty thousand, and a monument commemorating the strike was un-veiled by the Flint River. Two months later, on December 10, GM closed the historic factory that was the center of the strike. "Fisher 1 is history," read the *Flint Journal* in an edition filled with bad news. Above the story of the plant's closing was an announcement that the U.S. trade deficit had reached an all-time high. Winter had come to Flint. Sunny days and parades were a distant, pleasant memory.

ii

The three men were sitting around a small square table. They were leaning back in their chairs, drinking Budweiser beer with shots of vodka and smoking cigarettes—something you'd prefer to do in a place blessed with a padded floor and a high level of fireproofing. Payne's Bar had neither, but it lingered when nearly everything else had departed, and on South Saginaw Street, that's really all that mattered.

The three were regulars and they knew the waitress, who delivered another round and showed off a ring she wore. "I'm engaged to get married," she announced in a deep voice. She had short, wavy blonde hair and was dressed in white shorts and a T-shirt. She appeared to be pushing forty.

"You going to start wearing a bra, then?" asked one of the men. The waitress smacked the back of the man's head, jarring loose a round of marriage jokes.

"How do you tell if your wife is dead?" the man began.

His friends looked at him, waiting.

"The sex is the same, but the dishes pile up."

Two patrons sitting at the bar had been listen-ing, and they laughed. One of them wore a black T-shirt and was counting coins scattered on the bar before him. He had gone through the dimes and nickels. Not enough to buy a beer. He had origi-nally vowed to drink only until he ran out of change, but now lack of financial resources seemed a silly reason to stay sober. He had turned to those at the table because he knew they were good for at least a loan, maybe an outright grant. It wouldn't take much: this was fifty-cent draft night at Payne's. Time for cheap drinks, though no one in this small, dark establishment was calling it Happy Hour.

Payne's had been around for a long time. It sat on a wide and busy stretch of Saginaw, near the city line, about two miles south of downtown. Several years before, Payne's had served as a watering hole for those who had worked at one of the country's most historic factories—Fisher Body No. 1, which was located directly across the street. Employees used to stop by during lunch breaks for quick sandwiches and drinks. Now the factory was gone—demolished in 1988, less than a year after it was closed by GM—but the plant's ghostly presence was still felt at Payne's. Many of the bar's regular customers were former Fisher No. 1 workers. They stopped by because their friends were there, or because it was a habit they

didn't want to break, or because the beer was cheap.

Two of the three at the table spent time at Fisher No. 1.

"I was one of the last dogs there," said one. His name was Norm, he was forty-two years old, and he had spent eighteen years at the plant. He wore a blue baseball cap, a white T-shirt, and blue jeans that had been cut into shorts. "I was a booth cleaner, a relief man. You name it, I did it. I didn't want to stay in one job too long."

Another man cut in.

"I was AR—absentee replacement," he said. "If somebody didn't show up, I worked their job."

This second man was John, but "everybody here knows me as Little John," he explained. "When I started in the shop, there were three or four guys named John. I was the smallest one." Little John was forty-three, and he had shoulder-length hair that was turning gray. A bushy mustache curled over his lip and invaded his mouth. On this day, he wore a white T-shirt emblazoned with the phrase, "Super Turkey."

Both were at the plant on its final day of production—December 10, 1987. Workers scrawled their names on the inside of the last car body to roll off the line.

"It was a big party," Norm said. "It was bad feelings, too, because people were losing their jobs."

"I've been to five plants since then," Little John said. "Now I'm at Flint Metal Fab, which makes fenders, hoods. It's a parts plant."

He paused, then thought about his last day at Fisher No. 1. "It was an up-and-down day."

"Yeah, not knowing what would happen next," Norm added. "We were all like family. You spent more time with the friends you worked with than you did your family."

"There was moonshine, whiskey. Just about anything you wanted, they had in there." Little John had returned to the party. "The people wanted to close it down in style." He took a camera to work that day. "Damn, I should have brought the pictures."

"A lot of people just didn't believe they'd close the plant," Norm said. "GM had just put money into the vent area, spent money on the paint area. Then, six months later, they closed the plant."

A portion of *Roger & Me* was filmed the day Fisher No. 1 was closed. On the last hour of the plant's operation, filmmaker Michael Moore tried to interview some of the workers through a first-floor window, but was told by a GM spokesperson that he has to leave because he's invading "a very private, emotional family time, and we would not let outsiders in the plant."

"I had eighteen years in with GM," Norm said. "I took a buyout."

"I had about fifteen years," Little John said. "I threw my arms up in the air and said, 'Fuck it.' I went on unemployment and GIS [Guaranteed Income Supplement]. I ended up with about half my pay."

"Yeah, you're making five hundred a week, then all the sudden you're down to two fifty," Norm said. "You do a lot of side jobs and get paid in cash."

"I did some painting and landscaping," John explained.

"I took the buyout and started hanging drywall," Norm said. "My dad worked at Metal Fab. Then he went to Fisher Body. My dad worked in the factory 29.8 years. He retired after he had a heart attack. They wouldn't let him come back into the shop. They said he was unfit for industrial work. He was out eight or nine years, then he had a massive heart attack. GM didn't care."

"As long as you don't stop the line," Little John added.

"If it's down a minute, it costs thousands of dollars."

"You'd better have one very good reason to stop it."

Suddenly, we heard a *beep-beep-beep*. Behind us, a man playing pool at the only billiards table in the bar stopped in midshot and checked a pager attached to his belt. "It's an Internet pager," he explained, looking at us. "I've got to keep an eye on my stocks."

Norm paid no attention.

"I don't miss factory work," he said.

"Not even the camaraderie?" Little John asked.

"I miss my buddies. I work twice as hard now as I did in the shop. Over there, all I did was stand and sweat. Put a few screws in. Well, more than a few. Now I hang sixteen-foot sheets of drywall. But I like it a lot better. I'm my own boss."

Little John nodded in agreement. "There's too much political bullshit in the shop. Union and management bullshit. The union will feed you with bullshit up to here."

"Two more years and I could have retired," Norm lamented. "I took a buyout. I don't work there no more, so it don't matter to me."

With that, Norm stood up and headed to the bathroom at the back of the bar. There was a pause in the conversation, so I took a good look at Payne's. The walls were covered with dark paneling, NASCAR posters, Budweiser ads, and schedules for Detroit's professional hockey and football teams—the Red Wings and the Lions. Gray carpet covered the floor. Payne's was designed to absorb anything and everything—beer, smoke, even light. Walk into the place on a sunny day, as I did, and you're blinded for several moments until your eyes adjust to the dark.

Little John began to detail his work experience: "I was on unemployment two and a half years after Fisher 1 closed. Then I went to Truck and Bus in Fort Wayne for two years. Then I went to Saginaw for two years. Then to Flint Truck and Bus for two years. Now I'm at Metal Fab. I've been there a year. I wish I didn't have to move so much. I've worked

on cars, vans, and trucks. Anything on the inside of your vehicle, I can do. Six years to go before retirement. I've got twenty-four years in."

The third man at the table had been silent. His name was Scott, and he was a burly, muscular man of thirty-three years. He had dark hair and a boyish face. A woman walked by and he nodded at her. I asked him, "Did you work at Fisher 1?"

"No," he replied. "They were laying off left and right when I got out of school, so I said, 'I'm going into the service. I've got to get out of Flint.' I came back in '86. It was rough. Then the plant across the street closed. I said, 'Oh my God.'"

He continued: "When you grow up in an auto town like this, you think, 'Man, I can't wait. These guys working in the factory are making big money.' But I've got to hang goddamn drywall. I've got to work like hell to keep up with the guys in the shop. And I don't have the benefits."

"That's the only thing I stay in for is the bennies," Little John interrupted.

"As close as I could get to the shop was auto mechanics in high school," Scott said. "But it all went to hell. I had to go into the navy and learn diesel engines. Then when I got out and came home to Flint, it was worse than when I left—eight times worse. I thought, 'This is going to be harder than I ever imagined.' I worked on semi trucks for two years. But then it got so tight, there wasn't any work. So I went back into the navy. Then, after I got out of the service again, I lived down South. I was working on autos for Chrysler in South Carolina as a technician—it sounds more professional than a mechanic. Then I came back. I missed my family. I've been hanging drywall for two years now. I've got to make something of my future. You can't count on nothing. I want to do the best I can. I want to be successful, and I want a whole lot of money. And I'll do it."

Payne's Bar is separated from the lunatic drivers on South Saginaw by a thin strip of concrete. Walking along this sidewalk, I felt the whoosh of speeding cars and realized I was but a few feet from getting hit. On the bar's side of the street are a number of small businesses, most of them in short, dumpy buildings several decades old. There's Jim's Garage Liquor Store, Stooges Suds and Lunch, Kimberly's Pub, Ray's Bar, a tanning salon called "Perfect 10," and a massage parlor.

You can cross the street at a traffic light, retrace the steps of thousands of workers from Fisher Body No. 1, but there's not much to see once you reach the other side. Fisher No. 1 has been replaced by an ugly, uninviting complex given an appropriately ugly name—the Great Lakes Technology Centre.

Demolition of Fisher No. 1 began in September 1988, and on warm days retirees would sit on benches and watch as the aging plant's walls came tumbling down. When it got cold, the old-timers would sit in their cars, "lined up as if at a drive-in movie," according to the *Flint Journal*.

"It kind of hurt," said Bob Keith, who had spent so much of his life laboring at Fisher No. 1. "It was like they were taking a part of you with it." Younger workers were affected, too. "I avoided this area for a while," Little John told me. "I'd get choked up when I'd drive by. I wanted to remember it for the way it was."

General Motors still has a presence on the old Fisher No. 1 site—the Tech Centre is home to several GM entities, such as an engineering and development center and AC Rochester division's world headquarters. Built in 1989, its small windows and high brick walls give it the look of a garrison, a Fort Apache for the suburban business suit crowd trapped in an unsightly urban setting. A moat of grass one hundred feet wide separates the complex from the road. Those who built the center must have feared that the populace would once again rise up, as it did in 1936, and storm the gates. This time the bosses would be ready.

Despite the fortification, I wanted to storm the gates, but I had trouble finding a door. I walked around to a side entrance and entered a wide hallway. Inside, several men in business suits walked purposefully and quietly, their heads down, hands in pockets. I followed them until I came to a glass atrium that looked out over an expanse of grass, to South Saginaw and the beer joints on the other side. Rush-hour traffic, so close and menacing on the sidewalk at Payne's Bar, seemed to crawl slowly and silently. If I hadn't recently felt the breeze created by four thousand pounds of metal whizzing past at forty miles per hour, I'd have thought the safety of South Saginaw was simply a matter of perspective.

The next day, a dozen or so men relaxed in the shade of a large maple tree four miles north of Payne's Bar, on the other side of Flint. It was just past noon and already it was muggy. Rays of sun filtered down through the leaves and formed pockets of light and heat within the cool shade. Most of the men under the tree were auto workers on break from their jobs at the Buick City complex, half a block away, across a barren parking lot and a two-lane strip of road called Industrial Avenue. A few workers sat in worn and weathered chairs, remnants from a cheap dining room set. One tall man sprawled in a liberated automobile seat that was hemorrhaging yellow stuffing. Others stood or sat on a concrete parking pad that served as the group's base.

At the time, Buick City was still humming, still breathing. For Flint, the huge plant—several stories high in many places, and extending more than twenty blocks—was a special place. Pride and

history made it so. The facility was a sort of last stand, the only factory where Flint's workers could continue to say proudly, "We make cars." And it stood on hallowed ground. Buick City was located on the same piece of land once occupied by the factory in which Billy Durant and David Buick pooled their talents and resources in 1905.

On this day of sun and shade, more than ninety years later, LeSabres continued to roll off the assembly line and approximately three thousand people continued to collect paychecks. Those who knew what to listen for, however, heard a rattle in the factory's lungs, a wheeze as it exhaled. Attentive workers knew the end was near. "In the next two years, this will be all gone," predicted one. "Buick City is not promising."

But most of those relaxing under the tree weren't worried about the future. The factory had life today, and it at once sustained and drained them. They lounged with their shirttails out and bitched about the shop. Then they extolled its virtues. It made them miserable and merry. It killed them and gave them life.

"They'll slowly work you to death in there," complained one lanky middle-aged man. He sat with his legs crossed and wore work boots with no socks. "There's nothing in your favor."

"You start out with thirty people in a department, then you're down to nineteen. But you still have to do the same work that thirty people did. Then they'll cut the department down to twelve people. It never stops."

"Then a guy at the top gets a million dollar salary," added another. "That hurts, too. That's below the belt. The profit-sharing check we got last year was only $350—and then the union took their part. The day we got those checks, we were mad. If a guy would have come in a bar that night with a Ford or Chrysler shirt, he would have gotten robbed.

"We make the best cars there is," he continued.

"I don't mind working hard, but I wish those guys who make millions would give some of these guys some of that money. When these guys are happy, they work harder."

Another worker said, "The parts we make require lots of coolants. There are a lot of fumes in the air. I used to work in the transmission shop. After work I'd go into a bar to have a drink and the guys next to me would say, 'Hey, you just got out of the shop.' All those fumes, they could smell it."

"A guy who puts in thirty years don't live two or three years after he retires," added an extremely thin man wearing a plaid shirt and large sunglasses. "Then he dies."

That comment started a discussion about former workers who had passed away—a morbid task drawn to a conclusion by a tall man wearing a cowboy hat.

"I love it here," he said.

"That's because you've got it made."

Another man was rubbing his eyes. "I don't love it, but I've got to deal with it," he said. He looked exhausted. "The police were at my house all night. It was because of the neighbors."

Other workers wandered from the plant and joined the group. They exchanged shop gossip, talked about cars and spouses and kids, and bummed cigarettes from each other. A few were drinking forty-ounce beers wrapped in brown paper bags. Two women arrived—they stood and chatted with a few men near the trunk of the maple. Suddenly, there was laughter, and one man darted from the small circle. He was briefly chased by a middle-aged woman holding a beer and wearing a Mickey Mouse shirt. "Keep your hands off me," she yelled at the man. "I'll get my razor." Both cackled.

The man was wearing a blue work shirt with a name tag sewn over the breast pocket. "Shelly," it read. He sat on the concrete slab and listened to the other workers talk about their jobs. He smoked a cigarette and smiled easily. The shop talk seemed

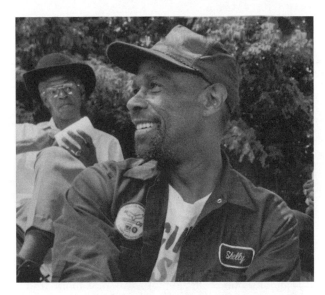

of little interest to him. When the middle-aged lady stood nearby, he grabbed her leg and said, "They do have some big thighs in this town." She slapped him on the back.

"I'm sixty-two and I'm still in good shape," she said.

"You in good shape," Shelly agreed.

The woman looked at me. I was holding a notebook and a pen. She asked why I was taking notes. I told her I was writing about Flint, and the people who lived and worked in the city.

"I was from the South," she announced. "This was the Promised Land. To get away from picking cotton, you came up North, to work in the factories."

"Do you work for GM?" I asked.

No, she replied, she didn't work for GM. But she seemed to long for an auto worker's paycheck and the problems of working in the shop. "I've been here since 1955," the woman said. "I've put applications in all over the place and they never called me. Now I work in a minimum wage job. I take care of handicapped people. We don't get the raises these guys get. They don't change my damn salary. You know how much bread is? Dollar ninety-nine a loaf. It used to cost a dollar seventy-five a

loaf. I know. I go to the store. If GM gets a raise, everything here goes up. It affects everybody—even those who don't get a raise."

Several of the men nodded in agreement. Most had been working for GM for more than twenty-five years, and they knew they had good jobs. For a few moments, there was silence. Then one man spoke about the younger workers, those without seniority. They'd be the first to go in the event of layoffs, he said.

"Those are the guys who are on edge. They don't have any seniority. Rumors bother them. They know they're next in line to get laid off. They wonder where they're going to go. They've lived here all their lives. Where are they going to go?"

~

The day matured, as Midwestern summer days often do, into ambiguity. The sun hid behind a thin layer of white clouds, so it was neither cloudy nor clear, or it was both, depending on your level of optimism. Was it hot? Was it cool? Yes and yes, or no and no. Everything seemed uncertain. Even the local newspaper got into the act. "Buick City's fate still said to be undetermined," read a headline in the next day's edition. There had been speculation that the assembly center was doomed to close, the story said, but GM officials were assuring local politicians that its fate had yet to be decided. "It's not bad news," one politician said of the company's pronouncement.

On this afternoon of uncertainty, Vicki Brill and several of her co-workers exited Buick City with at least one bit of concrete knowledge: they would be out of work for at least two days. The temporary closing was the result of a transmission shortage, caused by a strike at a GM facility in Warren, Michigan. A photographer from the *Flint Journal* snapped pictures of the exodus of workers. Plant closures were old news in Flint, but they were still

news, and the next day Vicki would find herself on the front page of the *Journal,* sandwiched between the headline about Buick City's uncertain fate and a story about the strike.

Several months later, all the uncertainty would vanish, all the questions would be answered. The Buick City assembly center closed in June 1999 and became yet another giant factory with the wind whistling through its empty loading docks. Flint, the birthplace of GM, became a maker of pieces of cars, but not the cars themselves. "It's over," the *Flint Journal* cried in bold type.

But on the day of unknowns, when Vicki Brill was photographed at the plant gate, there was still hope that the assembly center would remain open. Vicki wanted to retire from Buick City. She'd started there in 1976, a time when men still hooted and whistled when a woman walked down the aisle. The catcalls finally stopped, but time didn't. It goes by quickly, she said. Twenty-one years at the plant. She shook her head, like she couldn't believe it herself.

She was forty-two now, still attractive, a redhead who, on this day, wore white shorts and tennis shoes and a red T-shirt. A large purse was slung over one shoulder. If not for the plastic lunch container she carried, you could mistake her for a woman heading to the mall, or to a Little League ball game to watch her kids.

Her talk was of blue-collar concerns. About life in the shop, she said, "It's only gotten more difficult. The downsizing, shipping work out. If three people are doing a job, they'll just get rid of one. Then they expect two people to do the job."

She paused and added, "Plus, we're getting older."

Then this woman who looked so young and vibrant talked of retirement. She'd like to finish her career at Buick City, but wasn't certain it would happen. She wondered why some of the older workers, those who could have retired long ago,

stuck around. "There are a few in there who've put forty years in," she said, motioning back to the plant. "Why are they still there? You'd think they'd retire and let some of us younger people stay around."

Her voice contained resignation, not bitterness. She's a Flint native, and Flint natives have seen uncertainty before. They've seen uncertainty evolve into bad news. She hangs on to the good news: she's a well-protected UAW member—if Buick City closes, she'd probably be transferred to a GM facility in Saginaw or Lake Orion. She'd keep her home in a Flint suburb and every day her need to work would take her away from the city, the way it had recently taken her twenty-two-year-old son to Colorado. "He'll stay there, probably forever," she said. "There's nothing here anymore."

vi

Tennessee soil can be hard and unforgiving, and when it was shoveled into Hattie Chilton's grave, it landed with a dull sound that found a home deep inside Hattie's twelve-year-old daughter Emma. With that sound, the girl lost her mother, and the Chilton family lost the mooring pin that held it in the small Tennessee town of Brownsville. Once ovarian cancer claimed Hattie, the economic currents flowing north toward the factories in Michigan swept up the Chiltons, carried them more than six hundred miles into Flint. Then fifty years passed. Emma grew up, married, raised a daughter, and worked. She heard a lot of things in that time—the gospel music she loves to sing, lawyers arguing over the death of her murdered sister, occasional gunshots in a declining neighborhood, the hum and honk of workers' cars streaming out of a General Motors plant two blocks away, and, as factory work dried up and the neighborhood calmed, mostly silence—but nothing that sounded like God's own earth falling

six feet into a dark hole and crashing onto her mother's coffin.

I first saw Emma on a warm afternoon while I was driving along Leith Street, which dead-ends at an entrance to Buick City. Emma was wearing a bright pink dress and sitting on a white plastic lawn chair, and she stood out in a neighborhood rubbed raw by its proximity to a major industrial complex. Collapsing homes blistered the area, but Emma was on the porch of a wood frame house that appeared solid. I stopped to chat for a few minutes. I wanted to ask her what it was like to live in the shadow of GM's giant facility, but we never got to that subject. Buick City, which at first seemed to diminish all human presence, quickly receded as we talked about the two tragic events that had shaped Emma's life—the death of her mother in 1949, and her sister's murder in the late 1970s. As I listened to her story, how she survived tremendous loss, I wondered: had her spirit remained intact? Or was there, deep inside, a bitterness waiting to percolate to the surface?

Emma grew up in Brownsville, a small town fifty miles northeast of Memphis. She was one of ten children—five girls and five boys—born to Henry and Hattie Chilton. Most were birthed by midwifes in the Chilton home. Emma, the third girl in the family, was born in a hospital. Both parents worked—Henry was a carpenter and Hattie washed clothes for white families in the Brownsville area. As a girl, Emma often helped her mother by carrying laundry and ironing.

Emma remembers the racism of a Southern town in the 1940s. Her father sometimes talked about a lynching that had taken place in Brownsville. Other, less violent acts of bigotry were more than just stories. "They'd blow a whistle at ten o'clock and all the blacks had to get off the street," Emma said. "I can remember asking my father, 'Why would they do that? Why would they call me *gal?*' I could never understand why I'd have

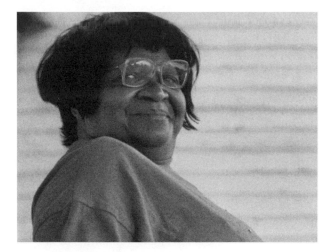

to wait in the back of lines. My father said, 'You just have to understand. That's the way it is.'"

So there was racism. Then came the cancer.

Emma began to tell me about the pain her mother suffered, how Hattie could eat only baby food in her final days, but the daughter's voice trailed off and she moved on to talk about other things, mostly the music she sings. I clumsily drew Emma back to the subject of her mother's death—I had experienced the loss of a parent, knew how it could fling your life in unpredictable directions, and wanted to hear how Emma's life had changed. I felt uncomfortable doing so. A sadness settled over Emma. She choked on her words. Half a century has passed, and yet the sting lingers. On a spring Sunday, Emma explained, her mother asked for the smallest children in the family to leave the house. That evening, while the children were at church, Hattie died. A cousin came to relay the news, and within days there was the trip to the graveyard, the falling Tennessee dirt, and the sound Emma hears to this day. "It was really a trauma, yes, Lord," Emma said. "But I adjusted." Henry figured there was nothing left in Brownsville for the Chiltons, so he moved the family to Flint, where he knew there were plenty of jobs. They weren't alone—in the 1940s and 1950s, those jobs

lured an estimated 4.3 million Southern blacks to Northern industrial cities, marking one of the largest migrations in U.S. history.

Emma made the trip in a car with her older sister Mary Jane and a few friends. For a while, Emma lived on Leith Street with one of her brothers. In Michigan, she finished what was left of her childhood, went to school, got married, had a daughter, then divorced. She talked little of her former husband, other than to say he never kept up with alimony payments. "Even though he worked for GM," she added. She mentioned her daughter often. She's a secretary, Emma said, and she has two daughters of her own. "I miss my granddaughters," Emma told me. "They said they'd rather live South than in Flint, Michigan. One is in Birmingham, teaching special education. She's moving to Atlanta. She has job offers from here in Troy, in Muskegon, and in Minnesota, but she don't want to live up this way anymore. Most of our youngsters, they graduate and leave and they don't come back here."

Emma spent much of her life working as a secretary in an office shared by two physicians. It's something she's proud of. "I never got help from no agency," she said. "I worked." She also played piano and organ and sang at a number of church functions—weddings, funerals, and the like. In December 1978, she was rehearsing for a Christmas musical when she received a telephone call alerting her that something had happened to Mary Jane, the oldest Chilton daughter. Mary Jane managed a grocery store in the Ann Arbor area, and Emma learned that night that she had been shot to death during a robbery. Several months later, a young white man was arrested and charged with the killing. "I went to the trial in Ann Arbor," Emma said. "These are things I can't forget. It was an all-white jury. My sister was killed with a gun the man had taken from someone else's house. They told it all in the trial."

The trial lasted a couple of weeks, but in the end, the young man was found "not guilty," Emma said. So now she lives with frustration as well as grief. "It's painful," she said, "yes, it still is."

Imagine you were in that car in the summer of 1949, a twelve-year-old girl at once frightened and excited by the adventure of moving hundreds of miles from home, still confused and shocked by the death of your mother, wondering if you'd ever see your friends again, too young to know if it's a good thing to leave a town that sends you to the back of every line, a town that insults you, calls you "gal." Thank God your older sister is there, an anchor, a reminder that you are part of a whole, part of a family. You and your sister look so much alike— people say they can't tell the two of you apart. And you both survived. Survived the trip, the grief, the changes. You adjusted. And then years later, on a night you would have remembered for Christmas carols and music that praised God, some fool with a gun takes that sister away. Now you remember that night for its shock, its sadness. You say farewell to your sister on a winter day, hundreds of miles from the Tennessee heat, then sit through a trial, hear the details of her death and, in the end, live with the knowledge that her murder goes unavenged.

At your home by the factory you watch, year after year, as workers leave at the end of their shifts, driving past in shiny Luminas, Dodge Ram trucks, and minivans. They're heading to the suburbs, where so much is so right, so safe, a land of uniformly neat houses, of wide-screen televisions and 401K savings plans, of easy laughter around a charcoal grill on a warm summer night. The procession of vehicles becomes a parade that magnifies the injustice you feel. Why must you be haunted by memories of dirt falling on a mother's coffin, memories of a murdered sister, and, especially, memories of the alleged killer who walked

away? Of course you burn for retribution, the only thing that will restore a sense of fairness and order to a wickedly unjust, chaotic world.

Or do you? Is it possible to rise above monumental injustice and loss, to find a measure of contentment, even happiness, in the wake of tragedy? The answer can be found on Leith Street, where one woman refuses to be hardened by the events that have caused her such pain. Emma Chilton thinks for a moment about the man accused of killing her sister, then softly says, "I have forgiven him."

vii

I listened to a lot of bad radio while driving to Flint. Finally, I got sick of it and braved the silence, only it wasn't really silence, because at sixty miles an hour, silence is impossible. The car engine rattles and hums, the rain splatters against the windshield, the wipers sound off with a *thump-thump-thump,* and the wind whistles from a passenger-side door that's not properly sealed. Still, it's all dead noise, nothing that occupies the mind.

When I crossed into Michigan near Ann Arbor and Detroit, the traffic thickened. I turned on the radio, searched for news—listened to reports about a shooting in Miami, a presidential fund-raising controversy.

An hour later, I brought my car to a stop in downtown Flint. There were still a few hours of light left in the day. A sign above a small storefront counseling office caught my attention—All Equal Center, it read. Inside, I was greeted by a man wearing a white shirt and tie and possessing an easy smile. His name was Lawrence Marks.

For forty minutes, we talked. I was surprised and pleased to meet someone of my own generation so quickly. Marks was thirty-eight and said he grew up in Flint when the city boomed and its

factories hummed. Decades earlier, his father, Jello Marks, an Alabama farmer who had won contests with the hogs he raised, had joined the great migration North. "My father's grandmother was found dead in a field in Alabama," Marks said. "They found her because of the smell. She'd been killed. My father never got over it. He was only nine or ten years old at the time. They came up here so they wouldn't have to deal with the harsh racism, and they could make quite a bit of money."

Jello Marks had a third-grade education, a strong back, and lots of desire—enough to get himself a job in one of Flint's auto factories, where he would stay until retirement. He and his wife, Ethelena, raised eight children—six sons and two daughters. The father urged his son Lawrence to seek a future in the shop. The son had other ideas. He had seen his older brother graduate from college and secure a job as a broadcast news reporter in New York. Lawrence Marks wanted to get an education. "That caused a conflict with my parents," Marks said. "They thought I should graduate from high school, get a job, get married, then get a house and retire from the shop after thirty years, and die five years after that."

When he was young, Marks thought athletics would get him out of Flint and away from a future in factories. His high school football coach once took him to Ann Arbor to see a University of Michigan game. Marks dreamed about playing for the Wolverines, perhaps as a "walk-on."

"That didn't pan out the way I wanted it to," he said with a shrug.

So in 1981 Marks joined the army. Got out three years later and returned to Flint, only to discover his hometown had changed. Wearing his uniform, he hopped off a bus, tossed his bag into a cab, and told the driver where he was going: Pierson Road in north Flint. The driver politely pulled the bag out of the cab and put it back on the

street. "No sir," he told Marks. "We don't go there after dark." Too dangerous. Hard times, homicide, and crack cocaine had come to his hometown.

"To me, it was almost like war was being declared on African-American communities," Marks said. "Economic shells were being dropped with layoffs and cutbacks. Then crack [cocaine] came in. People can make money with crack. You don't have to have an education. The [illegal drug-selling] industry took over for the factory industry. That's nonskilled labor right there." The risk? "You take a chance on getting arrested or shot, or having to shoot somebody else."

By then the shop jobs had dried up. Unemployment was climbing. He watched as Flint's great migration reversed itself. His friends were leaving, returning to the land their fathers and grandfathers had left a generation ago. There were jobs in the South, they heard, in places like Houston and Atlanta and the Carolinas. But Marks stuck around. For a while, he worked as a security guard and was briefly employed in that capacity at AutoWorld. Then for six years he worked as a corrections officer at a women's prison in Ohio.

Marks said he had only recently returned to Flint. Now he helped out at the All Equal Center, an organization whose posted purpose is to "combat and dispel all rumors, hearsay and innuendoes for the sole purpose of making this world a better place to live." Its founder was man named Omega McCurtis, Sr. His picture appeared on the photocopied informational flyers available near the front door. "If you're being discharged from your job, or have a workman's comp claim, we can look at the situation, gather information, put it all together," Marks explained. "And if you need anything, we'll refer you to the proper agency." There was pride in his voice when he said he had recently been appointed a "senior co-pastor" of the organization, and seemed sincere when he said he believed in the center's mission.

Marks said his father retired from the shop in 1980. When he left his job, no one was hired to replace him. Eight years later, Ethelena Marks died. The couple had been married more than forty years. After Ethelena's death, Jello Marks "went through a depression and never came out of it," said the son. Jello Marks lost a lung to cancer, then died in 1995.

On my final day in Flint, I saw Marks in a small downtown restaurant. It was morning, and sun poured in through large windows, making several seats too bright and hot to occupy. Marks was wearing shorts, anticipating the day's warmth. And he carried college textbooks. He was studying to earn an associate's degree. "The field I'm interested in is criminal justice," Marks said while standing in line. "Then I'll go into sociology."

Will he make it? Can Marks fulfill his dream? During the long ride home, and over the next several months, questions such as these hung in the air, nagging at me until finally I returned to Flint on a chilly November day to find answers. Once again, I parked on Saginaw Street, across from Jewelry World, walked past Paging Plus and Family Dollar. I looked for the counseling office where I had met Marks, and found the address. Above the storefront was the faint outline of a sign that had been removed: All Equal Center. A new sign has been attached. "Classic," it read. The location was now a men's clothing store.

Inside, a graying Asian man was sitting behind a counter, working on the store's books. What happened to the All Equal Center? The man behind the counter shrugged. "It's been gone a while," he said. "What's the man's name? Curtis? McCurtis? I don't know where he is. He never paid his rent. Everybody's looking for him. I'm looking, the IRS is looking. He didn't show up in court. He just disappeared. So I took all of his stuff out of the building. Nobody will pay rent here."

And what of Lawrence Marks? The man behind the counter had never heard of him. When asked, others on Saginaw Street reply: Who's Lawrence Marks? There is no Lawrence Marks in the Flint/Genesee County telephone directory. So where has he gone? There is hope that Lawrence Marks took the departure of the All Equal Center and its founder Omega McCurtis, Sr., as an opportunity and not just another disappointment, that he finally made his way to Ann Arbor and was studying criminal justice. It is possible. It does happen. You can ask enough questions, make enough phone calls, perhaps even knock on a few doors on Pierson Street, and discover the truth. But on this day, with its winds whipping through the shuttered sections of Buick City and stripping leaves from the trees on Riverfront Park, the simple truth seemed a frightening thing. Perhaps on this day it was best to remember Lawrence Marks as he was in the restaurant during an earlier visit—no longer young and perhaps a bit disillusioned, yet somewhat optimistic, energized by the warm summer day and the possibilities it offered. He was burdened but not crushed by his struggle, stirred but not bedeviled by the mystery of his future. It was a moment of equilibrium and perfect balance in an unsteady place.

Epilogue

Broken bricks and mortar were scattered on the wet pavement. Newly amputated tree limbs, still green with leaves, littered the street. The girl noticed none of it. She ignored the chaos, the shouts, the sirens, and strode quickly through the Mount Washington section of Pittsburgh, less than a mile from the city's downtown. She appeared to be fourteen years old, maybe fifteen, a young woman walking through hell to get home. From a distance, I followed her. We passed a car that had been pummeled by fallen bricks. I said to myself: "You should stop and photograph the destruction." Minutes earlier, a tornado had struck Pittsburgh. I was at a newspaper office downtown when the twister hit, had seen the disembodied roofs flying over Mount Washington. I ran from the building to my car in a nearby parking lot and felt the sting of tiny hailstones. Minutes later I arrived on the scene. This was news and I was on deadline.

Yet I couldn't stop following the girl. Her urgency pulled me along.

It was difficult to keep up. She would occasionally break into a jog for short distances. I was weighted down with camera equipment. After several blocks, the girl turned onto a road called Williams Street and began to sob. Here, the twister had ripped some trees from the ground, snapped others in half, stripped leaves and limbs from the survivors. On Williams Street, the tornado had thinned the woods and expanded an already stunning view of Pittsburgh's skyline—something residents wouldn't notice until much later. Certainly the girl paid no attention. She was closing in on a nightmare of unknown proportions. Her pace quickened until finally it was a run, a sprint that carried her into the arms of her family members, standing in front of their home, which had been ripped apart.

Amid the debris, parents and brothers and sisters embraced and wept. Within minutes, they were smiling, even as tears streaked down their cheeks. One family found comfort in the fact that it was together and whole in a place that had been torn apart. It was one small part of a larger story that needed to be told. I took pictures of the family members as they hugged. Minutes later, they told me about

their experiences during the storm. I learned their story so it could be shared by those who had felt the storm's wrath as well as by those who had been spared.

Quite often, we need to be reminded that we are part of a whole, that we are not alone in our grief or in our joy. Places like Homestead, Braddock, Lewiston, Matewan, and Flint have much to teach us—about the value and importance of work; about the risk in measuring yourself solely by that work; about the danger in becoming too dependent upon entities driven by profit; about the foolishness in believing the good times will never end. But their most crucial lesson is this: it is possible to endure the loss of many things, provided you don't suffer the burden alone. The knowledge that we are bonded to others through blood, and through common experience, gives us the strength to survive.

It is tragic that in many of our old and bruised industrial towns—towns that helped build the country and the lives we enjoy today—economic forces are eroding the institutions of family and community when they are most needed. Families split apart as sons and daughters leave to find work elsewhere. Downtown stores that were once gathering places go out of business as consumers take their money to shopping malls. Churches close as congregations die off or move to the suburbs. It's a testament to their strength that families and communities have survived at all, that they remain steadying forces even as they ebb.

In late 2000, we began hearing reports of an economic slowdown. Much of it was centered in the high-tech industry. Dot-com companies were laying off workers. Some were closing. Hard times were coming again, only this time the country had changed. Many young workers had known only a roaring economy—they had never experienced a recession. Chasing jobs and careers, they often found themselves in distant states, hundreds or thousands of miles from their parents, siblings, aunts, and uncles, all of whom had their own career concerns. In this new age, in communities forged during good times, where will people turn for support and strength when things go sour? Will communities of people who connect by cell phone and e-mail be cohesive enough to sustain their members in difficult days? In places like Braddock, Pennsylvania, the fibers binding the community together were weakening every day, but they were still there. On Talbot Avenue, the Dutrieuille family remained a presence, even though Miss Vicky was gone. Her son Andre and his family had moved into the house he'd purchased for his mother. The town's older men, though thinning in number, still trekked to the Polish Club. Every Sunday morning, worshippers continued to fill the Bethel Baptist Church. And until Joseph Szwarc became seriously ill, his barbershop continued to be a haven. His customers could have gone elsewhere, someplace newer and closer to their homes, but they insisted on coming to the small shop on Talbot Avenue because being there made them part of something, even though that something was falling apart. After Szwarc's death, older men in the Mon Valley savored the

memory of the man and his shop. They were bound together by that memory, and by the sadness they felt after losing another vital part of their lives. What would have happened to the street, to the town, if Szwarc and Miss Vicky had never been present?

In the late 1990s, my wife, Brenda, and I began the process of starting our own family—we completed the paperwork necessary to adopt children. A family needs the stability of a regular job, a regular paycheck, so I looked for a job and was lucky enough to find one at a Pittsburgh newspaper called the *Post-Gazette*. I closed the freelance photography business I had started in 1993. It had always been weighted down by my failure as a businessman and my limitations as a photographer. I was glad to be working as a newspaper photojournalist again, but I was not the trusting employee I had been before 1992, before the *Pittsburgh Press* disappeared. I had come to understand the newspaper business the way residents of Pittsburgh's Mount Washington understand summer weather: I know its stillness and light can be deceptive, that it can quickly give way to destruction.

Brenda and I adopted one child, then a second. Soon, our house was alive with the chaos of a growing family. It became a place of diapers, Big Bird, Dr. Seuss books, and small shoes clomping on hardwood floors. At night, when there is quiet, Brenda and I often discuss the lessons we want to teach our children. We want our daughters to know that work is important, that they should take pride in what they do, and do it well. But they should also understand that their lives are too broad and complex to be defined by that work. Jobs and professions can be rewarding and liberating, can provide a sense of accomplishment and connection. But jobs can also be swept away. Change can come quickly, wreck lives and communities. The gift we hope to give our daughters is the knowledge that they will not be profoundly alone should they find themselves surrounded by the debris of a destructive storm. The bonds of family and friends, and the faith in these things, will sustain them.

Index